exploring

SOUND DESIGN FOR INTERACTIVE MEDIA

Joseph Cancellaro

DELMAR
CENGAGE Learning™

Australia • Brazil • Japan • Korea • Mexico • Singapore • Spain • United Kingdom • United States

DELMAR
CENGAGE Learning

Exploring Sound Design for Interactive Media
Joseph Cancellaro

Vice President, Technology and Trades SBU:
 Alar Elken

Editorial Director: Sandy Clark

Acquisitions Editor: James Gish

Development Editor: Jaimie Wetzel

Marketing: David Garza

Channel Manager: William Lawrenson

Marketing Coordinator: Mark Pierro

Production Director: Mary Ellen Black

Production Editor: Dawn Jacobson

Technology Project Manager: Kevin Smith

Editorial Assistant: Niamh Matthews

Cover Image: *Wild River Reflections*
 © Jeanine Leech

For product information and technology assistance, contact us at
Cengage Learning Customer & Sales Support, 1-800-354-9706

For permission to use material from this text or product,
submit all requests online at **www.cengage.com/permissions**
Further permissions questions can be emailed to
permissionrequest@cengage.com

Library of Congress Control Number: 2005013974

ISBN-13: 978-1-4018-8102-3

ISBN-10: 1-4018-8102-5

Delmar
Executive Woods
5 Maxwell Drive
Clifton Park, NY 12065
USA

Cengage Learning is a leading provider of customized learning solutions with office locations around the globe, including Singapore, the United Kingdom, Australia, Mexico, Brazil, and Japan. Locate your local office at **www.cengage.com/global**

Cengage Learning products are represented in Canada by Nelson Education, Ltd.

To learn more about Delmar, visit **www.cengage.com/delmar**

Purchase any of our products at your local bookstore or at our preferred online store **www.CengageBrain.com**

Printed in the United States of America
4 5 6 7 14 13 12 11 10

dedication

I dedicate this book to my wife, Monika, and my children Nastazja, Julia and Joseph, and to the memory of my mother and father.

table of contents

TABLE OF CONTENTS

INTENDED AUDIENCE

Exploring Sound Design for Interactive Media was written with the sound student and professional in mind, but it doesn't stop there. Many aspects of sound design are explored, including introductory music theory which may be useful for even the veteran sound designer.

I decided early on that a step-by-step approach to sound would be necessary in order for students to get a thorough grounding in sound design. My first concern was making sure all aspects of the science of sound and the technical details of digital audio were included; without this knowledge, it is very difficult to move forward with the concepts of sound design. Once that material is firmly understood, the theoretical concepts of sound design and music theory are covered.

If you are interested in the principals of sound design for interactive media, then this is the book for you.The student of sound was my initial motivation for writing the book, but as work progressed I realized that some of the material—albeit, covered in less than a concentrated form—was important for even those who are professionally active in the field.

BACKGROUND OF THIS TEXT

I wrote this book because I saw a need in the classroom for a book that would introduce the primary topics associated with sound design and its relation to interactive media. Many students enter a class with very little knowledge of sound or the principals of sound. This book emerged from two classes: The introductory class (which addresses the fundamentals of acoustics, recording and reproduction, digital audio and contains many projects to help the student become familiar with the digital tools of the trade; web site sound integration is also covered) and the advanced sound design class (which covers the psychological and musical implications sound has on linear and non-linear visual media). The information contained in this book derives from both my own experiences—both teaching and working in the field as a composer and sound designer—as well as respected sources. My main goal was to put forth some of the more difficult aspects of sound in a form that could be easily grasped by the reader.

Finally, the professional is also considered in *Exploring Sound Design for Interactive Media*. Working with many sound designers helped me understand the needs and requirements of the current professional. Many sound designers want to study and understand music theory. Music theory provides great insight into the craft of sound design in relation to the entire soundtrack. The book contains a chapter on introductory music theory which should inspire the experienced sound designer and advanced student to further musical research.

The premise of the book is built on the assumption that the student learns to learn. Naturally, much more information could be given, but the student is encouraged to discover more about particular topics by investigating them independently. I hope that by reading this book both professionals and students will acquire enough knowledge to further their careers. After all, studying anything, especially sound and music, requires an endless curiosity and a love of the subject matter.

TEXTBOOK ORGANIZATION

Exploring Sound Design for Interactive Multimedia is divided into two parts. Part I addresses the practical considerations of sound and digital audio including working with audio and the computer. Chapter 1 explores the fundamentals of acoustics: The various ways in which sound moves in a space and the acoustic considerations necessary when constructing sound for multimedia projects. Chapter 2 examines microphones, loudspeakers, and consoles and how they are useful for a sound designer.

Chapter 3 discusses the basics of digital audio theory along with common types of errors. Chapter 4 covers the common hardware and software used in sound production on workstations. Tips and techniques are discussed regarding achieving the best audio quality possible for a given project.

Part II examines the theoretical aspects of sound design. Chapter 5 reviews music theory and ties together the commonalities between music and sound. Chapter 6 gets to the heart of the matter by exploring sound design techniques and principals which help the novice sound designer get started in both linear and nonlinear environments. Chapter 7 and 8 cover sound design techniques and theories for the web, streaming media and MIDI.

Finally Chapter 9 provides a few 3D frameworks from which to construct interactive 3D spaces using audio as the main tool. Different types of available game editors and 3D software packages are addressed.

BACK OF BOOK CD

The CD contains audio software which can be used to record, playback and manipulate sound. This allows the reader to immediately take advantage of some of the concepts presented. Along with this are examples

of different sound files representing different audio resolutions for the reader to hear. Music and sound examples are also given to support the theoretical concepts presented in the second-half of the book.

E.RESOURCE

This guide on CD was developed to assist instructors in planning and implementing their instructional programs. It includes sample syllabi for using this book in either an 11 or 15 week semester. It also provides chapter review questions and answers, exercises, PowerPoint slides highlighting the main topics, and additional instructor resources.

ISBN: 1-4018-8103-3

FEATURES

- Examines the adaptive audio techniques associated with game engines and editors, with practical examples that stimulate users to do their own problem-solving

- Covers the concepts that apply most directly to sound designers—and understanding of frequency and the intervallic and harmonic relationships provided by traditional harmony

- Features an exceptional overview of music theory for sound designers that highlights the psychological and acoustical relations between sound and image

- Presents a logical progression of content and clear, well-defined images, promoting a methodical approach to becoming a successful sound designer for interactive media

- Examines the principles of acoustics and digital audio in a clear and concise way, written for the beginner

- Provides a great starting point for recording and reproducing sound

HOW TO USE THIS TEXT

The following features can be found throughout this book:

▶ Objectives

Learning Objectives start off each chapter. They describe the competencies the reader should achieve upon understanding the chapter material.

▶ Notes

Notes provide special hints, practical techniques, and information to the reader.

▶ Profiles

All of the Profiles are Historical in nature.

▶ Review Questions and Exercises

Review Questions are located at the end of each chapter and allow the reader to assess their understanding of the text. Exercises are found at the end of select chapters and are intended to reinforce chapter material through practical application.

about the author

Active as composer and sound designer for over twenty years, Joseph Cancellaro has worked both professionally and academically in many parts of the world. His music is performed worldwide and he has a constant stream of film and interactive sound work which keeps him busy when not composing music for the concert stage.

Joseph Cancellaro was the lead sound designer at the Poznan Super-computing and Networking Center in Poznan, Poland as well as an adjunct Professor of Music at the I.M Paderewski Poznan Academy of music, in Poland. In 1995 Joseph coordinated the NEXUS conference in Edinburgh, Scotland which presented research regarding the combined disciplines of architecture, music, sound, sacred geometry and mathematics. He organized many concerts at home and abroad for American artists and American contemporary music.

Joseph received a BM in Film Scoring and Composition from Berklee College of Music, an MM in Composition from the New England Conservatory of Music and a Ph.D. in Composition from the University of Edinburgh, Scotland. He has been teaching since 1989 and is currently a full-time faculty member at Columbia College, Chicago.

Joseph lives in the Western Suburbs of Chicago with his wife Monika and three children, Nastazja, Julia and Joseph.

acknowledgments

This book is here today because of the desire and curiosity of the many students I have had the pleasure of teaching. Without their well-crafted questions to spark the inquiring process there, this would be a very thin book.

Parts of this book just could not be written, particularly chapters 2, 4, 7 and 8, without the help of a few extremely enlightened people, namely Jeff Meyers and Dave Gerding.

One of the most important things to have when writing a book is time. I must acknowledge a few individuals who allowed me the opportunity to write without the pressures associated with work and smaller tasks which needed to be taken care of regardless of books or anything else. It could not have been done without the effort of Robyn Martin and Katrina Williams, the generosity of Doreen Bartoni, Debra Schneiger and Wade Roberts, and the endless patience and understanding of my wife Monika.

Truly, this entire effort would not come to fruition if it were not for the great help and understanding of the crew at Delmar, especially Jaimie Wetzel, Dawn Jacobson, Niamh Matthews and Meghan Barbosa. A special thanks to Jim Gish who is really one of a kind, he made the entire process painless and very comfortable. If I forgot anybody, I sincerely apologize.

Thomson Delmar Learning and the author would also like to thank the following reviewers for their valuable suggestions and expertise:

Dr. John Mark Harris
Music Department
Preuss School
University of California, San Diego
San Diego, California

Jeff Meyers
Interactive Media Department
Columbia College Chicago
Chicago, Illinois

Matt Meyer
Digital Media Production Department
Art Institute of Portland
Portland, Oregon

Colin O'Neill
Digital Media Production Department
Art Institute of Portland
Portland, Oregon

Joseph Cancellaro, *2005*

QUESTIONS AND FEEDBACK

Thomson Delmar Learning and the author welcome your questions and feedback. If you have suggestions that you think others would benefit from, please let us know and we will try to include them in the next edition.

To send us your questions and/or feedback, you can contact the publisher at:

Thomson Delmar Learning
Executive Woods
5 Maxwell Drive
Clifton Park, NY 12065
Attn: Graphic Communications Team
800-998-7498

Or the author at:

jcancellaro@interactive.colum.edu

introduction

Sound is a wonderful physical event which has the power to shape what is seen and understood. It can create the darkest moods or the most brilliant warmth and alternate between then with the most unique subtlety. Sound, of course includes music, sound effects and dialogue, and the combination of these three essentials make up the sound world around you. Understanding the principals behind these sound entities is crucial. Once the general concepts behind sound are understood, more advanced sound topics can be addressed such as music theory and sound design theory.

It is important to remember that all composers and sound designers had to start from the beginning. The urge of many is to jump ahead because they feel that seemingly remedial material is unnecessary to review or read again, or that they do not need to read one section or another. Please try not to do this, even if you know the material. It is always constructive to read about a topic from someone else's point of view, even familiar subjects. Be patient and methodically work your way through the chapters. Slowly all of the information will meld into a conclusive whole and then the real creativity can start.

SECTION

| practical knowledge |

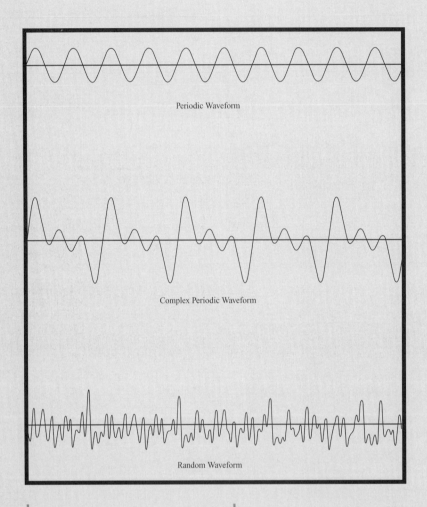

Periodic Waveform

Complex Periodic Waveform

Random Waveform

acoustics from the beginning

objectives

Introduce the fundamental concepts of acoustics and the nature of sound

Present the relationships between acoustics and sound design

introduction

This chapter introduces the fundamental concepts associated with the science of acoustics. All of the applicable information needed to create a firm foundation on which to build solid sound design techniques are presented.

ACOUSTICS FROM THE BEGINNING

DID YOU HEAR THAT?

Well, did you? Most likely the answer will be "I didn't hear anything," but in fact you heard a lot. Sound is all around us. Pay attention for a moment to the sounds your environment is creating. Hear the computer, the heater in your house, the 15-kHz buzz from your monitor, the birds chirping. These are the obvious sounds of your surroundings. Did you notice the sound of the air moving in and out of your lungs? This is not so obvious, partially because you are used to hearing yourself breathe. Your breath is correlated with your need for oxygen, which is fueled by your heart. Did you hear your heart beating? Now your are listening. The rhythm and tempo of your heart plays an important role in how you feel and cognate beats and rhythm in music.

Your exposure to music and sound is much different than for any generation before you. This is partly due to the explosion of the digital recording and reproduction process and the astounding technological advances and ready availability of audio hardware. One of the most important reasons for our massive exposure to sound is the ease with which we can consume it. In the past, when the only place you could hear music was in your living room or a concert hall, the sensation of listening was enhanced and sharpened. Imagine if you could hear a piece of music that you love only when a live performer could play it. Your aural memory would become astoundingly astute. The nuances and gestures would be imprinted into your aural memory because of the level of concentration that would be required to retain the musical image. In general, the retention of what you heard would be enhanced. The other side of the scale looks a little different. Every time you turn on the radio, CD player, DVD player, or surround sound system, you are exposed to sound in the form of human voice, sound effects, and music. A popular song on the radio could be played as much as once an hour. Once an hour! You could buy the CD and listen to it nonstop if you wanted. That is a lot of exposure. This can be advantageous when trying to analyze or key into certain aspects of an aural event. The downside is that aural memory does not have to work as hard when the music/sound material can be accessed at any time. By keeping this in mind, you can become a more active listener and creator of sound. You will appreciate and care for all of the sound work you create by keeping a sense of freshness and urgency to your work.

Now that you are primed, where do we start when trying to understand the effects and consequences that sound has on individual users or listeners? One of the first things that needs to be addressed is the science of sound. Examining the properties of sound in order to fully understand how we can effectively use sound for both the entertainment industry and for interactive media is a logical starting point.

Sound as a Science

Acoustics is the science of sound and is one of the main divisions of classical physics. You may think of it as the study and analysis of sound properties. The adventure in sound naturally starts here. Your first impulse may be to get right down to sound designing and let your ear and

troubleshooting skills rule the day. This may be effective to a certain degree, but understanding the elements of your trade allows you to create a more subtle and organic soundtrack. If you are going to take sound seriously, and want the chops to go along with your passion, then studying acoustics is one of the most important long-term information sets you can obtain. Understanding acoustics will create many avenues of thought later when you are actually generating sound for an interactive or linear visual media project. Think of it as an essential step in gaining expertise in the sound design field.

What Is Sound?

Simply put, sound is the aural perception of vibrations. There are many other aspects of sound that make up the phenomenon, but generally, sound is just aural vibrations. There are generally two types of audible sound that we perceive and interact with all of the time: noise and music. Noise is defined as all sounds that are not organized or harmonious that, of course, surround us constantly. Music is organized and intentional. The distinct differences between noise and music are not so clearly defined, however. This is particularly true in the post-World War II era of music, sometimes called modernism, post-modernism, or some other unacceptable term.

In the world of contemporary music, what was once called music and what was once called noise are now one and the same. You can find many examples of the combination of sound-noise and music all over the musical spectrum. John Cage, Harry Parch, and Tan Dun are just a few examples of composers who have used multiple sound creating devices, both musical and nonmusical, to compose music. Cage, for example, composed many pieces of music for prepared piano, which he invented. One that stands out is "The Perilous Night," a suite for piano solo. All of the sounds produced are from a piano that was prepared by placing various objects in and on the strings of a piano. It is well worth your time investigating these seminary figures in music. They will reveal an otherwise unknown world of sound potential you may not have thought existed.

This chapter focuses on periodic sounds. Analyzing these types of sounds is more convenient, at this stage, than working with more complex sounds. The principles of acoustics apply to all sounds, but we look only at simple sound structures for the time being. With this in mind, let's gain some initial knowledge of the three principles of sound.

The Three P's

Once again, the age-old question must be posed. If a tree falls in the middle of a forest and no one is around to hear it, does it make any sound? The absolute scientific answer is "yes," whether there is someone there to perceive it or not, or for that matter, whether there is anything there to perceive it or not. Sound is part of the physical world and as such follows the

principles and laws of physics. Our perception and understanding of sound, as humans, is purely empirical. If that tree fell in the forest and no one was there to hear it, no one experienced the sound and, therefore, as far as human perception is concerned, the tree made no sound. But physically it did.

The human cognition of sound relies on three essential sound properties. These must be present in order for a sound to exist and be perceived as such:

- Production—a vibrating body, or mass, usually through the mechanical transference of energy: source of the sound
- Propagation—the medium through which sound waves travel
- Perception—a receptor of sound, such as the human ear or a microphone

These are the three P's. These properties are also termed *generation*, *transmission*, and *reception* depending on where you read it. The important point to remember is that all of these properties form a complete organic whole. One cannot be viable as contributory to a sound event without the other. Our study of acoustics deals with all three of these properties in varying degrees. We need, however, to examine the general principles of each of these properties before we look at the details that underlie the core foundation of acoustics.

Production

A sound is produced when an object is set in motion through the transference and conversion of mechanical energy into acoustical energy. In other words, when an object is struck, bowed, or plucked, it begins to vibrate. The result of this vibration yields acoustical energy in the form of pressure waves in the medium, in the most common case, in the air surrounding it. So it is important to remember that all vibrating objects have the potential to create sound. If you put your fingers to where your vocal cords lie, roughly in the middle of your neck, and speak, you can feel a vibration through your fingers.

The sound is produced as your vocal cords vibrate and is then projected out of your mouth. Now put your hand on top of your computer tower while it is running. What do you hear or feel? You should feel the tower vibrating and hear the sound it creates. There are many examples of your tactile senses reinforcing the evidence of sound production. Become aware of your aural surroundings. That is your first assignment from this book and one that never has a due date.

Propagation

A sound has to travel though a medium from its source to a receptor. It cannot exist in a vacuum. The medium is most likely going to be air and our study concentrates, for the most part, on the transmission of sound traveling in air. The process of how an acoustic signal is transmitted is relatively simple. A vibrating object, such as a timpani head, moves back and forth after being struck with a mallet and slowly loses energy until it stops. This back and forth motion

creates a disturbance in the air in front of the timpani head, which creates areas of pressure above and below normal atmospheric pressure.

These disturbances in air molecules caused by the vibration of the timpani head are known as **compressions** and **rarefactions**. The dense configuration of air molecules occurring as the result of being directly adjacent to the timpani head moving upward is the compression stage of the wave event, and the expansion of molecules below atmospheric pressure caused by the timpani head moving downward is the rarefaction stage. This pattern of compression and rarefaction repeatedly moves away from the source in all directions, thus the wave moves outward and parallel to the direction of travel as the local molecular disturbances propagates from one region to the next. The molecules do not move with the sound; they are simply dislocated from their original position. Only the sound wave moves through the air, away from its source in all directions. This basic principle is known as wave *propagation*. This exact form of acoustical energy transmission is represented by a **longitudinal waveform**. Sound travels in the form of a longitudinal wave.

| NOTE |

Atmospheric pressure is measured to be 14.7 psi (pounds per square inch) or 1 Pascal. These pressure change deviations are very, very minute. If atmospheric pressure is 14.7 psi, then a large deviation in air molecules, or in other words, a loud sound, may cause a variation from 14.667 psi to 14.702 psi. Our ears are extremely sensitive sound collectors.

Perception

After being produced and propagated, the sound is received and interpreted. The ear is an excellent example of a receiver. It takes the sound wave and, through various conversions, sends information to the brain where it is processed and identified as a sound with characteristics. The scientific study of sound perception is called **psychoacoustics** and is sometimes referred to as the psychological study of human hearing. Psychoacoustics is not concerned with how sounds produce a particular emotional or cognitive response. This type of analysis is saved for **psychology**.

Generally, the psychological perception of sound is divided into two categories: **pitch** (sounds perceived as high or low) and **loudness** (the subjective impression of the strength or weakness of a sound). The acoustical equivalent would be **frequency** and **amplitude.** The differences between loudness and amplitude and between frequency and pitch are made easier to comprehend as long as a few concepts are kept clear.

Pitch is basically the psychological perception of how high or low a sound is. Frequency is the specific measurement of the rate of repetition of a vibrating mass, which, as a result, produces sound. While it may be well known to those who are semi-musically trained that there are treble (high) pitches and bass (low) pitches, it is not so well known that there are tenor (lower middle range) pitches and alto (upper middle range) pitches as well as variations of all.

The term *loudness* is used to describe the subjective perception of how loud or soft a sound is. Amplitude is the measurement of the strength or weakness of air pressure produced by a sound signal. The volume of a sound is not the same as the amplitude of a sound. Volume is

the psychological measurement of the **magnitude** of a sound, which includes everything from its frequency, pressure, **harmonics**, surface properties within the sound space, and duration.

There is another category of sound which plays an important role in understanding your audio environment: **timbre**. Timbre (pronounced tamber and sometimes called *timber*) is the characteristic quality given to a sound by its **overtones**. The strength and weight of the harmonic content yielded by the **fundamental frequency** supplies the color of the tone as well as the relative amplitude of the overtones as they change over time. Timbre and the harmonic spectrum are extremely significant in music and sound design. More detail will be presented when **harmonics** are discussed later in this chapter and in Chapter 5, Music Theory for Sound Designers.

Sound travels in the form of a longitudinal waveform. There are other types of waveforms to consider if sound is to be analyzed and fully understood. Let us now consider some of the properties and characteristics of waveforms and their impact on how we understand and visualize sound.

Figure | 1-1 |

Sound travels as a longitudinal wave. Compressions and rarefactions can be seen by the density of the molecules at certain points along the wave.

Waveforms

The study of waves allows us to better understand the phenomena of how waves move and react in our environment. A **waveform** is a visual representation of a wave so that we can break down its components and analyze it. Sound travels in the form of a longitudinal wave, which is one type of waveform. If we could physically see a sound wave as a series of compressions and rarefactions, it would look something like Figure 1–1. The dense regions of the waveform represent the compressions, and the rarefactions are the lighter regions. Notice that the compressions and rarefactions travel in a parallel direction to the direction of the sound. Think of that toy, the Slinky, you played with as a child. Sound waves act in a similar way. The wave moves through the Slinky by displacing a part of it and then the slink moves back to its original position.

Analyzing this type of waveform visualization could be a little complex. A more useful way to visualize sound so that we may understand its components more clearly is to use the transverse wave as our model. This model is used for the rest of this discussion of acoustics. A transverse wave is a wave in which the tendency of the motion of the wave, or direction, is perpendicular to the motion of the particles or molecules. Figure 1–2 shows this more precisely.

If there is no vibration at all, the transverse wave looks like a straight line. It would be considered at rest or at a point of equilibrium. We can relate this directly to the study of sound by realizing that this state exists when there is normal atmospheric pressure. The middle line in

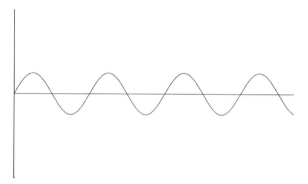

Figure **1-2**

The direction of the wave is from left to right but the particles surrounding the wave are always moving at right angles to the direction of travel.

Figure 1–2 represents the state at which molecules are at rest and are not being affected by a sound waveform. This is also called the **standard reference level**.

The compressions and rarefactions as well as the time it takes these to occur can be better visualized as a transverse wave even though sound travels in the form of a longitudinal wave. The classic example of how to associate transverse waves with longitudinal waves is to imagine a rock being thrown into a calm lake. The ripples on the surface of the water are moving away from the source of the disturbance in all directions. Although water waves are both longitudinal and transverse at the same time, we can associate the motion of waves, viewed from above, with how sound travels through air (Figure 1-3).

Figure **1-3**

Ripples emanating away from the point of disturbance as seen from above.

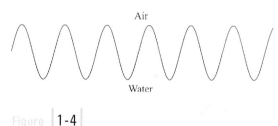

Figure **1-4**

Side view of ripples producing transverse waves.

If we visualize this phenomenon from its side we can see a transverse wave traveling along the surface of the water (Figure 1-4).

The upper part of one of the curves represents the greatest point of compression and the lower part represents the greatest point of expansion, or the rarefaction.

The shape of the wave in Figure 1–5 is called **sinusoidal**. It represents **simple harmonic motion** (SHM). The sine wave is the fundamental waveform used to analyze sound and can be further categorized as a **periodic** wave when it repeats over and over without variation. Why is the sine wave used as the standard? The answer can be summarized by saying that the sine waveform results from a mass vibrating in the simplest, most economical way because it only contains a single frequency and has no harmonic content. This yields the

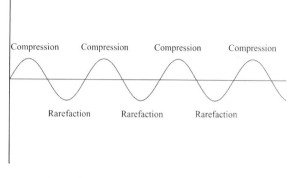

Figure **1-5**

Compressions and rarefactions visualized as a transverse wave.

most pure form of a wave and, thus, is the standard for analysis. If the wave was inconsistent or irregular but still repeated over and over, it would be considered a **complex periodic** waveform. Complex periodic waveforms and **random** waveforms are what make up most of the sound that you hear every day.

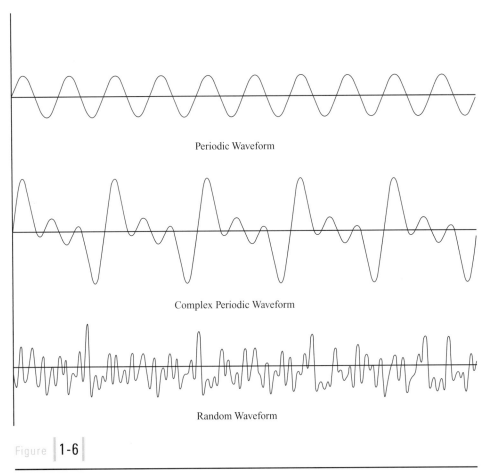

Periodic Waveform

Complex Periodic Waveform

Random Waveform

Figure | 1-6 |

A periodic waveform, a complex periodic waveform, and a random waveform.

Now that we know how to look at a transverse wave as an audible event and how to identify the name of the waveform shape it creates, we can further break this down and include the main characteristics of sound into our transverse wave representation.

Characteristics of a Waveform

In order to understand how a sound wave propagates in air, we need to examine the characteristics of that sound event. The following are the general characteristics to consider:

- Frequency
- Amplitude
- Wavelength
- Velocity
- Envelope
- Harmonics
- Surface effects and propagation characteristics

The general starting point when examining the science of sound includes the two most fundamental characteristics: frequency and amplitude.

Frequency

Frequency is defined as the rate at which a vibrating mass, electrical signal, or acoustic generator reiterates a complete **cycle** of compression and rarefaction. A cycle is the single exposition of one compression and rarefaction.

A cycle is represented by the 360 degrees of a circle. This is very important when considering phase relationships, presented later.

If we further look at the cycle, we notice that it is divided into two halves. One half is above the standard reference line and the other is below. This divides the sine wave directly into polar halves. The positive side, above the line, is the compression state and the negative side is the rarefaction state of the sound wave. The crest of each curve represents the point at which the compression or rarefaction is at its maximum density or expansion, respectively.

Hertz

The rate at which the cycles occur per second, or the frequency, is measured in Hertz (Hz). For example, if something vibrates and produces 300 complete cycles per second, we could then say that the frequency of the vibration is 300 Hz. To put this into a more practical context we can consider a vibrating string. If a violin plays the note C4, which in musical terminology would be called middle C, the frequency produced by the vibrating string would be approximately 262 Hz. Have you ever heard an orchestra tune up before a concert? The frequency at which they pitch is 440 Hz, or A4. If we look closer at these two pitches, we notice that the C4 has a lower frequency than the A4. This brings us to one of the basic principles of acoustics: The higher the frequency, the higher the perceived pitch; the lower the frequency, the lower the perceived pitch. Pitch can be thought of as the musical representation of frequency.

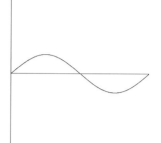

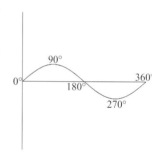

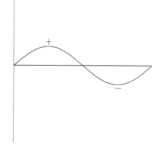

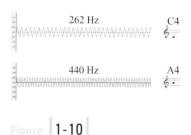

Figure 1-10

The difference between the C4 frequency and the A4 frequency and their equivalent in musical notation.

Frequency is represented by *f*. Therefore the frequency of A4 could be written like this: $f = 440$ Hz.

Thus far we have examined frequency and cycle and their relationship to pitch. It could be said that the frequency characteristic is time dependent, which means that as time unfolds linearly so does the sound event. Thus, the frequency as well as all other parameters are determined. Sound is a linear temporal event!

PROFILES

Heinrich Rudolf Hertz

Heinrich Rudolf Hertz was born in Hamburg, Germany in 1857. He was educated at the University of Berlin and was professor of physics at the technical school in Karlsruhe, Germany, between 1885 and 1889 and in 1889 was professor of physics at the University of Bonn, Germany.

Hertz expanded upon the electromagnetic theory of light previously established by the British physicist James Clerk Maxwell. Hertz proved that it was possible to transmit electricity in electromagnetic waves. The experiments Hertz conducted with reflection, refraction, polarization, and interference initiated the invention of the wireless telegraph and the radio. The Hertz name has become the official designation for radio and electrical frequencies as part of the international metric system in 1933. Hertz's contributions to the scientific field were cut short by his early death at the age of 36 in 1894.

To determine the frequency of a sound, two important pieces of information are needed: wavelength and the speed of sound. The details of wavelength and the speed of sound are given below. The Greek lambda λ is used to represent wavelength, or the physical length of a cycle, V represents the speed of sound, and f represents the frequency.

The frequency can be determined by dividing the wavelength into the speed of sound.

$$f = \frac{V}{\lambda}$$

For example, if the wavelength of a sound is 1 meter, and the speed of sound is 344 meters per second (m/s) then what is the frequency? If we enter the values given into the equation, we can simply solve this problem. Keep in mind that frequency is measured in Hz.

$$f = \frac{V}{\lambda}$$

$$f = \frac{344}{1}$$

$$f = 344 \text{ Hz}$$

The musical relationship between certain frequencies will have a great impact on the construction and pre-production of your sound design and music maps, as well as on the overall impact that the sound design will have on a particular project.

The Frequency Range of Human Hearing

The range of human hearing is approximately 20 Hz to 20,000 Hz. This means that we can perceive a sound as low as 20 cycles per second and as high as 20,000 cycles per second. Within this range, all of the sounds you hear—from noise to music—are decoded and interpreted by your brain as sound. If the sounds are below the threshold of hearing, they are considered to be subsonic; if the sounds are above our upper limit of hearing, they are called ultrasonic. Although we do not perceive sounds outside of this range, we still have the ability to feel the vibration they create in the subsonic range and derive useful data from frequencies in the ultrasonic range. This is particularly important to remember when designing a sound sculpture or object for use in visual or interactive media. The output devices, or frequency range of the system, must be taken into consideration before playback can yield constructive results. Other considerations must be taken into account when planning such high- and low-frequency production such as having the proper gear to produce such sounds and adequate space and architecture to accommodate these frequencies with optimal effect.

Although humans have a rather large range of hearing, some animals have ranges of hearing that is beyond that of humans (see Table 1-1). Bats, who are essentially blind and must rely on sound echolocation for navigation and hunting, can detect frequencies as high as 120,000 Hz. Dolphins can detect frequencies as high as 200,000 Hz.

Musical Considerations and the Range of Human Hearing

The range of human hearing is rather large when put into the context of music, however. Non-musical sounds create a far greater spectrum of frequencies than do the **fundamental tones** of music. Music occupies about one fourth of the range of hearing, whereas the noise of your surroundings occupy the entire range of hearing. The fundamental tone in music is that which you hear most prominently when an instrument is played: the actual core pitch coming from the instrument. It occupies about 50% of the total sound heard. Knowing that the range of hearing is 20 Hz to 20 kHz, it may not seem like a large span of frequencies for music to live in. Let me put all of this into some kind of perspective. The frequency of the highest note on a

Table 1-1. Frequency range of common animals

Name	Lowest Approximate Frequency	Highest Approximate Frequency
Human	20 Hz	20,000 Hz
Cat	45 Hz	85,000 Hz
Dog	50 Hz	45,000 Hz
Elephant	5 Hz	10,000 Hz
Bat	10,000 Hz	120,000 Hz
Dolphin	1,000 Hz	120,000 Hz

piano is approximately 4186 Hz. The lowest note is approximately 27.50 Hz. Table 1–2 lists some of the more common instruments in the orchestra and their corresponding frequency ranges. These are based on the fundamental pitches, excluding the harmonic content yielded as a result of these fundamentals.

Amplitude

The second basic characteristic examined here is amplitude. Previously the definitions of loudness and amplitude were compared. The amplitude of a sound wave is the maximum amount of instantaneous sound pressure deviation from normal atmospheric pressure. It is the measurement of the maximum compression and rarefaction of a sound wave or, to put it simply, it is the measurement of the greatest pressure created by a waveform generated by a source sound. We perceive this amplitude as being loud, soft, or something in between. The analysis of amplitude is also represented by the same waveform visualized for frequency.

Visualized Amplitude

The amplitude component of a sound wave is identified in the Y-axis of our sound representation. The greater the distance from the standard reference level (molecular equilibrium; normal atmospheric pressure) the louder and more intense the sound is perceived and felt. The standard reference level is usually used to represent the threshold of hearing, which is roughly the sound of a pin dropping. Scientifically, the threshold of hearing corresponds to a pressure variation less than a billionth of atmospheric pressure.

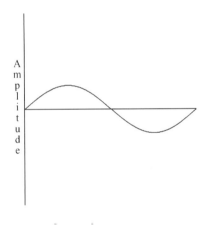

When a sound signal is introduced into air, the vibrating body that produced the sound forces the surrounding molecules to compress and expand. This, as mentioned above, is the compression and rarefaction of a waveform. If the energy behind the vibration is large, the result is a wider, or stronger, amplitude. If the energy behind the vibration is rather low, the resulting amplitude is smaller, or weaker. This makes sense if we try to visualize the molecules in air that surround the vibrating body. If the compressions and rarefactions are displacing more molecules at a particular moment, then the amplitude must be larger as a result. There is more energy being carried by the particles through the medium.

Figure | **1-11** |

Amplitude lies on the Y-axis.

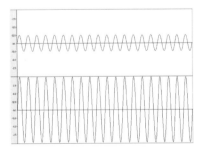

There are various ways in which to measure the amplitude of a sound signal. One of these ways is to measure the distance molecules travel from their normal position to their most displaced position when disturbed by a vibrating body's sound signal. This measurement, or the **displacement amplitude** measurement, is on such a small scale that it makes it impractical for analytical purposes and very hard to get precise data. Typical sound waves create molecular movement that is a few millionths of a meter or less. This makes the measurement process very difficult.

Figure | **1-12** |

The file on top has a lower amplitude than the one on the bottom.

Table 1-2. Frequency ranges of orchestral instruments and choir

Vocal	Approximate Frequency Range
Soprano	250 Hz—1 kHz
Contralto	200 Hz—700 Hz
Baritone	110 Hz—425 Hz
Bass	80 Hz—350 Hz
Woodwind	**Top**
Piccolo	630 Hz—5 kHz
Flute	250 Hz—2.5 kHz
Oboe	250 Hz—1.5 kHz
Clarinet (B flat or A)	125 Hz—2 kHz
Clarinet (E flat)	200 Hz—2 kHz
Bass clarinet	75 Hz—800 Hz
Basset horn	90 Hz—1 kHz
Cor Anglais	160 Hz—1 kHz
Bassoon	55 Hz—575 Hz
Double bassoon	25 Hz—200 Hz
Brass	**Top**
Soprano saxophone	225 Hz—1 kHz
Alto saxophone	125 Hz—900 Hz
Tenor Saxophone	110 Hz—630 Hz
Baritone saxophone	70 Hz—450 Hz
Bass saxophone	55 Hz—315 Hz
Trumpet (C)	170 Hz—1 kHz
Trumpet (F)	300 Hz—1 kHz
Alto trombone	110 Hz—630 Hz
Tenor Trombone	80Hz—600Hz
Bass Trombone	63Hz—400Hz
Tuba	45Hz—375Hz
Valve Horn	63Hz—700Hz
Strings	
Violin	200Hz—3.5K
Viola	125Hz—1K
Cello	63Hz—630Hz
Double Bass	40Hz—200Hz
Guitar	80Hz—630Hz
Keyboards	
Piano	28Hz—4.1K
Organ	20Hz—7K
Percussion	
Celeste	260Hz—3.5K
Timpani	90Hz—180Hz
Glockenspiel	63Hz—180Hz
Xylophone	700Hz—3.5K

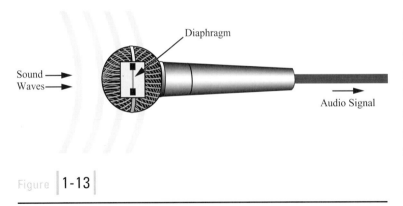

Figure **1-13**

Microphone diaphragm reacting to air pressure fluctuations.

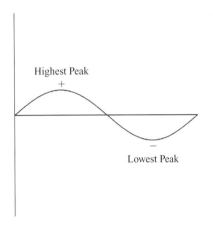

Figure **1-14**

The positive and negative peak signal levels.

A more accepted way of measuring the amplitude of a sound wave is to analyze data created by the maximum increase of wave pressure or the **peak amplitude value**. The diaphragm of a microphone picks up sound **pressure amplitudes** very easily. This allows very small pressure fluctuations to be converted into electrical signals and thus converted, once again, into a digital representation of the sound as a waveform.

Your ears act in a similar fashion. The tympanic membrane, or eardrum, also fluctuates and reacts according the air pressure that comes in contact with it at different strengths, giving you the impression of a loud sound or a soft sound and everything in between.

The **peak-to-peak** value is the measurement of the difference between the highest peak (positive) in the waveform and the lowest peak (negative).

Generally, amplitude has no relation to frequency or to the speed of a wave. If a sound gets louder or softer, neither the frequency nor the velocity is affected. Other factors (wind and heat) may cause changes, but amplitude is isolated from frequency and the speed of sound.

Root Mean Square (RMS)

When we hear a periodic sound, such as a sine wave, we can perceptually assign, in subjective terms, how loud that sound is by saying that it is loud or that it is soft. What we are actually hearing is a complex averaging of the waveform's peak-to-peak values. The RMS is the average level of a waveform over time. The RMS is determined by, in the case of a sine wave, squaring the amplitude value at each point along the sine wave and then averaging the results. The result of this equation is 0.707 times the peak amplitude level of a given signal at a given time.

$$RMS = 0.707 \times \text{peak values}$$

If a sound is aperiodic, like speech or music, the RMS value can only be measured using a special meter or detector circuit. If we hear a sound, we naturally can say it is above the threshold of hearing. In other words, the RMS, no matter how it is measured, is always positive even if we are squaring the negative value of the waveform, which really is not negative at all. We cannot hear what we cannot hear!

One more thing, RMS is also used in rating amplifiers as well but I will leave that for another book.

Decibels and Intensity

One of the most confusing aspects of studying acoustics is the use of decibels to measure sound level. Unlike frequency, the amplitude of a sound cannot be directly measured without the aid of a reference value.

The decibel is the scale used to evaluate and determine sound level. The decibel is not only used in measuring audio intensity but also strength in electronics and communication. One very important aspect about the decibel is that it is a logarithmic unit used to represent a ratio. This ratio may be anything from sound pressure, which is what we are concerned with, power, intensity, and voltage along with others. The logarithmic scale must be used in order to determine sound levels.

Before we examine the decibel scale, we need to understand something about the intensity of a signal and why exactly the decibel is used as the scale for measuring intensity.

As mentioned above, energy is carried by particles due to a vibrating mass. The intensity level of a sound is the measurement of the magnitude of a sound. Intensity is defined as the energy transmitted per unit time and area of a sound wave. The decibel is used to measure the sound intensity of a sound wave. Simply put, intensity is the measurement of the amount of energy per unit time past a given point. The greater the amplitude of the vibrations of particles, the greater the rate at which energy is transported through a medium resulting in a more intense sound wave.

Intensity (I) can be determined by dividing the energy or power (P) by the area (S) covered.

$$I = \frac{P}{S}$$

Intensity is usually measured in Watts per meter2 (W/m^2). The loudest sound you are likely to hear is about 1 W/m^2 in intensity. This seems like a reasonable place to start measuring sound intensity except that 1 W/m^2 has more than a trillion times more energy than the softest sound you can hear, which is $1 \cdot 10^{-12}$ W/m^2. This makes it very awkward to use the W/m^2 as our measuring stick for sound intensity. The sheer volume of numbers would be staggering to work with. Instead, we use the much-simplified decibel, which is a logarithmic identifier. The decibel is used for a few reasons. We hear sound intensity logarithmically. This is a natural state of hearing and is better interpreted by a decibel value rather than to an absolute number. Another reason the decibel is used is that it allows us to represent large numbers with relatively few.

The decibel (dB) is literally one tenth of a Bel. This name is derived from Alexander Graham Bell, who is possibly more famous for his work with telephones. The Bel is the logarithm of an acoustic, electrical, or other power ratio. It might be easier to think of the Bel as being a ratio of 10 to 1 between two distinct intensities. The Bel is not the discrete measurement of the amount of sound produced by a vibrating source. It represents a ratio of two sounds that are in a ratio of 10 to 1. Instead of using the Bel as a measuring quantity, the decibel is used in place of the Bel because of its more naturally relevant number scaling.

PROFILES

Alexander Graham Bell

Alexander Graham Bell was born in Scotland to a deaf mother. Although she was deaf, she was a musician and painter. Bell's father worked with and taught deaf people. Through Alexander's association with the deaf he became interested in speech and hearing. He was interested in working with the deaf throughout his life. In the early 1820s, the Bells moved to Canada where Alexander, who suffered from tuberculosis, was meant to recover. He did.

Soon after moving to Canada, he moved to Boston where he opened a school for the deaf and then became a professor at Boston University. Around this time he met Mabel Hubbard, married her, and they had three sons. Around the time of his wedding, he formed a company called Bell Telephone Company. Along with Thomas Watson he developed the telephone and patented it in 1876. He remained the sole telephone retailer in the United States for 19 years.

He invented many other things as well, including the phonograph, the iron lung, and the hydrofoil which broke the world speed record of 70 miles per hour.

Along with all of his work, he managed to find time to start a new society called the National Geographic Society. Alexander Graham Bell may be one of the most important people in human history. He died at the age of 75 in Canada.

The amount of energy difference between 1 Bel and 2 Bels is 10 times. Therefore, if we use the standard threshold of hearing reference of 0 dB **SPL (sound pressure level)** and measure it against another sound source of 10 dB SPL, we can say that 10 dB SPL is 10 times louder than 0 dB SPL. Twenty dB SPL is 10 times louder than 10 dB SPL but how much louder is 20 dB SPL than 0 dB SPL? The answer is not 20 times because of the logarithmic nature of measuring intensity. The answer is 20 dB SPL is 100 times louder than 0 dB SPL because 1 Bel is equal to 10 decibels and the Bel is defined as a ratio of 10 to 1 between two given **sound intensity levels (SIL).** SPL is used to describe the sound pressure level. The term dB SPL is commonly used because sound pressure is more directly related to perceived loudness and it is easier to measure. There are many different ways to use the decibel in measurements of all sorts of things and

Table 1-3. Correlations between the decibel and intensity scales

Intensity Scale	0 times louder than 0	10^1 times louder than 0	10^2 times louder than 0	10^3 times louder than 0	10^4 times louder than 0	10^5 times louder than 0	10^6 times louder than 0	10^7 times louder than 0	10^8 times louder than 0	10^9 times louder than 0	10^{10} times louder than 0
Decibel Scale	0 dB	10 dB	20 dB	30 dB	40 dB	50 dB	60 dB	70 dB	80 dB	90 dB	100 dB

Table 1-4. Decibel scale

Sound	Decibel (dB)	Description
Threshold of hearing	0	The quietest audible sound
Quiet whisper	10	Just audible
Quiet recording studio		
Bedroom		
Public library	30	Room ambience, very quiet
Very, very soft music		
Normal suburban outdoors	40	Quiet but clearly audible
A small office	50	Low-level speech
Very soft music		
Low radio volume		
Noisy business office		
Conversational speech between two people 3 to 5 feet apart	60	Very noticeable, intrusive
Ringing telephones		
Normal practice piano		
Very noisy, large office	70	Hard to talk on the telephone
Road traffic		
Noisy restaurant		
Very loud singer 3′		
Loud busy traffic corner		
Average factory	80	Agitating and annoying
Heavy truck	90	Level at which hearing loss will occur if sustained for more than 8 hours a day
New York subway		
Inside large orchestra	100	Hearing loss will occur if sustained for more than 2 hours per day
Power tools	110	Hearing loss will occur if sustained for more than 15 minutes per day
Planes on a runway	120	Hearing loss will occur if sustained for more than a short period of time
Artillery 100 yards	130	Pain threshold
Pneumatic (jack) hammer		Brief exposure can cause hearing damage
Jet engines 25 meters	140	Danger levels
Physical pain	150	Extreme danger levels
Chest vibrates		
Choking		Permanent, instantaneous hearing damage
Close proximity explosion	160—180	Death of hearing tissue
		Perforation of ear drum

a corresponding identifier is used for each of them. The term dBm is used to measure electrical power, dB PWL is used to measure acoustic power, and so on. It is enough for us to understand the power ratio and logarithmic associations between two sound intensities and the use of sound pressure level to indicate perceived loudness in order to move on.

In fact, 20 dB SPL is a very quiet sound. The chart below gives a rough estimate of where the decibel scale lies related to our everyday aural perception and the equivalent W/m^2 value.

It would be nice if all of the sounds we perceive were measured in 10 to 1 ratios, but what about decibel values between 1 dB SPL and 10 dB SPL? It is easier to see the power ratios between intensities if we look at the following table.

Table 1-5.

Decibel Level	Intensity Ratio
0 dB	1.0
1 dB	1.3
2 dB	1.6
3 dB	2.0
4 dB	2.5
5 dB	3.2
6 dB	4.0
7 dB	5.0
8 dB	6.3
9 dB	7.9
10 dB	10.0

If the power ratio is 2:1, then we have a 3-dB increase in intensity. If there is a 4:1 ratio, the increase in intensity is 6 dB. This brings us to the principles of how sound intensity spreads throughout a given space.

| NOTE |

The conservation of energy is a basic principle of physics along with conservation of momentum and conservation of mass. The law states that the amount of energy remains constant and energy is neither created nor destroyed. Basically all of the energy in a system remains constant.

The Law of Conservation of Energy, Sound Intensity, and the Inverse-Square Law

Imagine you are in a nonreflective, nonabsorptive open field under normal atmospheric conditions at 20° C. If a sound is created then according to the law of conservation of energy, there must be a decrease in intensity as distance increases.

This physical characteristic is very fortunate for us; otherwise it would be a very, very loud planet we live on. Because of this law, we can determine the dB value at certain distances from the source and draw a few conclusions. We know that if we are standing close to a sound with a high intensity level, or high amplitude, then the sound will be per-

ceived as loud. We also know that if we walk away from that sound, it will gradually decrease in intensity. Let us go back to our field. Under ideal conditions, for every doubling of distance from the source there is a decrease in intensity of 6 dB. The converse is also true. So, if there is 70-dB sound being generated 10 meters from the source of the sound, we can then deduce that at 20 meters the sound intensity will be measured at 64 dB. The inverse-square law is the reason for this attenuation, particularly in these proportions. It can be summarized by saying that the surface area of an intensity impact area is squared every time the distance doubles. Therefore there would be a 2:1 ratio from the source of the intensity to a given point and a 4:1 ratio at twice that distance. This brings us to the power ratios mentioned above. A 4:1 power ratio equates to 6 dB on our chart.

Wavelength

The wavelength of a sound wave is the physical distance of a complete cycle. The length of a wave is measured from one point on the waveform to the exact point of the next repeating cycle.

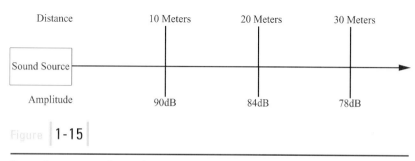

Figure 1-15

Power decreases as distance increases.

The longer the wavelength, the lower the frequency, thus the lower the perceived sound. The converse is also true, the shorter the wavelength, the higher the frequency; and as a result, the higher the sound. This makes sense if it is related to a vibrating mass. If, for example, the distance of a full rotation of a cycle is large: creating a large wavelength, the frequency must be low if we are measuring the amount of cycles per second. Large wavelengths occupy more physical space, thereby creating lower frequencies and fewer cycles per second. The wavelength and frequency properties are directly related to one another.

The wavelength of a sound is usually measured in meters. A 20-kilohertz (kHz) sound, the highest perceivable pitch, produces a wavelength of about 2 centimeters (cm). The lowest perceivable pitch, 20 Hz, is about 17 meters or 56 feet.

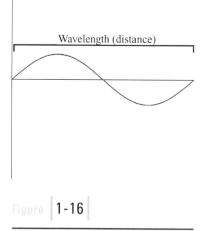

Figure 1-16

Wavelength of a sound wave.

There are three fundamental quantities that describe any repetitive wave: speed, wavelength, and frequency. Given these parameters, we can now figure out what the wavelength of a sound is.

$$\text{Wavelength} = \frac{\text{Speed of sound}}{\text{Frequency}} \text{ or } \left(\lambda = \frac{V}{f}\right)$$

If the frequency of a sound is 440 Hz and it travels through air at a speed of 344 m/s (the standard speed of sound at 20° C under normal atmospheric pressure), we can then solve the answer to its wavelength.

$$\lambda = V/f$$

$$\lambda = \frac{344\text{m/s}}{440\text{Hz}}$$

$$\lambda = 0.8 \text{ m or } 80 \text{ cm}$$

The wavelength of a 440-Hz frequency is 0.8 meters. Don't forget to apply the correct modifier to your answer. Wavelength is measured in meters.

Period

The period of a cycle is the measurement of the amount of time it takes a cycle to occur.

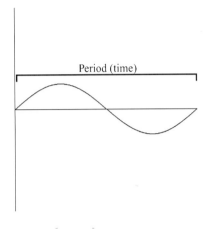
Period (time)

Naturally the period is measured in seconds or sometimes milliseconds. The formula for deriving the period when given the frequency is given below.

$$T = \frac{1}{f}$$

The opposite is also true. When given the period, the frequency of a signal can be solved.

Figure | 1-17 |

The period of a cycle.

$$f = \frac{1}{T}$$

For example, if a frequency of 300 Hz is given, the period of a 300-Hz frequency is 0.0033 second.

$$T = \frac{1}{300 \; Hz} = \begin{array}{l} 0.0033 \text{ second (s) or} \\ 3.3 \text{ milliseconds (ms)} \end{array}$$

If the period of a waveform is 0.01 second, then the frequency would be 100 Hz.

$$f = \frac{1}{.01s} = 100 \text{ Hz}$$

As you can see, the period is a rather small value when compared to our everyday perception of time. Hours, minutes, and seconds are usually our scale. The lowest frequency we can perceive (20 Hz) has a period of 0.05 second, or 50 milliseconds.

Speed of Sound

Before we can examine the speed of sound, we need to take a closer look at air and the molecules that make up air. Air is a nondispersive medium. This means that all sounds, no matter what frequency, travel at the same speed and can occupy the same space at the same time. This

is very useful for us as listeners, especially music listeners. Imagine what a concert would sound like if the high frequencies arrived at your ear at different times than the mid and lower frequencies. This state would yield cacophony not harmony. Air consists of many different types of molecules: 78% nitrogen, 21% oxygen, and the remaining 1% containing argon, carbon dioxide, neon, helium, krypton, xenon, methane, nitrous oxide, and hydrogen. The molecules in air are in constant motion, colliding and bouncing off of each other at moderately high speeds of about 1000 miles per hour. This excited state of air molecules is very important regarding the transmission of sound because various changes in the agitated state directly affect the speed at which sound travels.

The generally accepted speed of sound is 344 meters per second (m/s), or 1130 feet per second or 770 miles per hour. This sounds pretty fast by our everyday standards but compared to other forms of physical phenomena, it is relatively slow. Light, for example, is about 1 million times faster. An interesting aspect of the speed of sound is that the standard 344 m/s is not a constant and changes under varying conditions. In fact the standard is measured at room temperature or 20° C, 70% humidity, under normal atmospheric conditions. What do you think would happen if the temperature increased to 30° C? Would the speed of sound increase or decrease? Well if we look at this more closely, we know that at 20° C the speed of sound is 344 m/s, so if we increase the temperature, thereby increasing the agitated state of the air molecules, the sound signal must transmit through that air faster. The compressions and rarefactions will occur at a quicker rate in the violent air. Thus at 30° C the speed of sound is 350 m/s. For every single increase or decrease in Celsius degrees we must add or subtract 0.6 m to the standard measurement (1.1 ft/s for each degree Fahrenheit). A formula can be extracted to determine the speed of sound.

$$V = 0.6 \text{ m/s} \times y$$

V represents the speed of sound, y represents the difference between the given temperature, in Celsius, and the standard speed of sound. Using this formula, all speeds can be calculated. If the given temperature is lower than the standard 20° C, then subtract the result from the standard speed of sound. If the given temperature is higher, then add the result.

Envelope

The envelope of a sound is the defining characteristic of the attack and decay of a sound. All sounds possess a characteristic change in amplitude as time increases. The features included in an envelope are attack, decay, sustain, and release. The sudden increase of amplitude to full sound intensity represents the attack of a sound, the decay from the attack is followed, the sound is then held, or sustained and then attenuates, or is released. All

Figure **1-18**

The envelope of a wave.

sounds have a specific envelope attached to them and these change according to the environment it occupies. Sounds in reverberant spaces may create the illusion, sonically, that the envelope is longer, and as a physical, aural event it is, but if the same sound was played in an acoustically dry space, then the envelope would be condensed.

Harmonics

The sine waveform is a synthetically produced waveform in that is does not exist in its pure form in nature. When a sine generator produces a signal, the sound you hear is exactly the frequency put into the system. If a 400-Hz tone was produced, you would hear only those 400 Hz. In the world of periodic waves, sound perception is actually a combination of many different frequencies. Musical tones are a combination of these higher frequencies plus the **fundamental frequency**. The fundamental frequency can be defined as the base frequency that is heard. So, when a violin plays a pitch that has a frequency such as 262 Hz, the fundamental pitch would be called 262 Hz or middle C. But the characteristic sound of the violin is actually produced as a result of frequencies occurring in proportional stages above the fundamental. These harmonics, or sometimes called overtones, are always much quieter than the fundamental and combined make up about 50% of the sound amplitude. The individual harmonics are usually never heard separately but rather as a composite.

Light and color can be used in an analogy for how harmonics can be perceived. The light coming through your window is revealing colors and shading that exist in your visual range. The shades of different colors are actually the result of a combination of the three primary colors, in varying degrees (there are other sets of primary colors but the concept is the same). The primary colors are red, blue, and green. Through the combination of these we can see all of the different shades and highlights of the world around us. White light contains an equal amount of all of the primary colors comparable to white noise in the sound spectrum, which contains an equal but random distribution of all audible frequencies. Darkness is the absence of the three primary colors, or in musical or acoustic terms: silence. You cannot perceive all of the individual colors that contribute to the fundamental color. The same can be said of individual harmonics. They create the characteristic of the sound of instruments.

A fundamental pitch generates the harmonic spectrum. The resultant harmonics are generated by adding the frequency value of the fundamental to the next consecutive harmonic.

Although the combined harmonics are equal to about half of the intensity of the fundamental, they are crucial in defining the characteristics of an instrument. To take this a step further, the strengths and weaknesses of the harmonics can be mapped and plotted, thereby creating an electronic representation of the original instrumental sounds. The actual sounds of the electronically generated fundamentals are similar but not exactly like the original instrument being copied. Much more detail about harmonics is given in Chapter 5, Music Theory for Sound Designers.

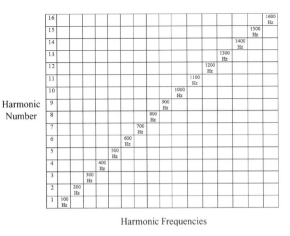

Harmonic Frequencies

Figure 1-19

A Harmonic progression above a 100 Hz tone up to the 16 harmonic.

Surface Effects and Propagation Characteristics

As a sound signal propagates through the air, it will inevitably encounter objects or another medium that will either redirect it, absorb it, bend it, or scatter it. The material, shape, and surface condition of the object will determine what happens to the sound wave after making contact with the surface. Multiple events occur to a sound wave when it reaches a **boundary.** The boundary is the interface where one medium ends and another begins. The **boundary behavior** is what happens to a wave when it reaches the end of one medium and encounters another. Sound waves generally reflect, diffract, scatter, refract, and are absorbed by a boundary. The boundary is meant to imply both a medium and an object. Each of these surface effects is described below.

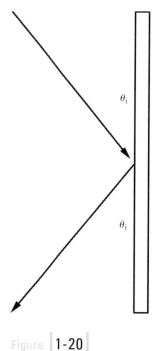

Reflection

Sound reflections are some of the most recognizable and familiar sonic events. We have all heard reverb in our own bathrooms. Clap your hands and listen to how long it takes for the sound to decay. That is reverb. When a sound wave approaches a flat, hard surface it reflects an identical wave away from the surface at the same incidental angle that it approached it at. This angle is referred to as the *angle of incidence.*

Figure | **1-20**

A pure reflection.

The angle of incidence is represented by the θ symbol.

Under these particular conditions, sound reflects away from the surface and loses intensity inversely as the distance increases. Usually these conditions do not occur because most surfaces are curved or contain deformations that make the wave diffuse. This is more likely the type of reflection you hear in the environment around you.

Diffusion/Scattering

Diffusion is basically the same as reflection except that it is not a pure reflection. When a sound wave impacts an irregular surface, the sound will partially reflect away from the surface at many different angles. This diffusion of sound is caused by the size of the irregularities of the surface. Usually if the irregularities are ≥ $0.25\,\lambda$, the scattering effect becomes very perceptible.

Figure | **1-21**

Scattering.

Diffraction

Sound can also bend. When an object is greater than the wavelength of an approaching sound wave, the wave will curve around the surface of the object in an attempt to fill in the space behind the obstruction. This creates an acoustic shadow, which results in a severely attenuated sound behind the object.

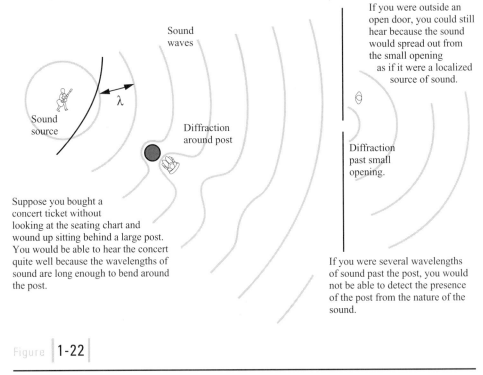

If you were outside an open door, you could still hear because the sound would spread out from the small opening as if it were a localized source of sound.

Sound waves

Diffraction around post

Diffraction past small opening.

Sound source

λ

Suppose you bought a concert ticket without looking at the seating chart and wound up sitting behind a large post. You would be able to hear the concert quite well because the wavelengths of sound are long enough to bend around the post.

If you were several wavelengths of sound past the post, you would not be able to detect the presence of the post from the nature of the sound.

Figure | 1-22 |

Acoustic shadow.

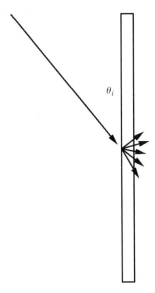

θ_i

Figure | 1-23 |

Absorption.

Absorption

Sound absorption is also common and easy to understand, but it is extremely important. You have most likely encountered sound absorption if you ever had to fill a room with furniture. Before the furniture was placed in the room, you could hear a fair amount of reflection, or reverb, going on in the space. Once you put the couches, chairs, lamps, and other objects in the room, it no longer reflected as much of the sound. It sounded dry. This is due to the absorptive properties of the materials of the furniture.

As a sound wave impacts a surface, some of that sound is absorbed into the surface. When there is a highly absorptive surface, the energy behind a sound wave is dissipated and directed into the surface thereby preventing reflection.

Refraction

One of the least obvious surface effects of sound is when it refracts when it passes from one medium to another. When a sound wave passes through air into water, for example, we know that the speed of sound will change from 344 m/s to about 1500 m/s in water. This also implies that the direction of the sound will change because of this increase in speed. The angle of incidence (θ) of the incoming sound wave will be different from the angle of refraction after it enters the water.

Figure | 1-24 |

Refraction.

When a sound signal passes from a thinner medium to a thicker, or denser one, it refracts away from the surface of the denser medium.

Although you will not usually experience any of these surface effects as a single event, in combination they affect how we move and relate to our environment.

Constructive and Destructive Interference

The next consideration regarding propagation characteristics of sound is when sounds culminate at one location from various locations. What actually happens when sounds combine at a certain place? Your first answer might be that the sound would be louder at the location but in fact sometimes the signal of the sound may be weaker than either of the original sounds. The enhancement or canceling out of the signal is called **interference**.

There are two types of interference: constructive and destructive. Constructive interference increases the amplitude and destructive interference decreases it, but how does this happen, and to what degree?

Imagine that one frequency is being produced by two separate sources at the same time. The crests and troughs of the two waves will intersect at different places. Some of the crests will intersect with each other and some of the troughs will intersect with the crests. When the crests exactly intersect each other they are said to be **in phase.** When waves are in phase, the amplitude of the combined signal is double that of either of the original signals alone. When a trough intersects a crest, the waves are said to be **out of phase** and a canceling effect takes place, yielding no disturbance or a

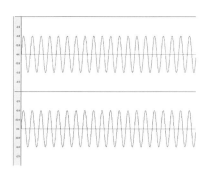

Figure | 1-25 |

In Phase.

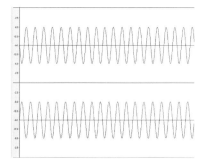

Figure | 1-26 |

Out of phase.

completely attenuated sound. In other words, there will be a straight line of zero amplitude. Exactly in phase and exactly out of phase are the two extreme cases. At all other points, the amplitude includes all values between zero amplitude and twice that of the single sound source being measured. If two waves interfere with each other but each one has a different amplitude, complete cancellation of the crest and trough is not possible. For zero disturbance to occur, the signals must be exactly the same amplitude.

Previously when we looked at cycles, we divided the cycle into degrees. The **phase** of a wave is measured in degrees (°). The sine wave is broken down into the 360° of a circle. At 0°, the amplitude is zero; the sine wave slopes up to its maximum highest positive crest where its phase degree angle is 90°. It then slopes back down to zero amplitude at 180°; down to the maximum negative crest at 270°, and back up to 360° where it starts the cycle all over again.

When two sound signals of equal frequency have no phase difference, they are in phase. When the same two signals have a phase difference of 180°, they are out of phase.

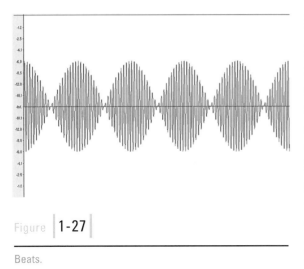

Figure **1-27**

Beats.

Beats

Now, let us consider another combinatorial effect on frequency. What happens when two signals of slightly different frequencies are produced at the same time? If, for example, a 100-Hz frequency and a 105-Hz frequency are combined, the mixture of these two signals would produce a pulsating effect. This effect is called **beats**. They are not the same beats that are related to music but do create a steady pulse of sound. Sometimes two waves are completely in phase and at other times they are completely out of phase. In consequence, these points of zero disturbance and the doubling of amplitude create the beat phenomenon.

The exact number of beats can be determined by subtracting the higher frequency from the lower frequency.

$$f_b = f_1 - f_2$$

If 100 Hz is subtracted from 105 Hz, which are defined as cycles per second, the result is a 5-Hz beat, or 5 Hz per second.

Beats are not heard regardless of the two frequencies examined. As a general rule, if the difference between two frequencies is greater than 30 Hz to 40 Hz, the beat phenomenon ceases to exist. In its place is the existence of the simultaneous sounding of two distinct frequencies. This is known in music as an interval or sum difference tones.

SUMMARY

All sound must start with a vibration. Molecules in air are set in motion in the form of compressions and rarefactions due to pressure changes created by the vibrating body. The actual analog signal is carried in the air as acoustic energy. As the signal moves away from the source of the vibration, it disperses in all directions. The local disturbances propagate outward resulting in a longitudinal wave formation leading to the conclusion that sound travels as a longitudinal wave. The characteristics of sound, which include frequency, wavelength, amplitude, envelope, harmonics, surface effects, and velocity are analyzed using a transverse waveform. Each of these characteristics plays an integral part in understanding comprehensive sound design for interactive and visual media.

in review

1. What is the difference between sounds that are in phase and out of phase?

2. What are the three fundamental requirements necessary for sound to physically exist for human perception?

3. What is the generally accepted range of human hearing?

4. What is the difference between wavelength and period?

5. Define constructive and destructive interference.

notes

analog recording and reproduction

2

objectives

Basic understanding of recording, mixing and monitoring

Principles of microphone functionality

Principles of mixing functionality

Principles of monitoring

Signal flow of a system

introduction

This chapter deals with the fundamentals of recording, mixing, and monitoring. The basic recording, mixing, and monitoring techniques include microphone capabilities, mixing tips, and monitor types and setups. The principles behind signal flow and the connection of all of these hardware devices are also considered.

AUDIO RECORDING, MIXING, AND PLAYBACK

Acoustics reveals the theoretical aspects of the science of sound. In order to apply some of this theory, it is important to understand the workings and processes of recording and reproduction. The recording and playback systems you use as well as the target playback systems, those you are preparing sound for, such as theaters or home systems, is fundamental to becoming a solid sound designer. Studying recording and reproduction techniques makes you a more qualified professional.

Recording, mixing, and monitoring your audio work requires a large amount of trial and error. Do not be afraid to experiment. The path a sound takes to eventually get into your computer is one of the most important aspects to understand in the recording and playback process. Do not be fooled; recording sound is a skill that needs to be developed. There are many details involved in getting the exact sound you want. This can only be achieved through practice—a lot of practice. Different types of microphones and playback devices are the tools of the trade in achieving this end. It is not essential that every brand be known, but it is essential to understand the different device types and what they can do to a recording. Knowing the differences between them is the first step to capturing quality audio for your projects. Examining the most common types of microphones used in the field and in recording studios is a good place to start, but first we need to understand something about electricity and transducers.

A Few Things About Electricity and Magnetism

Understanding electricity is not that complicated. Let's first look at a few terms. **Current** is the flow of charges from one place to another. In order to quantify and gauge this flow, we use the **ampere.** One ampere equates to 6×10^{18} electrons moving past a given point at any given second. The superscript 18 indicates that it is to the power of 18 or there are 18 zeros after the number 1 (1,000,000,000,000,000,000), quite a large number of electrons. Something must be behind this current, pushing it along in a given direction. This "push" is called **voltage.** Measuring voltage is an integral part of the audio signal path from the microphone to the console and beyond voltage is used as the measuring stick for sound intensity and amplitude entering a system.

Many components that contribute to the recording and reproduction of sound use electricity. To understand these components, a basic introduction to the electrical device is necessary.

Transducers

Any device that converts one form of energy into another is called a **transducer.** In terms of audio, this would be a device that converts audio waves into electrical signals and vice versa. A microphone is a transducer that converts the pressure created by a vibrating mass into an electrical voltage or signal. The opposite is a loudspeaker or monitor. A monitor converts electri-

cal signals into acoustic waves. If you have an old, cheap Radio Shack dynamic microphone and don't really need it for anything, plug it into the output jack on a playback device. With the volume up high enough, you can hear the playback, that is, the sound coming from it. **Note**: Do not do this with a decent microphone; you may damage it irreversibly. Thus, when speaking of dynamic devices, loudspeakers are microphones in reverse!

Magnetism

Something interesting occurs when an electronically conductive metal is suspended in the flux field of a magnet: It has the potential to create an electric charge equal and proportionate to the movement of the suspended metal. This phenomenon exists due to the **theory of electromagnetic induction,** which generally states that when an electrically conductive metal lies within the flux lines of a magnetic field, a current of a given direction and magnitude will be created within the metal. A **magnetic field** is the transparent field of energy that surrounds a magnet.

If these conductive materials are set in motion, they produce an electric current. A **microphone** acts as a transducer converting sound pressure waves into electric impulses.

FRONT

Figure | 2-1 |

A conductive metal suspended in a magnetic field.

Microphones

Microphones are the tools used to record sound. They act as an interface between acoustic pressure waves and electrical signals. The signal is then sent through cables to the mixer, if there is one, and to the recording device or output monitors.

Capturing Sounds

The first question to ask when studying microphones is "What are we trying to record?" Is the source outside, inside, in a reflective space, in a hurricane, or any other possible location for a source to exist? The exact nature of the recording and the sound recorded determines what type of microphone to use. This is the beginning of the recording chain. Note that not all of the sound in a project comes from source recordings. Many times, prerecorded sounds from libraries are used, although the best results always come from original recordings that are under your direct control.

Microphone Types

The three most common microphone types used in the professional recording industry are the dynamic, condenser, and ribbon.

Dynamic Microphones

The most commonly used microphone is the **dynamic microphone.** These are famous for being extremely durable and tough, as well as being relatively inexpensive compared to condenser "mics." Dynamic mics can be used in many situations. Generally, the mics seen at concerts and live performances are dynamic microphones.

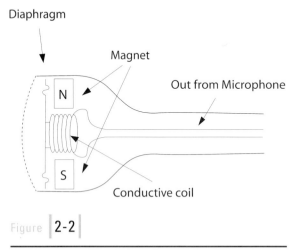

Figure │ **2-2** │

A basic dynamic microphone design.

The construction of a dynamic mic is based on a diaphragm connected to a coil of electrically conductive metal floating in the flux planes of a magnet. When the diaphragm reacts to the pressure of the impact of a sound wave, the coil moves, sending an electric current through output lines connected to the coil and to its destination. The magnitude and direction of the current is proportional to the motion of the coil, which means that there is an electrical representation of the diaphragm motion. A dynamic microphone can generate its own electrical signal, albeit a weak one. The destination of that signal may be anything from a public address system, a sound reinforcement rig, to a **mixing desk** or **console.**

The dynamic microphone contains a magnet, as well as other rather heavy components. These contribute to its durability, plus the fact that a magnetic field is very strong and makes it difficult to dislodge the coils suspended within it. Because of the general weight of the components, the reaction of the diaphragm is a little slow. This limits the **frequency response** of the microphone. High frequencies require a diaphragm to move very quickly and high frequencies also have short wavelengths that require a more sensitive response. If the components of the mic are bulky, then the response is slower, thus attenuating higher frequencies. If **transient** shifts, fast musical attacks, or signal peaks are going to occur in a recording, then maybe a dynamic is not the proper microphone to use. There are very sensitive dynamic microphones used professionally, but if a large frequency response is desired, there may be better solutions. In most live situations, however, a dynamic is all you need.

Purchasing a Dynamic Microphone

Figure │ **2-3** │

Shure SM-57 microphone.

When you buy a dynamic microphone, first and foremost it should be understood that the microphone that comes with your computer rig is probably below the quality level you want. There are many different brands and types of dynamic mics available in stores, and they do sound different from each other, but there is one in particular that everybody who records anything has: Shure SM-57.

This microphone is seen in every recording studio and sound designer's toolbox. Without fail, it is the workhorse

for many, many situations. It is not too expensive and lasts a long time under different circumstances. My SM-57 has been dropped, stepped on, rained on, and has been accidentally located within the blast radius of an explosion I was recording for some sound effects work, and it still functioned well. The SM-57 is a great way to start your microphone collection and you can perform many experiments without worrying too much about hurting it. Go out and get one as soon as you can.

Generally, any dynamic microphone ranging from $50 to $150 is good enough to get started with, but a condenser can also be bought within this price range and that may turn out to be more appealing if a wider frequency response is needed.

Condenser Microphones

The next most popularly used microphone is the condenser microphone. The construction of the condenser is nothing like that of the dynamic. First, it is not magnetically based but can generate a voltage. This voltage, however, has almost no power behind it, which is needed to send it out through the output lines. Second, the condenser is much more physically sensitive than the dynamic. If you drop a condenser you may well have damaged it, whereas, if you drop the dynamic, in most cases, you can simply pick it up and move on. Another important aspect is the frequency response. The condenser has a much more sensitive frequency response, which is discussed more below.

The design principles behind the condenser microphone are based on the movement of electrons and the workings of an open-air capacitor. A diaphragm sits in front of an electronically conductive back plate. The diaphragm and back plate are separated by a small pocket of air, forming an electronic component called a condenser or capacitor. Unlike the dynamic microphone, the condenser needs an external power supply in order to send a flow of electricity through the condenser. When the diaphragm reacts to the air pressure created by a sound signal, it moves inward and then outward, decreasing and then increasing the capacitance in the condenser. This change in capacitance changes the amount of current flowing through the condenser, thereby creating a signal useful for recording and processing the sound. In other words, this creates an electrical representation of the motion of the diaphragm and sends this through the output lines to its destination.

A condenser microphone requires an external power supply in order to transmit a useful signal. This power supply is known as **phantom power**. An electronic polarizing voltage of about 48 volts is applied to the condenser microphone by an external source. This creates a fixed static voltage, which then allows an analogous electrical representation of the sound wave to be created. Phantom power is supplied from a separate external device or, more often, from the console (mixing desk) or batteries.

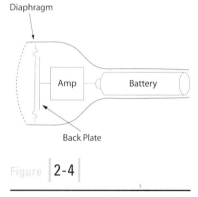

Figure **2-4**

A condenser microphone design.

Purchasing a Condenser

There are many places you can find condenser microphones. Your local tech store will likely have condensers for sale but don't be fooled; the odds

are that you will be purchasing something that is not made very well. A better bet would be to go on line. There are many great resources for you to check out microphones on line. You can buy a pretty good stereo condenser microphone for under $150.00 dollars if you search carefully.

Ribbon Microphones

The ribbon microphone is the least used but has a certain characteristic that is very attractive to acoustic instrument sound reinforcement and to the radio broadcast industry. The ribbon is based on the same general magnetic principles as the dynamic, wherein a thin ribbon of corrugated aluminum is located between the poles of a strong magnet attached by output lines at the top and bottom of the magnetic field. The ribbon is clamped tightly into place. This position allows the ribbon to move lengthwise as the diaphragm induces motion, thereby acting as the diaphragm itself. Although it is based on the principles of electromagnetism, it does not create a strong enough signal to achieve mic level. It does not use phantom power; instead, current ribbon microphones are designed with a built-in transformer that boosts the level up to an acceptable point. It is like having a signal-booster built in to the microphone. This device is a type of pre-amp. A pre-amp is a separate device that helps boost a signal strength up to a level that is compatible with a mixer or recording device.

Ribbon microphones are famous for having a warm sound by having a great transient response. This lends itself well for voice either in a singing capacity or speaking. The microphone is heavy and very fragile. Today's manufacturers of ribbon microphones are making them more sturdy than in the past; even so, you don't want to take the chance of banging or hitting a ribbon because they are also very expensive!

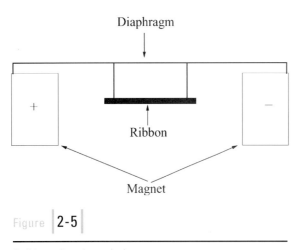

Figure **2-5**

A ribbon microphone design.

Purchasing a Ribbon

Ribbon microphones are expensive and if you are going to buy one you should first consider what you would actually need it for. If you are going to be recording in the field, you do not need one. If you are going to record **Foley** type sound, you do not need one. If you are going to record vocals in a studio and you require that special warmth of sound, you do need one. The point is this: Choose the microphone that will accomplish your needs.

Every microphone has a unique frequency response and **dynamic range.** The analysis and measurement of frequency response and dynamic range is a science unto itself. When sizing up what kind of microphone would be good for a job, deciphering these important characteristics will enable you to choose the best microphone for the project. The "performance" of a microphone is the key to understanding how a recording will sound.

Dynamic Range, Frequency Response, and Directionality

All microphones can be characterized by how they respond to sound waves. The most important aspects of a microphone's response to sound waves are dynamic range, frequency response, and their pickup patterns or directionality.

Dynamic Range

The dynamic range of a microphone is the range of sound intensities that a microphone can provide as an acceptable signal to the recording device or mixing desk. Microphones have varying dynamic ranges based on construction, design, and, of course, sensitivity.

A small dynamic range would indicate that a microphone could only produce signals at a limited range of amplitude levels relative to the **noise floor.** A wider dynamic range would mean that a microphone could generate a useable signal under a greater range of amplitude levels. In live sound applications, a situation may exist wherein the noise floor could be at approximately 50 dB SPL (the empty concert hall with a few of the crew around) and the peak amplitude level could be 120 dB SPL at the microphone. To figure the dynamic range, we simply subtract the noise floor value from the peak amplitude value.

$$\text{Peak Amplitude value} - \text{Noise Floor value} = \text{dynamic range}$$
$$120 \text{ dB SPL} - 50 \text{ dB SPL} = 70 \text{ dB SPL}$$

Thus, it can then be said that the dynamic range at the microphone is 70 dB SPL. That might not sound like a lot but decibels are logarithmic (see Chapter 1), so from the softest sound to the peak amplitude there is a ratio of 10 million times the intensity to 1. That is quite a range but by no means is it optimal in all conditions.

You have been introduced to a new term: noise floor. The noise floor of a system is the point at which the softest sound can be registered as a useable signal. All devices make noise and create noise in a system. Any sound that lies under the noise floor is covered by the noise floor and is not heard.

Figure **2-6**

The noise floor of a system.

Frequency Response

The frequency response of a microphone is, in general terms, how a microphone responds to translating sound pressure levels (SPL) into audio signals at varying frequencies. Usually you can determine what the frequency response of a microphone is by looking at the specs, although this does not tell the entire story. A microphone with a flat frequency response is one that is able to convert a given pressure level into an equal amplitude level at all audible frequencies. This is an ideal response for a sound reinforcement microphone.

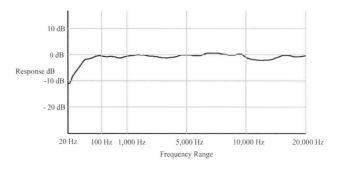

Figure 2-7

A flat frequency response of a microphone based on the audible range of the human ear.

In the figure above, the y-axis represents the amplitude and the x-axis represents the frequency range being measured. As a sweep of signals is sent to the microphone at a fixed amplitude level, the output signal from that microphone is equal at all frequencies. This is not ideal for all situations, however.

Some microphones are designed to respond to a certain range of frequencies based on the needs of a particular situation. For example, a frequency response peaking from around 4000 Hz to around 8000 Hz and rolling of at the bottom at about 100 Hz would be an ideal microphone for a vocalist. The vocal harmonics resonate well in the upper range and a vocalist will never go any lower that 100 Hz in the bass, making this a good overall response for the mic.

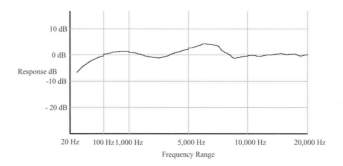

Figure 2-8

The frequency response of a microphone ideal for vocal recording.

On the other hand, if recording a drum set or other low frequency instrument is planned, a microphone that starts to attenuate below 50 Hz and containing a peak response from around 100 Hz to about 1000 Hz would be ideal.

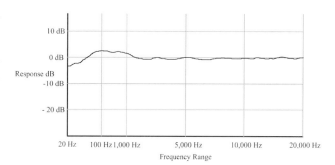

The frequency peak response from around 100 Hz to 1000 Hz.

Directionality

The directionality of a microphone is the area around the head which constitutes the polar pattern that the microphone responds to. Every microphone has a polar response but all responses are not the same.

Basically there are two aspects of a microphone that need to be considered when studying polarity response: on-axis and off-axis. The on-axis angle, or 0°, is the point where the sound signal enters the microphone directly. Off-axis is always located at 180° from the on-axis angle. The off-axis angle of incidence is usually the point where the signal entering the microphone becomes attenuated. To plot out the polar response area, a chart of 360° must be created around the head of a microphone in order to determine where the direction of a signal comes from as well as which frequencies respond at various angles of incidence.

on-axis

Front

0 degrees

The two directional categories by which microphones are classified are the omnidirectional polar response and the directional polar response. The omnidirectional microphone responds to acoustic sound pressure from all directions. Another way of thinking about this is to visualize the diaphragm responding to sound pressure equally well from all directions.

Figure 2-10

Directional axis of a microphone based on the on-axis 0°.

A directional mic, on the other hand, responds to sound pressure from a particular angle. This is a pressure-gradient microphone, which means that it does not react equally well to sound pressures from all directions. In fact, a pure pressure-gradient bidirectional microphone will have a polar pattern as indicated below. The front, back, and sides respond differently to an incoming sound than does the direct on-axis point of the microphone.

Below are more specific types of polar responses that are associated with typical microphones.

Front

0 degrees

Figure 2-11

Omnidirectional pick-up pattern.

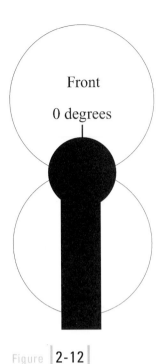

Figure 2-12

Pure pressure-gradient
bidirectional polar response.

Polar Response

The field of response around a microphone is called the polar response pattern and depends on the type of microphone you have. Different types of polar patterns are used in different situations.

Omnidirectional

Omnidirectional microphones, mentioned above, pick up sound with a certain amount of accuracy from all directions and are usually condensers. The omni is generally, but by no means exclusively, used in the studio. It has a better frequency response in the lower bands than directional microphones and has a lower threshold for feedback due to its overall smooth response, which makes it ideal for some outdoor recording as well. For sound design recording, the omni has some positive and some negative features. The great thing about omnidirectional microphones is that they pick up sounds from all around the diaphragm. This is of particular interest when trying to record outdoor ambience or crowd noises. You can get a well-balanced recording with an omni. The bad thing about omni microphones is that they pick up all of the sounds surrounding the diaphragm. This could mean that unintentional sounds "bleed" into the microphone, like the sound of breathing, clothes moving, and position shifts. These things are usually distractive to a recording and may end up sending you back out into the field to try again, usually when it is raining. That is no fun! Below is the polar response pattern for a typical omni microphone.

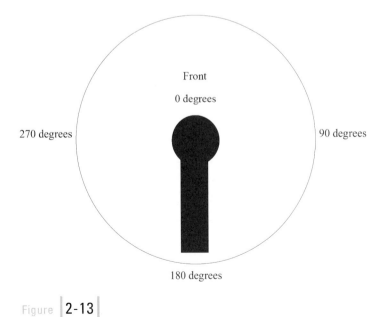

Figure 2-13

Polar pattern of an omnidirectional microphone.

Cardoid

The **cardoid** pick-up pattern is by far the most commonly used type of response and both condensers and dynamics come with this response pattern. The response pattern is shaped like a heart, which is what the name is derived from. The cardoid picks up sound on-axis extremely well but suffers at the sides and back of the microphone. This is a desired pattern, particularly in sound reinforcement, but how does that help record sounds for projects or sound effects? Well it prevents sound from entering from the off-axis side of the microphone, which, in many cases, allows you to record without worrying too much about noise entering from various move-

ments behind the microphone. When recording voice, it is imperative that the primary axis of the pick-up pattern is always directly pointed at the singer, speaker, or vocal sound effect. If the sound source moves from its position in front of the microphone, there is a severe audible drop-off in sound presence and the sound becomes thin. Are you starting to see how important the **boom man** is on a **production sound** crew? Most likely, you have seen a microphone poking down from the top of the screen on your television. That is the boom microphone trying get the "hottest" signal possible from the actors or news anchors. Sometimes these microphones are cardoids and other times they are hypercardoids or supercardoids. Figure 2-14 shows the pick-up pattern of a cardoid.

Hypercardoid

The hypercardoid microphone is similar to the cardoid but is much more directional. The tube of the microphone is longer, allowing for more rear vents, which creates a more directional response. Another common name for the hypercardoid is the "mini-shotgun." It is used when you are unable to get close to a source or when you need to keep a little distance from the source for safety reasons. Figure 2-15 shows the polar pick-up pattern for a hypercardoid microphone.

Supercardoid

The supercardoid is the "shotgun" microphone. It is highly directional and supplies a very clear recording signal from a great distance. This is not a good choice if your subject will be moving around a lot. You probably have seen them on the sidelines during a Monday Night Football game. They are trying to capture the quarterback, or other player under focus, before the ball is snapped. The polar response pattern of a supercardoid microphone is given in Figure 2-16.

Bidirectional

The bidirectional microphone has a polar pick-up pattern that responds to signals in front and in back of the microphone equally as well. The signal is strongest in on-axis position, or at 0°, and in the off-axis position, or at 180°. The sides of the microphone do not respond to direct sound. Although they are not common, they do have a useful purpose. They are most often used when two people are speaking on screen within a close proximity, usually sitting or standing opposite each other. Figure 2-17 shows the pick-up pattern for a bidirectional microphone.

Figure | **2-14** |

Polar pattern of a cardoid microphone.

Figure | **2-15** |

Polar pattern of a hypercardoid microphone.

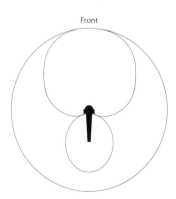

Figure | **2-16** |

Polar pattern of a supercardoid microphone "shotgun."

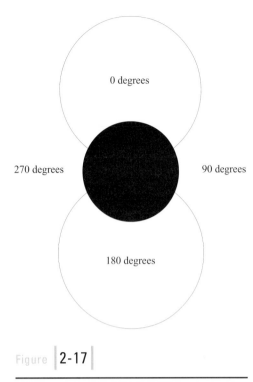

0 degrees

270 degrees

90 degrees

180 degrees

Figure | 2-17 |

The polar pattern of a bidirectional microphone.

Mic Placement and Recording Techniques

The subject of microphone placement is extremely large and it is not possible to cover all of the nuances and detail necessary to completely investigate this field, but some basic fundamentals will help with your field recordings.

The first thing to remember is that the recording is only as good as the gear used. If cheap gear is used, there is a strong chance that poor recordings will result. Even if you do not have a lot of money to spend on audio gear at this stage of your sound designing career, there are alternatives that will suffice, especially designing sound for web-based media.

If an audience or users are web participants, then more often than not they will be using a low-end or a low-resolution set of speakers to listen to the web site or interface. Things have changed slightly with the explosion of the game industry, resulting in more and more people rigging up new audio systems to accommodate the game environment. By default, they also have the gear for fantastic audio Internet participation. Either way, the main objective should be the best source recording possible, even if the public will not get that fat frequency spectrum you have built in to your sound files.

Most likely, there will not be an ideal situation to make a perfectly pristine recording, but there are key locations that a microphone can be placed to get the "hottest" signal possible. There are two considerations before "rolling tape." The first is that there are many different types and makes of microphones. Each one has its own unique sound characteristics and usually it is left up to the engineer or production mixer to decide what goes where. It is important to do some testing with a few microphones in order to get the sound most appropriate for the situation. Once you choose the proper microphone, it is time to think about microphone placement—the second consideration.

There are many different solutions to microphone placement. There is no right or wrong way of doing it. It all depends on what the desired sound is.

Stereo vs Mono

The first thing to think of regarding microphone placement is whether or not the mic is a **stereo** microphone or a **mono** microphone. In the latter case, two mono microphones can be used to get left-right balance. The two setups commonly used for this are the "XY" configuration and the "V" configuration.

Figure | 2-18 |

The standard XY configuration with two cardoid mono microphones. The diaphragms are close to each other and the microphones should form a 45- to 60-degree angle.

Both configurations claim to give a clear image. Only the ear can determine which sounds better. Try them both and do as many experiments as it takes to get the results you are looking for.

If there is a stereo microphone available that can capture a stereo image, setup and placement will obviously be a little different.

At its most rudimentary, microphones should be placed in front of the sound source and in the case of instruments, in front of or at a slight angle to the part of the instrument where the vibration leaves or projects. There are two general types of mic-ing techniques: close and distant. The close mic technique, usually within 3 feet of the source, reduces ambient sound getting into the microphone, generally gives a hot signal, and increases the bass response. Another result of close mic-ing is that the proximity to the microphone creates a very close presence, which sometimes requires some post-processing to give it a little distance. The proximity effect occurs when the source, usually a voice, is very close to a microphone, typically 1 foot. The effect is an increased bass push in the equalization, sometimes as much as 16 dB in the low end. Radio announcers take advantage of this effect all of the time. The proximity effect usually starts from a radius of about 2 feet from the microphone and increases to the 1 foot radius. Directional mics are particularly susceptible to the proximity effect, whereas omni microphones are not affected by it at all.

Figure | 2-19 |

The standard "V" configuration. Usually the bases meet and form a "V" shape.

Distant mic-ing allows more ambient sound to get into the microphone, possibly increasing the noise floor of the recording; it also creates a sense of space in the recording and decreases the bass response. There are advantages and disadvantages to both mic-ing distances. The choice of which one to use depends on what you are willing to trade off.

How do you know what type of microphone to use under any given circumstance? Table 2-1 contains some guidelines that may help in your decision making.

A few more aspects of recording sounds should be mentioned before moving on to loud-speakers. The effects listed below are the cause of much frustration, but the fix is neither that complicated nor that difficult to achieve.

Sibilance

Sibilance is the effect the spoken letter "S" has on the diaphragm of a microphone. The effect is a sharp high-frequency attack on the frequency response of the mic. This can cause undesirable effects on the overall sound file. When editing such a file, usually special attention is given to those points where sibilance exists. Hours can be spent trying to get the file to sound correct, or at least, passable. Avoid this by using an acoustic screen (sometimes called a pop filter) (Figure 2-20).

Table 2-1. General properties of common microphones

Dynamic microphone	Durable
	Relatively inexpensive
	Does not require phantom power
	Great for live sound
	Sometimes used to mic drums, guitars and bass guitars in a studio
	Not very efficient which may lead to more gain resulting in unwanted noise
Condenser microphone	Not too durable
	Mid to high priced
	More sensitive than the dynamic microphone
	Requires phantom power
	Sometimes used as vocal microphones in studios
	Used often in studio recordings
Ribbon microphone	Very delicate
	Can be very expensive
	Great for radio broadcast
	Sometimes does and sometimes does not require phantom power
	Makes the voice sound warm and has been described as sounding like "velvet"

Plosives

A plosive is the percussive "P" and "B" sound which penetrates the diaphragm of a microphone. These pronunciations cause a "thud" type sound at the output stage and could cause distortion or, digitally speaking, clipping. Again, use a pop filter to avoid some of these effects.

Loudspeakers

Now is a good time to look at the other end of the signal chain: the monitoring stage.

The loudspeaker is simply a microphone in reverse. As mentioned above, the transducer loudspeaker converts electrical signals into sound waves. These sound waves are then heard in your audio environment and the process of conversion is complete.

As project work begins, the importance of having a solid monitoring system in place to play back the work produced will become brutally apparent. At first, a good pair of commercial speakers will be enough, but as paying jobs start to come in, or if income permits, it will be imperative that a good pair of monitors be bought. Monitors are speaker systems that are designed with a flat response in mind. The average commercial speaker is

Figure **2-20**

A pop filter located on a stand in a sound booth.

designed more for the general consumer, who is not necessarily after audio accuracy; these are generally constructed for their cosmetic appeal although they can sound pretty good depending on the brand and construction. A flat response implies that a monitor can produce almost all of the frequencies in the audible range at a constant amplitude. A sweeping tone is used to measure these responses.

Some of the more popular monitor brands are Tannoy, JBL, Genelec, M-audio, Alesis, Mackie, and Yamaha. They are not cheap, but they are well worth the price when looking for audio accuracy. A decent pair of monitors should be part of your sound design rig.

As a sound designer, why is it so important to listen to sound and music through monitors? What difference will it make? Well, it makes an enormous difference. Sometimes this can be a little confusing to understand, but if the audio cannot be heard and analyzed with the clearest possible resolution and precise accuracy, then what will your work sound like through the average computer speaker or television speaker? Even worse, what will it sound like through another good system in which you would have been able to show off your stuff if something other than a decent pair of monitors was used. If mixing on inferior monitors, the end product will be less than fantastic. The point is that the work should be distributed with the highest quality audio resolution possible. This will ensure that everything you wanted to hear is actually heard on reproduction and if

it is played back on a smaller, more frequency-restrictive set of speakers, at least the best possible sound created and monitored can come out of them.

Monitor Power

What powers the speaker? Unlike some of the microphones mentioned above, monitors and speakers require a lot of power to create an analog signal. Commercial speakers are usually powered by a stereo receiver. Monitors, on the other hand, come in two varieties: passive and active. Passive monitors require an amplifier to power the drivers, and active monitors have a power source built in to the cabinet. Naturally, active speakers are more expensive and are usually the best choice. One great point about active monitors is that most of them have a built-in cut-off, which prevents a surge of power from damaging the monitor drivers. If amplifiers were used, the drivers could easily get damaged if the amps were turned up high enough or the gain on the mixing desk was pushed a little too hard. If care is not taken, there is a real threat of damaging the speakers through inadvertent power rushes to the amplifier.

Monitor Sizes

Monitors basically come in two sizes: the two-way and three-way configurations. A two-way bookshelf speaker has a **tweeter,** usually about 1 inch in diameter, which produces high frequencies, usually from 4kHz and up, and a **woofer** which produces the lower frequencies. In the case of a two-way speaker, the woofer handles the rest of the frequencies below 4kHz. These devices, the tweeter and the woofer, are called **drivers.** The woofer, on a bookshelf two-way design, is generally between 6 inches and 8 inches.

The three-way configuration has a ½-inch to 1-inch tweeter and a 3-inch to 5-inch **midrange** driver, which produces the midrange frequencies, as well as a 10-inch to 15-inch woofer. The midrange driver roughly produces frequencies between 250 Hz and about 4kHz. All drivers vary, and the ranges given are approximations.

The frequency output of the individual drivers should, under ideal circumstances, cover the full range of hearing. Many go much higher.

Crossover

The **crossover** circuit is responsible for directing the frequency traffic to the as-

Figure | 2-21 |

Two-way speakers with tweeters and woofers.

signed drivers. As a signal enters the loudspeaker, all of the frequencies are entering as one composite. The crossover takes this and sends the frequencies off to the proper driver from reproduction. The crossover is the brainpower behind the monitor. Much research and energy has gone into developing and constructing high-quality crossovers. The better the crossover, the better the distribution of sound, and the better the quality of audio coming out of the drivers.

The monitoring stage of a project is crucial. Once a fair amount of work on a project has been completed, it is time for you to start considering the mix. Remember, it is important to get a high-resolution playback no matter what the quality of the user's audio rig.

Monitor Setup

Monitors need to be placed correctly in order to get an accurate audio "picture." The monitors should be about at the height of your head. Usually that level should be measured while sitting in a big, soft chair, so adjust accordingly. This should ideally form a triangle with you as one of the points. Each component (the two monitors and yourself) should all be equidistant from each other. This configuration is for the sound designer working at a **DAW** (digital audio workstation). In addition, a nice, fat sub-woofer can be placed on the floor in a corner for the bass frequencies. For interactive audio projects, which include games, virtual spaces, and soundscapes, this is the usual setup. This would be called a **near-field** monitoring configuration. The bookend speakers are basically within 3 to 4 feet of your sitting location. Naturally there is quite a bit of direct sound aimed at the seat, or "hot spot," so the clarity of the audio will, or should, be clear. This is great, but what happens if a project requires that the audio be dispersed throughout a larger space other than the work desk? Well, in professional studios this is seen all the time. They are big, commonly three-way speakers hanging at a distance from the console. These are the far-field monitors. They not only produce more of the overall signal better, but they also add that all-important aspect of size and distance into the equation. The combination of the near and **far-field** monitors gives a very good idea of what your work will sound like under just about any condition.

Figure | 2-22 |

A three-way speaker with tweeter, midrange, and woofer drivers.

Once the rig is set up and you have your sound system working to peak performance, you can start to think about the mix.

A Little About the Mix

The mix is when all of the audio you have created, recorded, and processed comes together. More details are given in the next section on consoles, but a few initial points should be made.

The mixing process should be approached with a fresh perspective, away from the toils of sound and music creation. Mixing is an art unto itself. You must pay close attention to the mix.

Figure | 2-23 |

Typical setup of a stereo near-field monitor configuration with sub-woofer.

If you feel uncomfortable mixing your own work, find someone who can do it for you. Most sound designers, whether in the interactive design field or in motion pictures, need to learn a bit about mixing for the simple reason that there is no one around who can do it for you. This is a happy problem. It forces you to get into the mix of things.

Mixing should be done in the correct environment. The monitor configuration mentioned above will do just fine for now. This ensures that the sound created will get the full benefit of the room acoustics and avoid the possible limitations of a pair of headphones.

Headphones

Now, after all of that talk about monitors, what are headphones used for? One thing can be said from the start: Never do final mixes with headphones. Rough mixes are fine but ultimately a real, open-air configuration is the ticket to good mixing. Headphones, however, are also a necessary component in the overall configuration of the sound design rig. Needless to say, a good pair of headphones will go a long way in both durability and signal production. Due to the proximity to the ear, headphones may reveal both positive and negative aspects of a piece of work. A click here and a pop there are very clearly heard with a good pair of headphones and, as a result, can be corrected. On a less than spectacular monitoring system, you may not hear those tiny clicks and pops. On the other hand, bass pitches, which may not be accurately produced by a monitoring system because of cheaper components, will make your teeth shake in a good pair of headphones, and if the ultimate output is to a good sound system, then you can be sure that those pitches will be reproduced more or less accurately. The problem lies in the

fact that with headphones, the bass frequencies can be overpowering and many times results in a lower mix on playback through monitoring in a real space. "It sounded different on my headphones" is a common observation. The opposite is also true; if mediocre headphones are used, then the bass may not come out strong enough and will be artificially boosted. When this example is played back, the bass will be extremely heavy and will need to be remixed.

Those creating sound effects and/or music for games will want to consider the possibility that the gamer will be using headphones while he or she plays. Many game sound configurations now accommodate for the type of sound system the gamer is using. For example, there may be a dropdown menu indicating the options you have for audio configuration in a given game. One such menu exists in Pacific Fighters by Ubi Soft (see Figure 2-24).

Cheap headphones will sound cheap. Generally a good pair of headphones cannot be bought for less than $50.00. The average pair costs between $75.00 and $250.00 or more. The difference is clear. When buying a pair, be aware of the frequency range. Anything around 15 Hz to 20 Hz on the low end up to 22 kHz to 35 kHz on the high end will be sufficient. You should have no problem finding a good pair either in the stores or on the Internet.

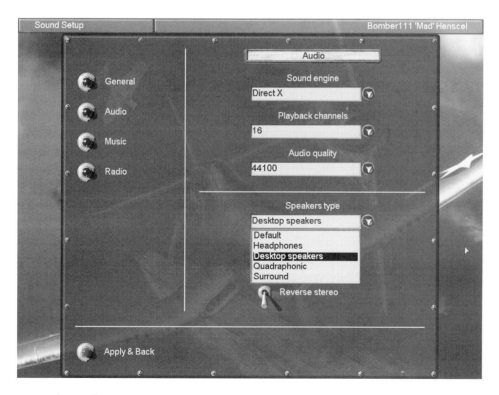

Figure 2-24

Image of a dropdown menu from the game Pacific Fighters sound configuration menu.

Cables

Before moving on to the last major section of this chapter, it is important to have a quick look at how the signals are transported to the output from the input stage of a device. Cables are used to connect devices and components together in an analog system. The signal, which travels along these cables, travels in one direction. There are good cables and there are poor cables. The difference lies in the quality of the cabling itself and the connectors.

Cable Types

There are two types of cables: balanced and unbalanced. Understanding the differences between them is vital to good sound production.

Unbalanced Cables

Noise is introduced at many stages of the signal path but one of the most common points of noise entry is the cable. As a signal travels, say from a microphone to the recorder through a cable, noise may accumulate along the signal path, possibly having a damaging effect on the final output sound. Unbalanced cables are constructed with two conducting wires. One is the hot (+) wire conductor, which carries the signal, and the other is a ground (−) wire conductor. The hot wire is surrounded with a layer of insulation enwrapped with the ground wire. The ground wire is also known as the "shield" wire. Basically it grounds the cable and prevents noise from being introduced into the signal traveling through the hot wire. This is particularly useful with short cables and nonprofessional work. The problem is that it does not keep noise out very effectively with longer cables, and noise increases with cable length. The **signal-to-noise ratio** (SNR) of the system will determine how much of that noise is heard, but if you hear noise in a recording, the cables may be at fault, especially if they are unbalanced. The signal-to-noise ratio is a measure of the strength of a signal relative to background noise. Typically, this ratio is measured in decibels. The SNR is related to the dynamic range of a system except that the upper ratio measurement, above the noise level, is usually a predetermined limit set by the mixer.

Figure | **2-25** |

Unbalanced cable dissection.

How do you recognize an unbalanced cable? Any single-pin connector used for audio is unbalanced, but the three-pin XLR can also be unbalanced as well.

Without anything built into the cable to prevent noise from getting into a system, the unbalanced cable is sure to give you some amount of noise. The balanced cable is the solution if your system and wallet can accommodate it.

Balanced Cables

Balanced cables are built with three conducting wires: The hot (+) wire, the cold (−) wire, and the ground wire. The hot and cold wires carry the signal and the ground is grounded. With unbalanced cables, a hum, otherwise known as a ground loop, can be heard if the ground wire of one AC-powered device is connected to another. To eliminate the hum, the ground needs to be

cut before it reaches the second device, but in the case of the unbalanced cable, the ground also carries the signal so it cannot be cut. The balanced cable allows you to cut the ground early without interfering with the signal, thus eliminating the hum. If you are still getting noise in your playback, start checking your devices one at a time. Also, the hot and cold lines transmit a signal out of phase with each other, thereby canceling out any possible noise created. The cold line is 180 degrees out of phase with the hot line. Noise can be introduced at many stages of a recording process and involve radio frequencies, power cables, and other hardware devices connected along the way. This noise is introduced when the hot and cold lines are out of phase. At the input stage, the audio signals are put back in phase which makes the introduced noise out of phase and canceled out. Pretty neat, eh!

Figure 2-26

Balanced cable dissection.

The type of cables you choose is important, particularly when long cables are used. Many times balanced cables are used in professional settings and unbalanced cables are used in less than professional settings.

Connectors

There are many types of cables but only a few standard connector designs are used with audio hardware and applications.

Unbalanced Connectors

The ¼-inch and ⅛-inch phone plug is used for many devices, usually the headphone plug; if it is not a professional pair, a ⅛-inch connector is used. Professional headphones use ¼-inch plugs. The tip of the connector is the hot conductor and the sleeve of the connector is the ground conductor.

The small ⅛-inch plug is similar but smaller. This smaller connector is used most often with portable CD and MP3 players as well as for the front and back face of the sound card. There are exceptions with higher end sound cards, but in general they have ⅛-inch ports.

Figure 2-27

A ¼-inch connector with tip and sleeve.

Figure | 2-28 |

A ⅛-inch connector.

Figure | 2-29 |

RCA Phono Plug with tip and sleeve conductors.

The RCA phono plug is also unbalanced and is seen with many high-fi systems. This is a standard TV/audio cable and is used with sound cards as well but only those appealing to a more serious audio consumer. The hot conductor is the tip and the surrounding sleeve is the ground.

Balanced Connectors

The ¼-inch TRS phone plug is similar to the ¼-inch phone plug except that it has an extra ring on the sleeve representing the neutral conductor. The TRS stands for tip, ring, and sleeve (Figure 2-30).

Professional audio devices usually have an XLR type of input or output port. The XLR male plug connects to the inputs of devices and has three prominent pins inside of its casing. The one pin is the ground conductor, the two pin is the hot conductor, and the three pin is the cold. These are seen everywhere in professional studios (Figure 2-31).

The XLR female plug has the same pin configuration as the male except that it has a female design. The XLR female plug is used for output connections (Figure 2-32).

Consoles

A **console** is the central bus stop for all signals to collect and exit. This is the place where the sound is mixed and equalizing effects are applied. The signal, as mentioned above, then moves on to tape recorders, to the monitors, or to the tape recorder and then out to the monitors.

Consoles, or desks, come in many different styles and sizes but in general they are simply devices that receive signals and pass them on to the monitors or **multitrack recorder.** This knowledge can alleviate any of the initial fears or misconceptions that may exist about live mixing and recording using a console.

At first, a console may look intimidating, but basically every **channel** does the same thing relevant to its function: input or output. A channel contains various ways to effect, **send, return,** increase input signal, equalize and buss the signal down the road to the main buss of the console.

Each console consists of channels which lead to **busses** and finally to the **master fader** out to the multitrack recorder or monitors. Basically that summarizes the

Figure **2-30**

A ¼-inch TSR phone plug with tip, sleeve, and ring.

Figure **2-31**

XLR male plug with three pins.

Figure **2-32**

XLR female plug with three pin inserts.

path a signal takes when entering a console from a microphone or other input source. This is also called **signal flow.** Signal flow is the path a sound signal takes from the moment it enters a system, which usually is the microphone stage, to the end of that system, commonly the monitors, power amplifiers, or multitrack recorder. The exact path of this signal allows the mixer to control what kind of sound will actually come out of the system as well as control, to a certain degree, the amount of noise getting into the recording or playback.

Before examining signal flow, the attributes and characteristics of consoles and their corresponding channels, busses, and master faders should be examined.

Mixer Types

Although the characteristics of a mixer are the same throughout, there are two general types of uses for consoles: the split and the in-line mixer. The split mixer contains a set number of channels used for inputs and a set number of channels used to monitor signals coming from the console. In-line consoles have the convenient option of switching the function of a channel by making it an input channel or a monitor channel.

Generally mixers are used for two reasons: for sound reinforcement and live audio presentations and for recording in a studio. The difference between the live sound mixer and the recording mixer is the added component of a recording device, usually a multitrack tape recorder, added to the recording mixer. These **tape returns** create an extra stage for the signal to pass through before it goes out to the monitors, whereas the live sound rig is a one stage process wherein the signal is sent from the desk to the monitors without the recording aspect.

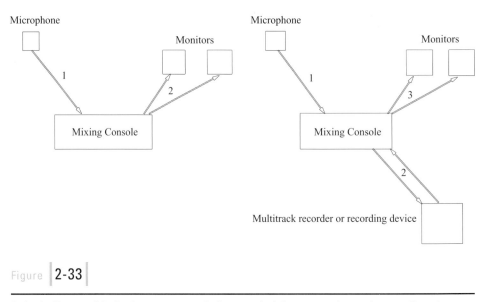

Figure 2-33

A simple diagram of the basic components of a live sound reinforcement mixer and a recording mixer.

Mixer Sizes

Mixers come in all sizes. Smaller **powered mixers,** which contain four to eight channels, accommodate a more mobile rig or smaller sessions for which many inputs are not needed. These consoles generally range in price from $400 to $1500, which is reasonable for the overall mixing power achieved. The middle range consoles contain 8 to 16 channels. These mixers usually contain their own amplifiers as well and are used for more moderate mixing tasks. This is the most common mixer because a few extra channels are necessary for backup. Many companies (Mackie, Tascam, Yamaha) have a standard 16-track mixer. The price ranges from $1000 to $2500 for the low- to mid-end consoles. There are, of course, others that cost many more thousands of dollars, but for our needs, only an average mixer is required.

The **unpowered mixers** contain from 8 to 40 channels or more. These require an external amplifier to power them up. They are generally used in professional studios and cost from $400 to $1,000,000. Save your money!

All consoles are listed with a number representing the channels available, the busses available, and the number of master faders available. These usually look like $16 \times 4 \times 2$ or $32 \times 8 \times 2$, which refer to the channels, busses, and master faders. This is a quick way to cipher through many consoles and find the one you want.

Channel Dissection

Now it is time to get to the details of an average mixing console. As mentioned above, the console is basically a collection of channels. Each channel has a certain arrangement of processes that lead down to the fader or volume knob. Figure 2-35 shows is a basic channel.

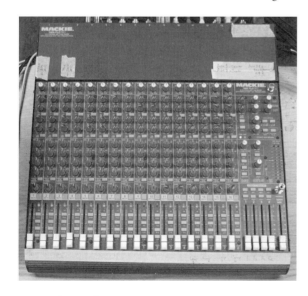

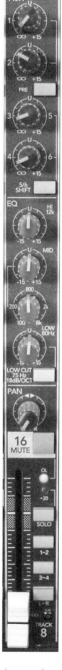

Figure 2-34

Mackie 1604 mixing console.

Figure 2-35

A single-channel on a mixing console.

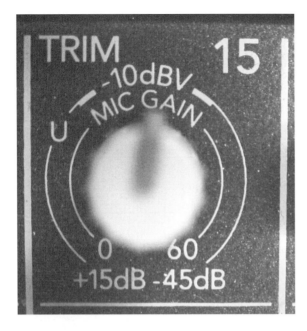

Figure **2-36**

The gain knob of a typical mixer.

Gain

The top of the channel has a **gain** stage. The gain, also known as trim or attenuation, is where input levels are adjusted and set so that the overall signal coming into the console on that track is not damaged or distorted. Normal practice dictates that the artist or artists perform the loudest part of a project so that you can get the hottest signal into the desk. When you have the hottest signal, indicated by the peak levels bouncing up to red or the VU meters pushing to the far right in the red, you should then adjust slightly down and then begin.

Auxiliary

The auxiliary knobs are used to route a signal to an external device, such as a reverb unit, and then, commonly, back into the desk to continue down the channel. This allows analog effects to be added to the signal. Some mixers have the aux, also called **cue, foldback, send, monitor,** or **effect,** below the equalization section. Our example in Figure 2-37 has the auxiliaries above the EQ stage.

Equalization

The equalization section of the channel constitutes the area where adjustments to sound characteristics can be made. There is a strong tendency to use too much EQ when just starting out, but after some experience you will realize that the EQ stage is usually saved for last. Many times the characteristic of a sound can be enhanced by microphone placement, performer proximity, and the like.

When EQ is called for, there is usually a group of knobs that handle this on the console. They are basically divided into the low, mid, and high frequencies covering the audible range of human hearing. One example of the frequency coverage of the EQ knobs is given in Figure 2-38 below.

The art of adding EQ requires many hours of trial and error. Understanding the divisions of EQ can help you better apply a balance to a mix.

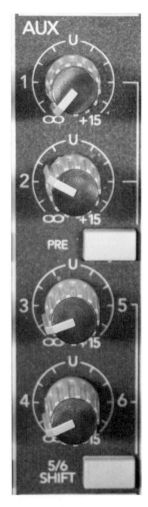

Figure **2-37**

The auxiliary area of a channel.

EQ and the Range of Human Hearing

EQ covers the range of human hearing, which can be divided into separate areas of general characteristics (Table 2-2).

Specific frequency ranges should be memorized. They are extremely important when dealing with EQ and recording in general (Table 2-3).

Types of EQ

There are three types of EQ: graphic, parametric and paragraphic. Graphic EQ allows you to change the frequency strength of a sound by manipulating an envelope graph. The parametric EQ has a set of filters that allows a specific choice of frequency enhancement. The paragraphic EQ also allows discrete changes to the frequency ranges as well as shelving filters that control the amount of high and low frequencies in your recording.

Fader

Once the signal has completed its path to the bottom of the channel, it reaches the fader or volume knob. This is where the input signal is once again adjusted. Its level has been generally set at the gain stage, but it may also be adjusted at the fader stage. This applies to a recording mixer. In the case of the sound reinforcement mixer, the fader controls the output volume if configured to do so. In both cases, the signal is usually bussed to the submix section of the console. This is another group of faders where all of the signals are collected from all of the active channels. These are usually called busses.

Busses come in many configurations. Smaller mixers have two to four busses. Larger consoles contain eight or more. Busses are mainly used for output to monitors or as a submix stage before being sent to the master faders.

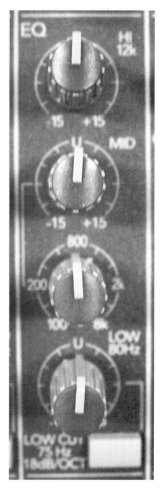

Figure | 2-38 |

EQ section of a channel with frequency ranges indicated.

Table 2-2. Basic breakdown of EQ bands within the range of human hearing

Frequency	Description	Range
20 Hz	Subsonic, damaging at loud volumes	Low
40 Hz	Thick and heavy	Low
70 Hz	Full and unclear	Low
200 Hz	Warm and transparent	Mid
500 Hz	Harsh and direct	Mid
2 kHz	Clear and piercing	Mid
5 kHz	Bright and whispery, but with force	High
10 kHz	Brilliance and penetrating	High
20 kHz	Sibilance and unclear pitch	High

Table 2-3. Frequency ranges that should be considered when applying EQ to a mix

Frequency Range	Description
50 Hz to 70 Hz	The low range where heavy kick is felt, particularly from bass drums.
90 Hz to 250 Hz	This is where clarity problems occur or support for a weak midrange recording.
250 Hz to 500 Hz	Can support thin or weak sounds. Adds warmth if used in moderation.
500 Hz to 2 kHz	This is usually the critical band that needs attention. This is reduced if sound is harsh.
2 kHz to 5 kHz	This is where the ear is most sensitive. Small adjustments are sometimes required but not large ones.
5 kHz to 10 kHz	This is where the brilliance of a sound is located; it also is where hiss resides.
10 kHz to 17 kHz	This band contains all of the harmonic and presence sound material. Reducing it cuts sibilance and other high-band undesirable sounds.

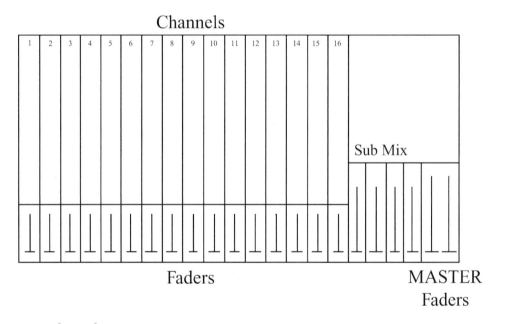

Figure 2-39

Diagram of a 16-channel, 4-buss console with two master faders.

The master fader is the last stop a signal makes before leaving the console where it either moves on toward the monitors or to the multitrack recorder.

It is commonly said that the only way to learn how to mix is to do a lot of mixing. Get yourself a small console and start playing around with it. Just take any multitrack session created and start experimenting with the mix. Try recording with multiple microphone inputs and do a live mix out to monitors. Get creative.

Signal Flow

We finally get back to signal flow. The signal flow path starts at the input stage, usually the microphone. Once a sound source enters the microphone, the electrical signal travels down the cable into the input of the console. It should be noted that this is a general description of the path a signal takes. Various devices along the cabling may boost the signal or perform some other function to the signal before it gets to the console and it is just assumed that the signal will travel from the microphone to the desk through some cabling configuration.

The signal then passes through the gain stage where it moves through the auxiliaries and is then sent and returned, if configured to do so. Then it is sent to the EQ and finally to the fader. From the fader, it is bussed to a specific submix buss in the case of a sound reinforcement rig. It then moves to the master fader out to the monitors. In the case of the multitrack recorder, or DAT, it is sent to the recording device and is then sent back to the console and then out to the monitors if so desired (Figures 2-40 and 2-41).

Final Comments on Consoles

One last button should be mentioned regarding consoles. At the top of the channel, there is sometimes a button called **pad.** This button can play a major part in preserving your gear as well as avoiding distortion in recordings. If there is a weak signal, such as those usually generated by various types of microphones, the gain is used to increase the signal level so that the input is above any noise floor or inherent noise in the system (defined above). But what if the

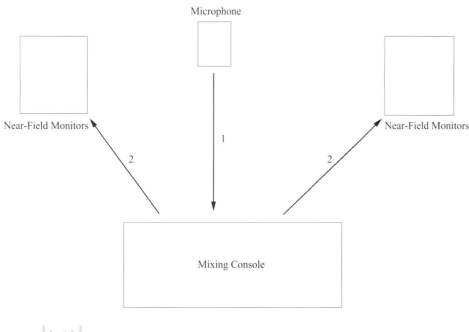

Figure **2-40**

The direct signal flow from microphone to monitors in a sound reinforcement configuration.

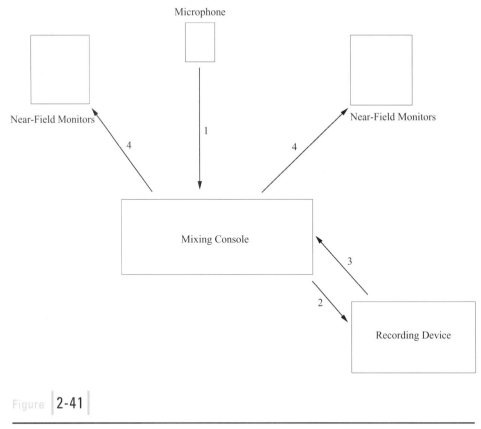

Figure | **2-41** |

The two-stage process of a recording mixer. The signal flow is from microphone to desk to tape, back to the desk, and off to the monitors.

signal is directly from a keyboard, for example, and the signal is very hot, even if the gain is turned down low? This is where the pad button comes in. The pad is usually set for a 20-dB decrease in the input signal, thereby allowing an extremely hot signal entering the console to be adjusted to proper levels. A very useful tool for the sound designer, or any recording engineer, due to the amount of recording done with direct instruments and direct input devices.

The console is the heart and brains of the entire rig. Learn it well for it will greatly enhance your sound work.

Effects and Signal Processing

There are different effects and processing that can be applied to a signal. In fact, there are thousands of them if digital effects are included, but to give an idea of some of the more commonly used sound devices applied to enhance and alter the sound, a short list is given below with brief descriptions. These effects and processes usually exist both as a hardware or a software solution.

Delay

The delay is the repeat of a single source signal produced. The distance between the original sound and the delay can vary. Delay time is measured in milliseconds wherein the minimum delay time should be about 10 to 20 milliseconds and the largest delay time should be, while still remaining realistic, up to about 240 to 250 milliseconds.

Delay can help improve a vocal line all the way up to creating the illusion that the original sound is in a very large room such as a church. Be careful with all added effects, they have a tendency to push up your levels if not properly monitored.

Echo

Echo is what you hear in very large spaces with reflective walls. Think of the Grand Canyon. It simply is the decaying repeat of an entire sound signal. Using echo has a very specific effect and is generally used in particular circumstances. Use it wisely.

Reverb

Think of reverb as a series of echoes that overlap. This overlapping of signals creates a continuous sound that eventually decays to zero. Reverb is used often to sweeten up a dialogue track or to create the impression that the sound is in an acoustically reverberant room. Concert halls usually have a decay of about 1.5 to 2.5 seconds long. Smaller halls may have 1- to 1.5-second reverb times.

Reverb is also produced with the wall materials in mind. **Pre-delay** is the setting that simulates how a wall will reflect before reverberation begins. Usually this is about 50 to 100 milliseconds and it adds more character to the reverb.

Chorus

The chorus effect takes the original signal and slightly delays the signal. All of this is heard at the same time, giving a very solid thick sound. Just imagine a real chorus of voices trying to sing on a group of consecutive notes. Not every performer will be singing exactly the same pitch and at the same time as all of the rest. The chorus has a convincing effect when applied to a string section for example. Experiment with this using various instruments and sounds.

Pitch Shifting/Bending

Pitching and bending a sound increases or decreases its overall frequency. This effect is basically meant for instrumental sounds but can be applied to nonpitched sound effects as well. The effect of shifting the pitch, or frequency as it may be, can have varying results. At a certain point, if the pitch is shifted very low, the length of the file will start to play a major part in how long the original will sound. Watch out for this and see if there are any workable solutions in the software packages you use.

Compressor/Limiter

When a signal has a large dynamic range, sometimes it is necessary to boost the lower levels of the recording without decreasing or changing the higher levels too much. The compressor can handle this job. The compressor effectively raises lower levels to a more generalized output level based on the existing higher level signals. Radio spots, dance music, popular music, and so on, usually require a compressor to get the entire track up to an acceptable level. Classical music or film scores would not benefit from a compressor because the nuances in dynamics are desired in these types of music.

The limiter acts as a barrier of sorts, pulling up amplitude to it but not allowing it to pass over it. Usually these devices, the limiter and compressor, are grouped together for good reason.

SUMMARY

We explored microphones, loudspeakers, and consoles. The types of microphones and loudspeakers play an important part in recording and reproducing sounds and music. The console, by far the most complex piece of equipment mentioned, is really just a collection of channels lined up next to each other. Once the channel is understood, the mixing process becomes easier to understand. The path a signal takes is vital to the understanding of how a mixer can perform.

The analog recording, reproduction of sound, and the hardware involved will take a little practice to get used to. Getting quickly adjusted to these concepts is the key to getting quality audio into projects. You will learn quickly how to create a rough mix after hearing a client say "The volume is too low" or "Why is that sound louder than all of the rest?" How long it takes you to get positive results will depend on how you absorb information and how much outside research is done.

It is up to you to find information regarding the topics you are interested in. Find out everything you can about microphones, monitors, and consoles, and get yourself a small rig. The practical work will not only be useful to you as a sound designer but also as a sound person in general.

in review

1. What is the difference between a dynamic and a condenser microphone?

2. What is phantom power?

3. What are the auxiliary/sends use for on a mixing desk?

4. What is the difference between balanced and unbalanced cables?

5. What is the definition of frequency response for both microphones and monitors?

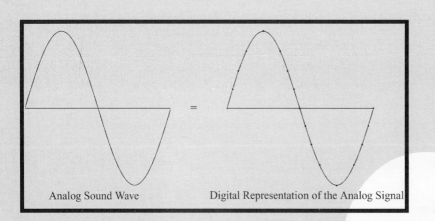

Analog Sound Wave Digital Representation of the Analog Signal

digital audio fundamentals

objectives

Digital audio concepts

Types of digital audio error

Digital audio recording and reproduction processes

introduction

This chapter discusses the basic concepts of digital audio theory. Typical error and solutions to these errors are explained. The digital recording and reproduction processes are reviewed, as are the individual components that make up the digital signal path.

ANALOG VS DIGITAL

There is a large debate going on concerning the way analog and digital audio sound. The debate mostly involves the aesthetic differences between the two. Some people say analog sounds better, even though the typical tape noise is present on the recording; others say that digital sound is better due to the clarity of the audio, which is attributed to the low noise floor created by the digitization process. This debate is pointless because people are going to listen to whatever they want and enjoy whatever they please. There are differences between analog and digital audio, but neither one is better or worse than the other, they are simply different.

Digital audio is the conversion of analog signals into a form that a computer can break down and "digest." The "food" that computers like to eat is numbers. Discrete numbers are the root of any digital system and are the fundamental building blocks of digital audio.

Analog sound, which literally means "the same as" or "similar to," is not based on discrete numbers but is recorded as a continuous sonic event, usually onto magnetic tape. Analog signals are exact replicas of the original sound source. There is, of course, noise introduced into the recording, which is not in the sound source itself but is still part of the analog recording. Either way, the entire signal is "captured" on tape and can be heard in its original state if not for both the noise floor and the natural noise floor that occur during the recording. If you recorded the same signal using a digital device, the signal recorded would not be continuous like analog. The recording process of a digital system takes "snapshots" of the analog signal as it enters the system. These snapshots are called samples. At a certain rate, these samples can give the ear the impression that the sound you are hearing is a continuous signal, but technically it is nowhere near a continuous signal. There is a certain amount of the original signal that did not get converted in the digital conversion. Sometimes your ear will not be able to hear the difference and other times it will. It all depends on the amount of binary representation available to redraw the analog signal and the number of snapshots taken per second.

Digital Audio Today

Your focus on digital audio is important for a few reasons: You will most likely use digital audio most of the time, through software and hardware, to create, record, and process your sound work; the startup expenses are relatively low compared with purchasing analog gear. One of the most important reasons for dedicating your time to digital audio techniques is that analog systems, as far as editing and recording, are slowly becoming obsolete. There is a slight debate about which is better as well, and you will be able to decide for yourself after some experience with both. You will always need loudspeakers and microphones, but consoles can conceivably be replaced entirely with a digital mixer. In the meantime, experience using both.

Today, just about every sound designer works in the digital arena. As mentioned in the previous chapter, many professional music recordings in the studio are recorded through the desk onto tape, whether that it is onto 24-track or ¼-inch tape. Usually this recording is digitized, processed, and edited in a DAW (digital audio workstation) and then sent back to tape or sent

to a storage medium like a hard drive. Sound effects the recording, however, is made directly to hard drive or DAT tape. Both the analog and digital processes are at work, but this is changing. Your task is to find the right balance of analog and digital to accommodate your workflow. You may need to experiment, but the knowledge is invaluable in the end.

Understanding the concepts and theory behind digital audio not only allows you to more efficiently work with the gear you have, but it will clarify some of the most advanced and exciting aspects of sound design. It is well worth your time to understand this chapter as well as discover every source you can on the topic in order to better understand your craft.

Before getting into the specifics of digital audio, it is necessary to examine some mathematics, or "food" of a computer, in order to understand how computers handle data as they relate to audio.

Binary Numbers

Our everyday lives are full of number systems. We sometimes relate to the world through various signals given to us through numbers—road signs, temperature, prices, and so on. The number system most commonly used is the decimal system. The decimal system is made up of the numbers 0 through 9. It is thought that the decimal system was derived, possibly, from the number of fingers and toes we possess. In general, we count from 1 to 10 instead of from 0 to 9. The base 10 system uses 10 numbers ranging from 0 to 9 to represent all of the numbers in the system. Any number can be configured using a combination of the numbers in this system. The decimal system is a base 10 system. There are numbers from 0 to 9, which is 10 discrete numbers, but we count from 1 to 10. Zero in the base 10 system has a value! It is sometimes tricky to think of 0 as having a value because you have been educated to think of 0 as equating to nil. The number 0 equals the first value and so on.

Number Values	1	2	3	4	5	6	7	8	9	10
Digit Values	0	1	2	3	4	5	6	7	8	9

Figure | 3-1 |

Base 10 numbers with their equivalent values.

Musicians are probably just as familiar with another type of number system, more so than the base 10 system, even though the numbers of the base 10 system are used to represent this other system. The base 60 number system is the system used to measure time. Every 60 seconds starts another minute, every 60 minutes starts another hour. The base 60 system is also used to measure geometric degrees: 0° to 360° of a circle. As mentioned above, people who deal with time and temporal considerations are familiar with this as is anyone who reads a watch everyday.

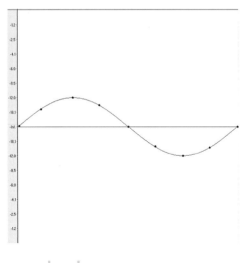

Figure **3-2**

Samples located along the x-axis.

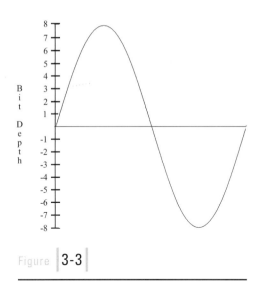

Figure **3-3**

Bit-depth measured along the y-axis.

Computers deal with only two values to make calculations: 0 and 1. If computers were to use the base 10 system to compute, the calculations would be enormous and would require an astronomical amount of memory to store the large numbers. The two values the computer uses are called binary values and make up the base 2 number system. Every computer calculation is made using this system. As in the decimal system, the base 2 system can represent any number using only zeroes and ones.

The binary system represents very large numbers, whether they are decimal numbers or not, using a small number of digits. This is particularly interesting because the end goal is to convert analog signals into binary representations.

Simply put, the shape of a sound wave entering a system goes through a circuit that creates a corresponding number to the incoming electrical voltage. This voltage is a measurement of the amplitude. Another way of thinking of amplitude is to think of it as the energy behind sound represented as voltage.

The Digitization Process

The coding of intensity of an incoming analog signal requires two particular processes: one that will suspend a moment of time and the other to measure and convert that suspended point's intensity into a number. The digitization process includes two distinct sets of discrete binary values used to represent the time and intensity, or amplitude, aspects of an analog waveform. One set represents the position in time of the samples taken. This is known as sampling. You can think of a sample as being a small piece of a recording, more commonly referred to as a snapshot of an analog signal. To visualize this, samples exist on the x-axis.

The second set of values represents the quantization or bit-depth equivalents of the amplitude component. The bit depth is measured and visualized along the y-axis and refers to the size of the binary number used to represent the dynamic value, or intensity, of the sample taken at a given point. The further away the sample is taken from the centerline, the higher the binary number needed to encode the amplitude.

The larger the quantization number, the more data information can be used to represent intensity, resulting in a higher resolution.

Bits, Bytes, and Nibbles

The smallest amount of data information a computer can work with is the *bit*, which comes from the combined words "binary digit." A bit can be either one of the two binary numbers, and the more bits you have, the more data information can be used. Bits can represent any Boolean algebraic configuration from off (0) to on (1), no (0) to yes (1), and everything in between. Boolean algebra is the mechanism applied to the manipulation and combination of binary signals. This Boolean algebra is used in digital audio packages as well as many other electronic and software devices.

Bit depth is measured by the amount of available binary number slots. In other words, if two binary numbers are going to be used to represent amplitude at any given point, we can then call the bit-depth set at two. A 2-bit configuration can yield four discrete numbers with which to represent amplitude.

Notice that the 0 is a discrete value, thus allowing the total to be from 0 to 3, or four countable values. This is important because even though the full binary word of 11 is equivalent to the decimal number 3, it is considered the fourth discrete value in a 2-bit system.

A group of bits together is called a word, or bit word. The bit depth given by the user determines the length of the word. An 8-bit configuration is called an 8-bit word.

In a 3-bit system, there are eight discrete values but its decimal equivalents are from 0 to 7.

A closer look at the comparison between a 2-bit system and a 3-bit system reveals some interesting points. In a 2-bit system, four values represent the decimal values of 0 to 3 and in a 3-bit system there are eight values of decimal equivalents from 0 to 7. Adding 1 bit of information to the 2-bit configuration effectively doubles the amount of discrete values used to represent incoming amplitude.

| NOTE |

Boolean procedures are credited to an English mathematician named George Boole (1815-1864). In 1854, he published a work entitled "An investigation of the Laws of Thought, on Which Are Founded the Mathematical Theories of Logic and Probabilities." Originally Boolean algebra was called "the calculus of logic." Boolean logic supplies the decision making option to all procedures within digital components, which leads to, among other things, interactivity. Using Boole's basic definitions of AND, OR and NOT, it is possible to search through an enormous amount of data quickly by continuously narrowing down the field of choice. It is said that George Boole did not continue his formal education past the third grade.

Table 3-1. 2-Bit value comparisons

Binary Number	Decimal Number Equivalent	Zero as a Value, Decimal Number Equivalent
00	1	0
01	2	1
10	3	2
11	4	3

Table 3-2. 3-Bit value comparison

Binary Number	Decimal Number Equivalent	Zero as a Value, Decimal Number Equivalent
000	1	0
001	2	1
010	3	2
011	4	3
100	5	4
101	6	5
110	7	6
111	8	7

Therefore, the addition of a single bit of information to a 2-bit word by no means contains one-third more useful information than a 2-bit system can provide. In fact, we have doubled the amount of useful information to represent intensity.

The addition of a bit of information to any word length doubles the amount of available data used to equate incoming voltage.

A list of all of the decimal equivalents associated with their corresponding bit depths up to 16 bits is presented below as are the common 24-bit and 32-bit equivalents.

Table 3-3. Bit depth decimal equivalents

Binary Number	Decimal Number Equivalent	Zero as a Value, Decimal Number Equivalent
0000000000000001	1	0
0000000000000011	2	1
0000000000000111	4	3
0000000000001111	8	7
0000000000011111	16	15
0000000000111111	32	31
0000000001111111	64	63
0000000011111111	128	127
0000000111111111	256	255
0000001111111111	512	511
0000011111111111	1024	1023
0000111111111111	2048	2047
0001111111111111	4096	4095
0011111111111111	8192	8191
0111111111111111	16384	16383
1111111111111111	32768	32767
111111111111111111111111	16,777,216	16,777,215
11111111111111111111111111111111	8,589,934,592	8,589,934,591

A group of 8 bits is called a byte. Computers usually work with 8-bit chunks of data and very often the 8-bit word length is the lowest common denominator. In the context of computer lingo, the numbers 256, 512, and 1024 probably look familiar to you. Ram is usually measured in terms of bytes as are many other computer-related parameters. The common underlying number is 8.

The measuring quantity of bytes is used throughout the digital domain.

Table 3-4. Various byte values across the digital domain spectrum

Name	Abbreviation	Size
Kilo	K	1,024
Mega	M	1,048,576
Giga	G	1,073,741,824
Tera	T	1,099,511,627,776
Peta	P	1,125,899,906,842,624
Exa	E	1,152,921,504,606,846,976
Zetta	Z	1,180,591,620,717,411,303,424
Yotta	Y	1,208,925,819,614,629,174,706,176

An 8-bit word contains 256 discrete numbers ranging in decimal equivalent value from 0 to 255. It is common to call the numbers of a binary word "steps" in digital audio. The naming convention comes from the visual stepwise motion created when an analog signal is quantized.

As the number of values in a system increases, the audio resolution similarly increases. Higher resolutions yield better sounding audio. An 8-bit system is considered low-bit resolution. If the bit depth is low, the audio quality suffers. The sound generated from an 8-bit recording, that is, a digital recording made with 256 values to represent all of the incoming amplitude, sounds scratchy, noisy, and contains many areas of dropout. This is due to the limited number of "options" available to re-create the intensity of the original analog signal. The sampling rate and the effect it has on the overall audio resolution also play a part, but it is not as significant to the playback resolution as the bit depth.

A higher resolution, such as 16 bits, yields a much better audio resolution. For every increase of 1 bit, the resolution doubles. A 16-bit recording is not twice as valuable as an 8-bit recording. A 9-bit recording is twice as valuable as an 8-bit recording.

There are 65,536 steps in a 16-bit system, which is pretty high. This is the standard bit depth used for CD recordings. At this resolution, the ear generally cannot hear artifacts introduced by bit depth resolution. There may be sound artifacts introduced during the recording, but not by the bit depth.

There is a debate over the bit-depth resolution and what is perceivable and what is not perceivable. As mentioned above, 16-bit is the international CD quality standard for bit depth but

in today's audio universe, there are commonly higher bit depths used. The 24-bit recording has become commonplace (notice that 8 is again the common denominator). There are 16,777,216 steps in a 24-bit system. That is a lot of steps to represent the dynamic content of a sound source, maybe too many steps. Therein lies the debate. The only way you can decide for yourself is to hear two identical recordings, side by side, which are recorded at both 16- and 24-bit resolutions. You make the choice of which sounds better.

Numbering Bits

Usually bits are visualized as a series of boxes read from right to left. The first box is the first bit and has a value of 1, the next box to the left is the second bit and has the value of 2. As we move further and further left, the numbers double with each additional bit.

Number Values	1	2	3	4	5	6	7	8
Digit Values	0	1	2	3	4	5	6	7
Maximum Available Intensity Levels per Bit (Decimal)	1	2	4	8	16	32	64	128
Binary Number	1	1	1	1	1	1	1	1

Figure 3-4

An 8-bit visual representation.

The example above represents a full word. Notice that the binary boxes are all filled with 1's. This means that the value in the corresponding bit is counted. If the boxes had a few zeroes, the bit associated with the box would not be counted, thus allowing us to represent all of the decimal values, better thought of as voltage input values, within the range of the bit-depth limitations.

Bit Depth Step Level	128	64	32	16	8	4	2	1	
Binary Number	0	1	0	0	1	1	0	1	= 77

Figure 3-5

An 8-bit word that is not filled.

You may have also noticed that the full 8-bit word above, when added together, equals 255. Keep in mind that this implies that 0 is a value. The number 255 actually is 256 steps: 0 to 255.

This basic understanding of the functionality of binary numbers will greatly improve your overall understanding of the digital audio process.

Now that you understand binary numbers and their relationship to bits, it is practical to examine some details about digital audio starting with sampling and quantization.

Sampling and Quantization

In the first chapter, the two basic fundamentals of acoustics were stated as frequency and amplitude. Time and intensity are equated to frequency, which unfolds as time moves forward linearly, and amplitude is the measurement of the amount of molecular displacement caused by a vibration. Similarly, there are equivalents in digital audio. These are sampling and quantization.

The two processes, sampling and quantization, are the most important aspects of digitizing audio. Each is equated to a binary form for processing in the computer but what is the exact function of sampling and quantization?

Sampling

Sampling is the process of taking snapshots of an incoming sound wave and storing them as data. Sampling is time-based. This could be thought of as analogous to frequency in that it is visualized in a timeline from left to right. Another good analogy to sampling is shooting film. In the United States, the frame rate for shooting 35-mm film is 24 frames per second (fps). This is the rate at which our eyes cannot detect missing image from the film. If we slowed down the rate, we would start to notice that this image would look jumpy and jerky. Why? If the frame rate was slower, we would notice a perceptual loss of image between each frame. Now think of the frames as samples. Each instantaneous picture follows another, separated by a small amount of space. Samples work in exactly the same way except they contain intensity data of an incoming sound signal. When there are lower sampling rates, there is poorer resolution output; higher sampling rates produce higher quality audio output.

All samples are taken at discrete times per second and the total number of samples per second is known as the sampling rate. The sampling rate is measured in Hertz. This, however, is not the same Hertz used in the acoustics discussion. A periodic signal frequency, in analog, is measured in Hertz representing the number of times a vibrating mass moves back and forth, whereas the sampling rate represents the number of samples taken and is also measured in Hertz. Do not confuse the two of these!

Theoretically, each sample taken is equidistant from each other. This also means that there is an equal amount of space between each sample. This distance is known as the sampling period.

Table 3-5. A comparison of frequency and sampling rate

REPRESENTATIONS OF SAMPLING RATES MEASURED IN HERTZ

1000 vibrations per second	1000-Hz signal frequency
1000 samples per second	1000-Hz sampling rate
44,100 samples per second	44,100-Hz or 44.1-kHz sampling rate

A 1000-Hz sampling rate will create samples that are 1/1000th of a second apart from each other or one sampling period will equal 1/1000th of a second. A sampling rate of 22,050 Hz will contain samples that are 1/22,050th of a second apart from each other. This may be hard to imagine, so it would be better to visualize this in some form. A sampling rate can be better visualized using the same sine wave representation applied in the previous chapter on acoustics. The picture on the left in Figure 3-6 is the original analog signal and the picture on the right is the sampled signal with the original signal mapped in behind it. Each sample is equidistant from each other. The sampling rate is intentionally very low so that the samples can be perceived for this figure.

Most digital audio editing software packages allow you to set the sampling rate for your recording. The extremely low sampling rates are impractical and have no real use in music and sound recording except for analysis reasons, but we will use them nonetheless to make the sampling process as clear as possible to understand.

Redbook Standard

There is a particular sampling rate, which was decided by the governing standards committee at the time when compact disc audio standards were being decided upon. This standard would

Analog Sound Wave = Digital Representation of the Analog Signal

Figure 3-6

Analog and digital equivalents.

allow all CD players to be able to read all CDs. The exact sampling rate that was derived was 44,100 Hz. Not one sample above or below this amount would be properly read by a commercial CD player. Above, it was mentioned that 16-bit audio was the standard set for bit depth, or quantization. In combination, a 16-bit, 44,100-Hz sampling rate in mono or stereo is known as the Redbook standard. Why was 44,100 Hz set as the standard sampling rate?

In order to fully understand why 44,100 Hz was set as the standard we must recall the range of human hearing. It has been determined that the human can hear from 20 Hz to 20 kHz. This implies that the highest pitch perceivable is measured at 20 kHz, but what about the extra 4,100 Hz? Read on.

Sampling Theorem

Once upon a time there was a man named Nyquist (who is still living at the time of this writing), who came up with a theory about sampling audio—the sampling theorem. Basically it states that, in order to digitally record any signal frequency, you must have a sampling rate that is twice as high as the highest signal frequency being recorded. Part of the reason the sampling rate has to be twice as high is because both polar sides of a sound file need to be sampled, not just one of them.

If the highest audible frequency is 20 kHz, then sampling rate should be 40 kHz. So why then is the standard 44,100 Hz? Well, just as it is important to capture all of the sound within the audible range, it is equally important to keep out any frequencies above the Nyquist limit. If frequencies enter the system, which are converted above the Nyquist limit, a form of digital error is created called aliasing. Clicks and pops occur within this form of error. It is also known as foldover because the offending upper frequencies are "folded" back onto the original recording as alias frequencies (Figures 3-8 and 3-9).

Back to the question, why is the sampling rate standard 44.1 kHz? In order to counter the effects of aliasing a filter must be introduced. This filter, called a low-pass filter or anti-aliasing filter, theoretically would allow only frequencies to pass that are under the Nyquist limit, set by the sampling rate. However, it is not possible to cut off the frequency seepage above the Nyquist limit at exactly a set given value, like a wall. There must be some room above the limit for the filter to properly function. This attenuation slope at the cut-off point, in this case 20 kHz, stretches up an additional 2050 Hz. If we then double 22,050 Hz, we get the Redbook standard of 44,100 Hz sampling rate (Figure 3-10).

If you would like to create sound and music for public consumption, it is a good idea to memorize the Redbook standard. All of your work will only be playable through your computer if you do not have this standard set exactly. The future will have

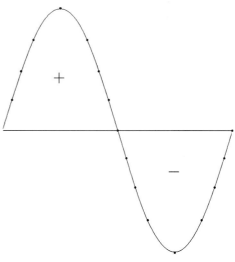

Figure **3-7**

Both sides need to be sampled in order to accurately represent incoming analog signals.

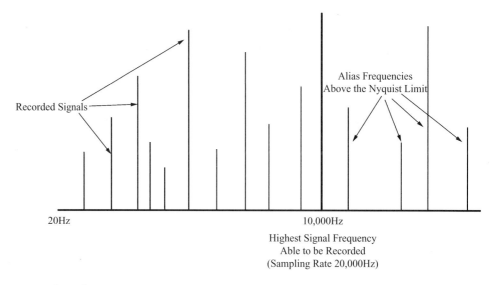

Recorded Signals

Alias Frequencies
Above the Nyquist Limit

20Hz

10,000Hz
Highest Signal Frequency
Able to be Recorded
(Sampling Rate 20,000Hz)

Figure 3-8

Alias frequencies.

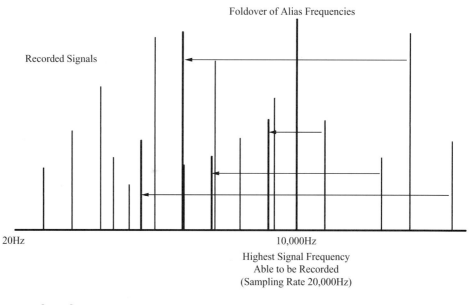

Foldover of Alias Frequencies

Recorded Signals

20Hz

10,000Hz
Highest Signal Frequency
Able to be Recorded
(Sampling Rate 20,000Hz)

Figure 3-9

Alias frequencies in the audio spectrum.

DVD as its standard delivery media type. DVD has a slightly different playback rate. Although a number of options can be selected with DVD, typically a 96,000-Hz sampling rate at 24-bits per sample, stereo or mono, is the most common.

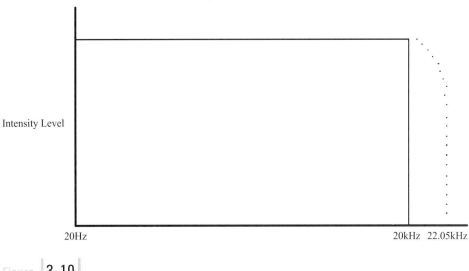

Figure **3-10**

Anti-aliasing filter with theoretical infinite attenuation at 20,000 Hz and the practical filter with the "roll-off" of 22,050 Hz.

Time-Based Error in Sampling

Besides aliasing, there is another prominent but rare form of error associated with sampling called jitter. Jitter is caused when samples, which are usually equidistant from each other, become separated by unequal distances. Usually jitter is a hardware error and can be fixed by either replacing cables or internal clock mechanisms or by sending a timing signal along with the digital audio data. When jitter is present, the distance between the samples varies; it is not a constant erroneous sampling period.

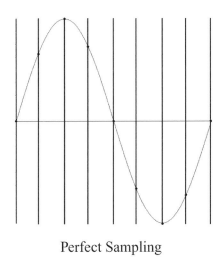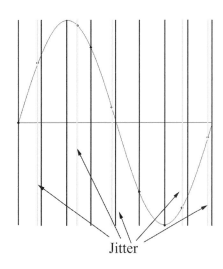

Perfect Sampling Jitter

Figure **3-11**

The effects of jitter on a recording. The left side is a perfect sampling and the right is a sample with jitter.

If the error is serious enough, there will be bad audible consequences. Although a highly misunderstood form of error, and quite complex, you should nonetheless be familiar that such a phenomenon exists.

Computer-Based Audio and Sampling

Lower sampling rates can be useful when it comes to the hard drive and portability. Just ask any game music composer what one of the most important considerations is when compiling music for a game. He will certainly tell you that file size is among the top three.

While you have the option with most digital audio packages to freely set your sampling rate, one consideration must be taken into account before a recording session is started. Always try to get the best quality audio on your recording, even if it is for the Internet where size is a major issue. You can always resample or change the bit depth after you have a clean recording. It is always better to have a clean original as a backup to any potential disasters.

Sampling is a key process that needs to be fully understood in order to become a solid sound designer. It affects the "weight" and bandwidth of a file, which will have an enormous impact when applying it to interactive media and nonlinear environments, not to mention your ear's satisfaction. Grasping these concepts will allow efficient workflow techniques as well as an overall professionalism to your work.

Quantization

Quantization is the process of coding and translating an incoming analog voltage to a binary equivalent. Quantization is the digital representation of the level or intensity of an incoming sound, this can also be thought of as the digital amplitude value of an analog signal. The two processes: sampling and quantization, together cover the entire spectrum of all sound entering a system. All of this is done to change the analog signal into something the computer can understand and analyze. By converting the intensity into a binary form, we can then analyze, process, manipulate, and otherwise do anything we like to the audio file once it is in the digital system. This is a great advantage over its analog predecessors.

To visualize quantization steps, we again use the sine wave graph and pay attention to the polar opposites like we did with the sampling theorem. If we have an 8-bit resolution, which contains 256 steps, we will have 128 steps above and below the centerline to represent amplitude values. Both of the polar opposites need to be accounted for in order to achieve a high level of precision regarding the quantization process.

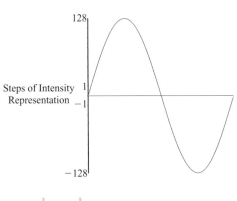

Steps of Intensity Representation

Figure **3-12**

Quantization divided into polar opposite sides of the centerline.

Encoding a continuous analog signal, based on selected points taken in time, i.e., sampling, is a discrete but erroneous procedure, and always will be. Continuous analog signals have an infinite number of amplitude values, but the quantization process is finite in that there is only a given number of values available to evaluate each analog impulse coming in. This value is set by the bit depth. The more bits used, the more information can be represented. In other words, the more values available to represent an analog signal, the better the resolution. This is not a perfect replica of the original signal, however. It cannot be because of the nature of the sampling process that takes snapshots of the audio signal. More than that, the accuracy of the actual value given to the measured, or sampled, location could also be incorrect.

Accuracy is really the goal when recording sound into a digital system. Many digital recordings are made using 24-bit resolutions along with a 96-kHz sampling rate to get the best recording possible. The more bits used, the better the representation of the original signal; the higher the sampling rate, the more samples can be taken for conversion. This solves the resolution side of the equation: Just use more bits and a higher sampling rate. The other side of the equation is a bit trickier; it involves the accuracy of the actual values of the amplitude impulses.

Quantization error

As samples are taken and evaluated, or quantized, there is a finite number of values able to be given to encode an incoming amplitude impulse. Because an analog signal is continuous and has an infinite number of amplitude values against a system that has a finite number of values to represent the continuous wave, there is bound to be some error introduced. In a digital binary system, all of the values must be made using either ones or zeroes, or any combination of them. If an incoming voltage does not exactly match a binary equivalent, the digital system must make a "guess" as to what the voltage value is. This is where the error occurs. Almost all of the error accumulates in the least significant bit (LSB). The LSB is the last bit to be evaluated in a system. It contains the least amount of information but has a big job.

Incidentally, the largest bit in a word is called the most significant bit (MSB). This becomes important during the output stage, or playback, in a digital system. It relates to error but in a different context.

Figure 3-13

Least significant bit (LSB).

MSB

Bit Depth Step Level	128	64	32	16	8	4	2	1
Binary Number	0	1	0	0	1	1	0	1

Figure | 3-14 |

Most significant bit (MSB).

The LSB is where the decision is made whether to code as a 1 or a 0. Because there is nothing in between 1 and 0, a choice must be made between the two.

For example, imagine you are recording sound source sounds. The amplitude of the incoming signal is measured at 1.6 volts. The binary word equivalent to this voltage is 101010. Great! That instantaneous amplitude pulse was exactly matched to a binary word and stored. The next pulse is measured at 1.7 volts, which equates to the binary word 101011. Great again! Another perfect match. The next pulse is measured at 1.65 volts. Uh oh! There is no binary word that fits between 101010 and 101011. There is no 101010-½. What happens? As you can see, the LSB of the word is either going to be a 1 or a 0. Most of the time the accuracy of the incoming analog amplitude extends further beyond the decimal point than in our example. The actual number may be 1.658 volts. The LSB would opt for the binary number of 1 in this case. But as we have seen, 101011 is equivalent to 1.7 volts, not 1.658 volts. Either way, there is going to be error. The largest this error can be, however, is one-half the distance between two steps of quantization. Now imagine this occurring 20,000 times a second in a 16-bit recording. Remember a 16-bit system has 65,536 values available to encode amplitude. Twenty thousand samples with error is a lot of error. Most of the time, you do not hear the error because the noise in the recording itself cancels it out, but if the resolution is low, such as in an 8-bit recording, the error will be heard more prominently, particularly during quiet sections of the playback.

Quantization error occurs all of the time in all digital recordings. This error is usually not perceived, even though it is present. The more bits available to represent amplitude impulses, the lower the quantization error is.

It is important to have a visual reference of the quantization process and how error occurs as a result of the complexity and precision of digital procedures. This is one of the hardest concepts to understand in digital audio.

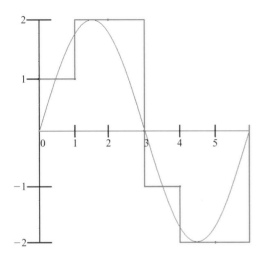

Figure | 3-15 |

Sample rate and quantization limitations of a signal recorded.

Notice the playback is looking pretty rough. Imagine how that will sound!

Signal-to-Error Ratio

The error created by the inaccuracies of quantization produces noise. White noise (defined in Chapter 1) is random but equally distributed frequencies across the entire audio spectrum. The noise exists at different levels based on the bit depth supplied. The higher the bit depth, the lower the noise floor. Recall that each consecutive additional bit doubles the resolution. So, by raising the word length by a power of 2, we can conclude each of the steps available in each bit depth category. For every doubling of resolution, the noise floor is decreased by 6 dB.

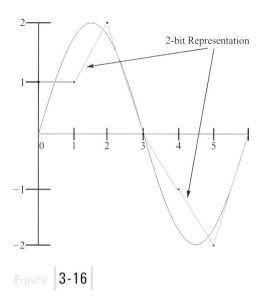

2-bit Representation

Figure **3-16**

The distance from 0 dBfs (decibel full scale) down to the noise floor is the signal-to-error ratio. The signal-to-error ratio (S/E ratio) is similar to but not the same as the signal-to-noise ratio,

Sample rate and quantization playback file representation.

which is the dynamic range of an analog system. The signal-to-error ratio is the amount of dynamic space available before audible quantization error is present. Where there is error there is noise; where there is noise, you lose your signal completely.

The formula for solving the S/E ratio is:

$$6(n) + 1.8 \text{ dB} = \text{S/N ratio}$$

N is the dBfs range of dynamic content and n is the bit depth number. If we have a 16-bit system, the S/E ratio is 97.8 dBfs, about 30 dB more quiet than ¼-inch tape. That is a pretty large range for audio content. If you listen to a 16-bit digital recording, you will probably not hear

Figure **3-17**

A 6-dB decrease for every additional bit added to a system.

the noise. If you have "silent" or very quiet parts of the recording, you may hear a slight hiss underlying the soundtrack. That is the noise floor. Keep in mind that other factors play into the noise floor, like the recording itself. You can do an experiment. Record silence with your favorite digital audio recorder, like Sony Sound Forge. Listen back and see if you can hear the noise floor of the recording.

If lower bit depths are being used, the noise floor creeps up and becomes more audible. An 8-bit system, for example, has a noise floor of 49.8 dBfs. This is loud compared to the 16-bit system. If you record using 8 bits for your resolution, you are likely to encounter major audio artifacts due to severe quantization error. One important fact to remember is that low bit resolutions always have large amounts of audible quantization error. If the intensity of the recording is high, the error is masked to a certain degree. If the playback encounters quiet sections of sound, the quantization error is very prominent. See the CD for an example of these sounds.

At 16-bit resolution, the noise floor was considered low enough to standardize. The 65,536 steps with which to code an incoming signal seemed appropriate at the time. Today, 24-bit resolution, which contains 16,777,216 steps, is more commonly used. By using 24-bit resolution, the recording may contain more of the nuances of the original performance or sound effect. Your ear is the only judge!

Dither

If quantization error is always present, even in very small amounts, how can you avoid some of the possible aural effects it has on a recording? One way to avoid the effects of low-resolution quantization error is simply to rerecord using a higher bit depth. This could be economically out of the question, as it might be in game sound or music, so another solution must exist. Dither, a highly complex subject, is the solution. Dither, in general, is the addition of small amounts of noise to an incoming signal. Dither is added before the analog signal is converted by the analog-to-digital (A/D) converter. This small amount of noise effectively allows the signal-to-error noise floors to be reduced below their normal levels. It does this by encoding signals that are less than the LSB (one quantization step). By doing so, it cancels some of the effect of quantization error but at a slight cost. By adding white noise to a file, you have white noise in the file. You will hear that noise, but it is preferable to the damaging effects of low-bit resolution quantization error. See the CD for examples of these sounds.

Sometimes dither can be added after a recording has been made. The effects are remarkable. If a file contains a lot of error, you may have to add dither to the file in order to save the signal.

The Recording and Reproduction Chain of Events

Our last stop in the discussion of digital audio is the recording and reproduction chain or path. The goal of the recording path is to convert analog signals into equivalent corresponding dig-

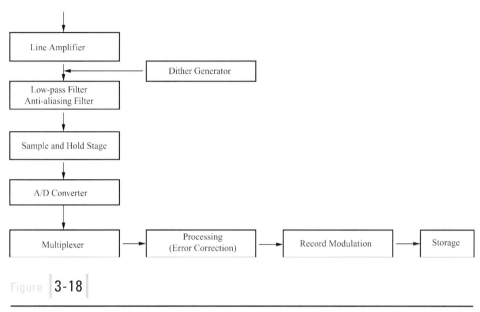

Figure | 3-18 |

The stages a signal passes through to get converted into digital data.

ital data forms, and the reproduction of these data into analog signals is the reverse process. Both are important to understand. The two paths presented below are descriptions of the general stages of each process.

Recording Digitally

The recording process is quite extensive but not everything in the picture above is necessary for a signal to be converted. The bare bones components of a digital recording process are a low-pass filter, a sample-and-hold circuit, an analog-to-digital converter, and devices for signal modulation, coding, and error correction. The overall process is amazing. At the line input stage, an analog signal enters the digital system.

Line Amplifier

Usually the first thing a signal encounters is the line amp, which boosts the signal to a level acceptable for processing through the system.

Dither Generator

The dither generator adds dither to the incoming signal to counter the effects of quantization error. Different types of dither affect different parts of a quantized signal. The choice of dither depends on the specific noise you want to affect in the file. In digital audio, there are three types of dither generally used: Gaussian pdf (probability density function), rectangular pdf, and triangular pdf. Each one of these is responsible for a certain type of noise introduced into the file.

It is not extremely important for you to get into the probability that a signal will fall between certain steps of the quantization process but it is important for you to experiment with dither with your digital audio editing software package. Most good packages have a selection of dither types to choose from. Try them out.

Low-Pass Filter (Anti-Aliasing Filter)

The anti-aliasing filter effectively prevents frequencies above the Nyquist limit from entering the system before it is converted to digital. As mentioned above, there is no such thing as a "brick wall" filter that attenuates exactly at a given frequency, so it is best to always set your sampling rate higher than the recommended doubling of the highest frequency, just in case.

Sample-and-Hold Circuit

After the low-pass filter has performed its job, the signal moves to the sample-and-hold circuit. Two things happen in the sample-and-hold stage. Samples are taken at discrete times, which sets forth the sampling theorem mentioned above. The sample is then held while the A/D converter takes the held analog value and converts it to a digital word. This is a critical step in the digitization process. Without the hold stage, the A/D converter would not re-create an accurate picture of the incoming analog signal due to the infinitely varying amplitude input.

Analog-to-Digital Converter

The A/D converter is the heart of the conversion process. The accuracy and time it takes for the converter to do its job are the most important aspects of this device. The higher the bit depth

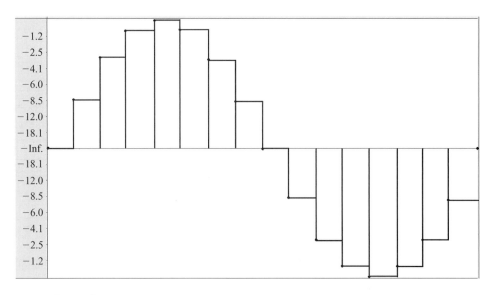

Figure │ 3-19 │

Sample-and-hold procedure from analog signal to stairstep visualization.

and sampling rate, the harder the A/D converter has to work. The converter takes the analog amplitude voltage at each sampling and derives a binary code from it. The better the A/D converter, the more accurate the audio representation will be. Basically, the A/D converter is the interface between the analog sound world and the digital audio sound world.

Multiplexer

The multiplexer's job is to serialize the flow of data coming from the A/D converter. A serial bit stream is a single flow of data as compared to multiple streams of data. The data output from the A/D converter may be parallel for redundancy reasons, or other error corrective reason, and needs to be put in line. Most digital audio processes are serial by nature. This single stream of data generated from the multiplexer is then sent on to error correction or processing for further conditioning in preparation for storage.

Error Correction (Processing)

To diminish the effects of error introduced in the bit stream from the outset of conversion, some form of error detection and correction must be applied. Basically it is creating a new set of data based on the bit stream sent from the multiplexer or in different types of correction, interleaving data are used. In other words, the data are made redundant or interleaved in order to check and correct errors. Processing also occurs at this stage. The data bit stream is processed with synchronization and address information and is basically stored as raw data. The goal now is to convert the data from the A/D converter into a storable form.

Record Modulation

The raw data produced from the error correction stage must then be coded into a form that can be most accurately and efficiently stored. The most common type of coding for audio is pulse-amplitude modulation (PCM). Modulation is a means of coding information so that is can be stored and transmitted. This form of modulation basically takes the input measured analog amplitude of each sample and represents that information as a pulse code. Normally there are several pulses for each sample representation. PCM forms a very healthy signal when played back and is the most efficient for storage and transmission. Other types of modulation include pulse-amplitude modulation (PAM), pulse-number modulation (PNM), pulse-position modulation (PPM), and pulse-width modulation (PWM), but the most common is PCM.

Reproducing Sound Digitally

The reproduction chain is basically the recording chain in reverse as can be seen above, but the function of a few of the devices is different than what might be imagined.

The storage data must be reconverted into an analog signal for consumption. PCM is the most efficient encoding scheme for digital audio both in the recording chain and the reproduction

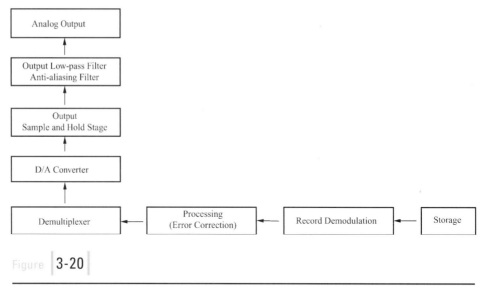

Figure 3-20

The stages digital data pass through to get reconverted back into an analog signal.

chain, so most of the raw audio that you encounter will be PCM encoded. Error correction is again required and is essential. Without error correction, the output signal would be severely degraded. The serial bit stream must be de-interleaved or demultiplexed into its original binary state so that the digital-to-analog (D/A) converter can interpret the data as voltage pulses and send them through a sample-and-hold circuit, and then once more through a low-pass filter and out to the monitors.

Digital-to-Analog Converter

The job of the D/A converter is to take the digitized output signal and, as accurately as possible, restore it into an analog form. This device is one of the most important parts of the reproduction chain. The D/A converted has to be incredibly precise. The voltages that are produced are extremely specific. In a 16-bit converter, there needs to be 65,536 degrees of voltage used to represent a particular sound or piece of music. A 24-bit converter, as stated above, has 16,777,216 degrees. Wow! That is a lot of work for one little device.

Sample-and-Hold

Unlike the input sample-and-hold circuit, the output sample-and-hold circuit must correct errors created by the D/A converter. As mentioned above, the process of converting digital binary to some form of voltage equivalent is enormously precise. This, naturally, leads to error. The D/A converter can generate erroneous signals, which are then placed together with the output voltage. The output sample-and-hold stage removes the irregular signals and then, when the signal is stabilized, it is held for the length of time it takes the D/A converter to switch between samples. The next sample is then evaluated and corrected.

Output Anti-Aliasing Filter

The final stage of the reproduction chain is the output anti-aliasing filter or output low-pass filter. This filter takes the D/A converter's output PAM staircase-like representation of the analog signal and smoothes it out for playback.

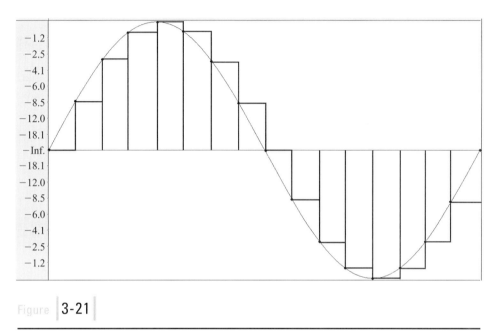

Figure **3-21**

Staircase representation from the D/A converter to a smooth representation from the low-pass filter.

SUMMARY

This chapter gives an idea of how accurate and intense the digital audio recording and reproduction path is. The processes of sampling and quantization, along with typical forms of inherent error associated with them, in conjunction with the hardware precision involved to accurately produce quality audio are a marvel. Study these concepts over and over. A large amount of material has been written on digital audio; investigate and inspect as many of these resources as you can. Some of the material is slightly different from others, but the general concepts are the same.

A complete understanding of the digital audio process is absolutely necessary for sound designers. Read over these concepts until they make sense. Furthermore, as with any theory or thesis, there must be an accompanying practice in which verification at an empirical level is made. The more you work with digital audio, the more these concepts will gel together.

in review

1. Define sampling rate and quantization.

2. What is low-bit resolution and how does it relate to quantization error?

3. What does dither do to a file or recording?

4. What is aliasing?

5. What is the function of an A/D converter?

notes

the computer and audio

Critical hardware and software components needed for a sound designer

Introduction to the basic components of software packages related to sound design

Technical terms used in the field as well as editing and rendering techniques

introduction

This chapter reviews all of the critical components, both hardware and software, needed for a sound designer to configure and work with a computer and its peripherals. The reader is introduced to the basic components of software packages related to sound design. Technical terms used in the field as well as editing and rendering techniques are covered. A short introduction to sound notation software is also presented with some of their uses.

THE COMPUTER AND AUDIO

MAKING GEAR WORK TOGETHER

So far, the information presented has been more or less theoretical. In order to put that information to use, an overview of the gear used is needed. The equipment, devices, software, and setup that you use are what make up the entire digital audio rig. The quality of this gear will make a significant difference in the audio output and overall sound design. In the beginning, any gear will do, but as techniques and, more importantly, the ear start to "sharpen," more advanced gear will be wanted.

The general setup of the entire rig is also important to understand. There are specific locations for monitors, the chair, and other gear that will help in the appreciation and analysis of project work. A "5.1 surround sound" setup is also critical for surround mixing to take place.

The sound generated by your system is like an aural fingerprint. Your sound will leave an impression on the listener, eventually leading to a characteristic style. Weak physical links in the audio chain will become apparent when tested on proper gear. For example, mixing through mediocre monitors might alter the overall mix and thus sound very poor through a commercial system or even worse through semiprofessional and professional sound rigs.

The better the gear and software, the cleaner the audio product will be.

Hardware

It all starts with the hardware. The power and accuracy of your computer will determine the quality of your audio whether it is input or output. The knowledge of how to construct a computer from the various available components is a valuable skill to have. It can help cut costs over the pre-made towers and allows you to pick and choose, to a certain degree, the exact configuration of the workstation. For example, pre-made machines may contain devices that you are not necessarily interested in or may contain only a certain type of processor. If you construct your own machine, then you can pick and choose the devices without being limited to what is contained in the computer "package." The downside is that you need to construct the machine from the ground up, and the software needs to be installed manually. Hard drives do not come with software pre-installed.

Most of the common brands of hardware devices give step-by-step directions regarding installation. On the average, if you have never built a tower before, the time it takes to construct the computer and install the **OS** (operating system) of your choosing takes about 4 to 6 hours. After completing one machine, the time it takes to build another (you have to have more than one!) decreases considerably. As with anything, practice increases familiarity which decreases the amount of time it takes to complete. Get to work.

Basically there are nine devices in a computer that should be understood: (1) the central processing unit (**CPU**); (2) motherboard; (3) random access memory (**RAM**); (4) hard drive; (5) tower with power supply; (6) modem or Ethernet card; (7) graphics card; (8) sound card;

and (9) peripheral device connections like a keyboard, mouse, mixer, monitors, or other external devices.

Power Plant (CPU)

The core of the entire machine is the central processing unit. This is where the processing speed comes from. Most current machines have plenty of CPU power to do most audio jobs. Your basic off-the-shelf computer will have enough speed to accomplish anything that may be done with audio. A faster CPU allows more streams of audio to be recorded or played back at a time. If there is going to be a large multitrack digital recording session, then more CPU power is suggested, but the amount of power from a typical CPU is surprisingly enough. A screamingly fast processor would be useful when calculating audio render times or edit manipulations. Sometimes with slower machines it takes a little while for the results of a particular added process or effect to occur. This is where the processing power is needed. The faster the processor, the faster things occur.

Figure 4-1

A CPU.

Motherboard

The motherboard is where all of the main processing occurs and where all of the data and power infrastructure for the computer are. Various attachable cards performing various functions (e.g., sound and video) all plug into similar sockets on a common motherboard. Each card has a special function and is powered by the slot or socket it is plugged into. The motherboard allows for customization of a computer to fit the needs of the user—very useful indeed.

The motherboard is constructed out of layers of printed circuit boards. These layers carry signals and voltage across the board. Some layers carry data for the memory, processor, and Basic Input-Output System (BIOS) buses, while others carry voltage and ground returns. This all happens without any intersections short-circuiting. These combined layers are placed and compressed on top of each other to form the motherboard. The chips and sockets are then soldered on the compressed board, which is what you buy in the stores.

Random Access Memory (RAM)

Random access memory (RAM) allows data to be stored in a temporary location, which makes it easier and faster to access than the hard drive. When you ask your computer to store or retrieve a piece of data, whether that is an audio file or not, it can basically check two areas: the hard drive and the RAM. Paging through a hard drive, no matter how fast or how many rotations per minute (RPM) it has, it is always going to be slower than accessing RAM. The difference can be compared to writing a

Figure **4-2**

A standard motherboard.

book. If the content of the book you are writing is not in your memory, then you need to look up the content and absorb it. This is basically what your hard drive does: It holds the data. If the content is in your head, the process of looking up the data is eliminated and the overall speed to retrieve the data is streamlined. Obviously, the more information in your head, the faster the book will be written. Similarly, working with audio can have the same results with a lot of RAM. One minute of CD quality audio requires approximately 10 Mb of space. If the audio project size is 300 Mb, which is rather small in sound design terms, 300 Mb of RAM plus whatever the operating system would need (a liberal estimate is 400 Mb, including the space required to swap data) is required to process this audio either in or out. Paging roughly 700 Mb of data on a hard drive is a bit of work and definitely takes longer than RAM does to retrieve it.

The more RAM the better. Most machines have slots to increase RAM capacity. Spend as much money as it takes to get your RAM as high as possible.

Figure **4-3**

Two 256-RAM sticks.

Hard Drives

Hard drives need to be fast for audio needs. Although not as fast as RAM, the hard drive speeds that exist today can handle a large part of the audio workload. Portable hard drives are also quite valuable. Using a Firewire or USB2 connection is fast enough for most CD-quality audio needs. A 44.1-kHz, 16-bit stereo file needs a data transfer rate of 150 KB per second to be effective. Many hard drives can transfer megabytes of data per second so 150 KB is not that much of a challenge. The higher the resolution of your audio file, the more **throughput** you will need from your hard drive.

Storage is another issue. The general project size basically determines the amount of space needed, but there is more to it than that. Writing and reading to and from one drive is a lot of work, especially when you are dealing with audio. A better solution would be to have a second drive dedicated to audio files. Writing to two drives can be twice as fast as writing that information from one drive back to the same drive again. A good idea would be to get a second drive dedicated to audio alone.

Table 4-1. Common hard drives

COMMON HARD DRIVE INTERFACE TYPES
• IDE (Integrated Drive Electronics) also known as ATA
• EIDE (Enhanced Integrated Drive Electronics)
• SCSI (Small Computer Systems Interface)

Table 4-2. Common connection types

	Dial-up	ISDN (Integrated Services Digital Network)	Cable	ADSL (Asymmetric Digital Subscriber Line)
Maximum download rate	56 Kbit/s	128 Kbit/s	8 Mbit/s	1.5 Mbit/s
Typical download rate	46 Kbit/s	64 Kbit/s	1 Mbit/s	512 Kbit/s
Typical upload rate	46 Kbit/s	64 Kbit/s	1 Mbit/s	256 Kbit/s

Graphics Card

An average video card is all that is needed. There is no real need to go buy a $500 blistering fast graphics card to work with your audio. Sometimes a particular graphics card does not work well with audio applications, resulting in visual artifacts or the application not working at all. Usually only a **driver** update is needed to fix any small problem or, if the problem is serious, a different graphics card may be needed. Basically, if you bought a pre-built machine, the graphics card supplied with it should be more than enough, realizing that most machines are being made with video gaming in mind. Video games require high frame rates, which require a faster render times generated from the graphics card. If your card can handle video games, it can easily handle audio.

Sound Card

The heart of an audio-configured computer is the sound card. In the past there were workstations built around the audio technology of the day; today a PC or Mac can handle just about any audio needs. The higher end you go, the more complex and expensive things get and the more power you will need.

Sound cards can be cheap or expensive. The better the card, the better the analog-to-digital (A/D) conversion entering your computer. The sound card is the A/D-D/A converter. Much of the calculating and conversion of audio discussed in Chapter 3 occurs in the sound card. To find out the specifications of your card, go to the web site of the card's manufacturer or join a user group forum and ask.

The novice sound designer does not need a $25,000 sound card, which could easily be a Pro-Tools HD rig. A card with an input and output is all you need when just starting out. Multiple inputs and outputs may be required at a later stage, but for now a simple card is fine. Many cards have a front face as well as a back face, basically for convenience. It is easier to plug into the front of a tower rather than getting on the floor and finding the correct ports on the rear card. The core sound card, however, is the rear card, inserted into the PCI slot on the mother-board. Usually this card has a microphone in, line in, line out, and sometimes a game port. Additions to this card may be multiple inputs and outputs as well as a **MIDI (Musical Instrument Digital Interface) I/O (In/Out)**, an **optical** connector, and an **SPDIF (Sony/Philips Digital Interface)** connector. Many times, the MIDI and optical connectors are located on the front face in the tower if there is one.

Cost-wise, the front face controls usually doubles the price of the sound card. Creative Sound-blaster Audigy sells the rear card alone or the entire package with the front controls. It basically

Color may vary according to manufacturer

Figure | **4-4** |

Typical sound card back face.

Figure | 4-5 |

Sound card front face.

is a matter of convenience. As mentioned above, if you are going to be using MIDI, make sure there is a MIDI in and out on the rear card or front face as well as a game port and MIDI adapters.

Look for the signal-to-noise ratio (SNR) of the card. One of the largest issues with sound cards is the amount of noise they create in your recordings. Some lower end cards have a low hum, due to poor components, which is introduced into the recording. When you read the specifications on the card, it is usually claimed that the SNR is very large, around 128 dB. This is a deceptive number. What is not readily stated is the high and low points measured. Usually this ratio amounts to the loudest sound the card can create and the inherent sound the card makes when the machine is turned off! That is not really an accurate measurement is it? Subjectively, take 15 dB off the top to achieve a reasonable number, or experiment to get results that satisfy you. Furthermore, the tower—the guts of your machine—is like a large RF (radio frequency) attractor. Inside the tower is an enormous amount of RF noise, and sometimes that noise sneaks into your recording. Watch out for the RF "swimming around" your box.

Table 4-3. Commonly used sound cards

- EMU
- Digidesign
- Creative
- M-Audio
- Motu
- RME

Tower

The tower is where all of the components of your computer reside. The main thing to keep in mind when purchasing a tower is whether the power supply built into the tower is strong enough to power your cards and devices. When purchasing a tower, have your list of hardware available so that you can check.

Even though there are custom-designed color schemes and so on for towers, the way the tower looks is not important. Make sure the tower is large enough to accommodate all of the extra cards and front drives that will be required. The size of the motherboard must be considered as well.

Software

There are hundreds of software packages that you can use to create audio assets. The industry is moving forward in making audio packages integrated with video packages. For both economic and strategic reasons, there are fewer and fewer audio applications solely devoted to audio, and the merger of video and audio is happening very quickly. Most of the applications now allow you to do just about everything in a video application as you can in a dedicated audio application. Some of the big name audio applications are Digidesign ProTools, Steinberg Nuendo, Sony Sound Forge, and Apple's Logic.

Below are some of the more common aspects of sound software packages used in the field of sound design and music composition. The essential features that are required to successfully create and implement audio assets should be located in one or two applications on your rig. Usually there is no need for five programs that all perform similar functions. Find out which one is best for you and stick with it. There are many other add-ons and plug-ins that can be applied to these, but these are circumstantial and many times costly.

Recording, editing, and adding effects and processes to audio files are the most common tasks you will do with an audio software application. Each one is relatively easy to understand but, as with any creative enterprise, the trick is in knowing where and when to use them and how to apply them.

Recording Audio

Recording with digital sound applications is a relatively easy process, given there is a signal registering in the peak level meters in the recording window. Many times the recording process is not an issue with the software but rather with the operating system. Usually there are separate audio applications built into the OS that need to be adjusted to accommodate the type of connection. In the Windows OS, the audio interface contains different options to play back and record.

Other times, if you have more than one sound card attached, you will need to make sure the correct one is selected for playback and recording.

Today, every software editing application has the capability of recording audio from one source or another. This involves getting a microphone signal into the back of your computer. From this stage, there must be a **line level** achieved from the software. If there is a signal registering, you could start recording but the results may vary. There are a few other aspects of the recording that must be addressed before successful results can be obtained.

Figure 4-6

Windows Audio Playback Interface.

Figure 4-7

Windows Audio Recording Interface.

Microphone to Computer

Most sound cards have a mic in and line in port. Practically speaking, all you need to do is plug a microphone into the 1/8-inch jack on the sound card and there should be a signal. The problem is that other sounds creep into the recording. As mentioned previously, radio frequencies exist inside the computer tower and cable length plays a role in noise being introduced into a recording. If a microphone is simply stuck into the mic in port of the sound card, the odds are that the sound quality of the recording is going to be terrible. Try it and hear the results for yourself. The reason so much noise is introduced into the file is because the line level of a typical dynamic microphone is very low. That low signal, in combination with the noise in the box, creates a very poor recording. A better solution would be to boost the level with a pre-amp and send the signal into the line in port of the sound card. The SNR should be as high as can be. The higher the SNR, the better the recording quality.

Figure | 4-8 |

DC Offset on a recorded file.

DC Offset

DC offset occurs when a signal coming into the sound card from an input device does not line up properly on the zero baseline. This is due to an electrical mismatch between the input device and the sound card. It occurs more often than you think, so keep your eyes open for it. It can also occur when bouncing a recording, such as one made on a DAT tape, down to your hard drive. The input device in this case is the DAT machine. The effect of DC offset will not really be apparent until a process or effect is applied to the file itself. At that point, audio artifacts and anomalies are clearly audible.

Software Recording Interface

Once you have achieved a proper level, it is time to record. The software recorder has all of the same features that an analog recorder has but the layout is usually slightly different.

Key areas to look for are the control panel, which contains all of the buttons for the recording and playback of audio, and the level meters. The level of the recording should generally bounce around −6 dB to −3 dB depending on the number of channels that will make up the whole when put into a multitrack editor. The more tracks, the higher chance of **clipping** in the overall mix. If there is going to be a single voice, for example, get the signal as hot as possible.

Figure | 4-9 |

Recording window of Sound Forge.

Clipping occurs when a signal entering the system is more powerful than the system can handle. The result is a poor recording. Most software recorders have a clipping signal indicated when a powerful sound is registered. This relates to the overall dynamic range dictated by the bit depth. When there is not enough data to encode intense sounds, the top of the file is clipped off, unlike distortion in analog systems where the distortion is heard.

Editing Audio Files

The editing techniques in digital audio are the staple of good sound designing. Cutting, removing, cleaning, and processing are all part of the editing process. Editing

Figure **4-10**

Figure **4-11**

Play meters indicating −6-dB
to −3-dB input signal.

Clipping in a software editor.

audio allows you, the sound designer, to create loops, segments, and anything else that can be created with audio files. Some of the more common techniques can be easily learned with some practice. The more time you spend editing and refining sound files, the better and faster your results will be.

Editors

A stereo editor is an application that facilitates the digital recording and editing, as well as digital signal processing of sound or music. It records either from an incoming signal or it samples audio from an audio CD, otherwise known as ripping audio, like a sound effects CD, whose sounds need to be worked on for a particular sequence. The incoming signal may be from a single microphone or from a console that is mixing an entire session. Either way, the user decides whether to record the audio as a mono track or a stereo two-track file. A stereo editor can only edit. You may mix multiple stereo files on top of one another, but you will not be able to edit or manipulate any of the specific tracks that have been mixed together. Usually this is done for experimental reasons due to the confined ability to mix each track separately. Many times students will ask how they can get more tracks available. The answer is always "You cannot use more than two tracks with a stereo editor." Multitracks are possible with a multitrack editor. A stereo editor is a stereo editor. It handles up to two tracks at a time. That is all. The power of a stereo editor should not be underestimated, however; in fact, much of the sound design groundwork is done with a stereo editor. Once the files

Figure | 4-12 |

A mono recording in Sound Forge.

are prepared, they are sent to the multitrack editor for synchronization or to be incorporated into a larger sound landscape.

There are general principles and procedures that pertain to all stereo editors, no matter what operating system is being used. They can all edit and manipulate audio files. The ease with which this is accomplished is up to the individual sound application. The examples presented in the next section all come from a very popular stereo editor that has many different assets besides the basic editing suite. Sound Forge is one of the best stereo editors around. Many professional studios have this application installed as part of their rig. Although ProTools is also part of every studio's digital configuration, and is the industry standard for digital audio, Sound Forge is priced reasonably for a beginner in the sound industry.

Viewing Audio Files

The first thing to understand when working with sound applications is how to "decode" the visual information. Sound, after all, is not a visual art but many, many hours are spent in front of the computer working with the visualization of audio files. What does all that visual audio mean? A clue to the answer is given by understanding what exactly is being visualized.

Mono or Stereo

There are two types of files available in a stereo editor: a mono file and a stereo file. A mono recording is a single file, whether originally stereo or not. The mono file shows up in your editor as a single graphical representation of the audio.

The mono file is used primarily for voice recording and for preparation for broadcasting or Internet distribution. The sampling rate and bit depth play an important part, but keep in mind the size of a mono file is half the size of stereo files because it is only a single track.

| NOTE |

The definition of stereo is a sound that contains data for more than one speaker simultaneously. The word *stereo* comes from the Greek meaning "solid," usually referred to as depth, breadth, and height.

Stereo files, on the other hand, consist of two tracks. These tracks are generally either two paired mono files, which are stereo files but not the kind we are used to listening to, or two interleaved stereo files, which contain information needed to reproduce a stereo balanced sound.

Stereo files are used for most projects, unless it is a spoken voice recording, which would be mono, but the size of these files must be considered. As always, make the highest quality recording you can make and downgrade it when you need to. Never record an original file at a low

Figure 4-13

Two mono files as a stereo file.

Figure 4-14

A stereo file.

bit resolution and poor sampling rate because once that recording is made, there is no up-grading it.

As with all files, before making any edits, make sure there is a backup of the original and start a series of iterations. Save any files separately if a separate version is made after a serious change or process has been applied.

What Are You Looking At?

A typical sound software package will contain features that are common to just about all of them. The visualization of audio and how to work with this visualization is all part of being a sound designer.

When you record audio, the sound is translated into a graphic visualization of amplitude and time. The interface that contains the file allows processes, effects, and other analytical procedures to occur. Notice all of the menus and their names.

In order to examine the frequency of a file, a tool called a spectrum analyzer is used. This tool is particularly useful when trying to determine the frequency average of a sound effect or other sound file. The usefulness of this will become clearly apparent in Chapter 6, Intervallic Relations in Music and Sound Design where the importance of evaluating the frequency of a sound is crucial. But to give you a quick

Figure 4-15

A sound file opened in Sound Forge.

glimpse, the matching of certain interval proportions of frequencies will have a certain impact on the visual media and how a viewer interprets the content derived from this visual. In other words, sounds that are separated by predetermined proportions and played together or consequentially will render a certain emotional significance.

Along with the file itself, there are other aspects of the graphical user interface. The control panel, curser line, and duration of the file indicator exists on every editor. There are usually many short-cuts that will increase workflow for the user.

Figure | 4-16 |

A spectrum analyzer indicating the frequency range and average of a given file.

Figure | 4-17 |

The curser, control panel, and file duration indicator.

Filling the Screen with Audio

When there is a lot of detail in the audio file or a particular spot on it which has a tiny artifact, it helps to have a zoom option. In fact, a lot of the time you will be moving in and out of an image in order to edit or process it in some way. Most, if not all editing applications, have some kind of zoom in/zoom out function. In terms of workflow, a keyboard mouse shortcut configuration usually works best.

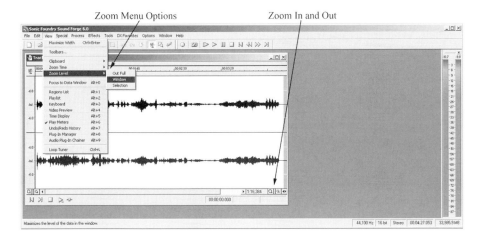

Figure **4-18**

Magnifier tools in Sound Forge.

Figure **4-19**

Do not clip.

Play Meters, Watch Them Closely

The play meters are the bouncing bars indicating the overall output of your sound file. This is where you watch for clipping and dangerously high levels. Watching the play meters becomes somewhat of an obsession. Every time a process or effect is applied to a file, the character of the file changes. Reverb added to a file has the tendency to increase the amplitude of the file, thus creating the possibility of clipping. The play meter is set up with zero at the clipping point. The dBfs below zero is considered within the acceptable dynamic range. If the meter is pushed above the zero threshold, clipping occurs. Clipping is *never* acceptable in an audio file. Avoid clipping at all costs. Get as close to zero as you like, but do not clip—ever!

Essential Sound Editing Skills

As with anything, there are certain techniques you need to learn in order to get positive, professional results.

Figure **4-20**

Loosely selecting a region.

Figure **4-21**

A region of audio within markers.

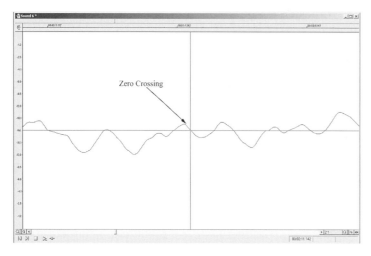

Figure **4-22**

The zero crossing point of a mono file.

Inserting and Removing Pieces of Audio

Two main editing tasks are essential to producing high-quality audio: cutting out audio and inserting audio.

The removal of audio occurs when the region in a selection is to be removed from the file. This can be done spontaneously or it can take place more precisely. The quick way of cutting a piece of audio out of a file is to click-drag a region in the edit window and hit the delete key on the keyboard. This is not a very effective way of editing if there are exact points to be considered.

The other way is to create specific markers in the file and highlight the region within the **markers** to delete, then hit the delete key.

Many applications allow you to adjust the marker to the **zero crossing** of an audio file. This is the point in a file where the sound waveform crosses the zero amplitude line. At these points, edits are particularly effective because actual data are not being interrupted, possibly creating pops and clicks in the playback.

This method of editing is very effective with mono files, but stereo files need to be considered as well. In an interleaved stereo file (two tracks), the zero crossing of an area on the right side might not coincide with the zero crossing on the left and vice versa. Experiment with this. Many times a good edit point can be achieved when only a single side of the stereo track has the marker over the zero crossing. Listen to hear if this results in aural artifacts.

Other times the placement of the marker itself can be adjusted slightly to achieve zero crossing in both sides of the stereo file. The result should make little difference in the edit as long as the window was magnified many times when adjusting the

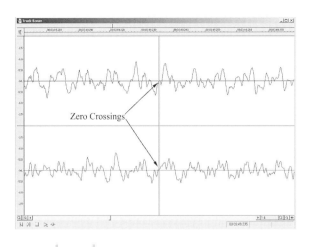

Figure | 4-23 |

Stereo zero crossing point on one side of the track.

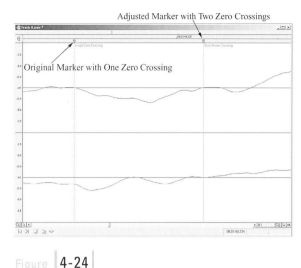

Figure | 4-24 |

A marker at two zero points of a stereo file.

marker. Your ear is extremely sensitive, but tiny movements at a high magnification will not be readily discerned.

Destructive and Nondestructive Editing

There are two basic types of altering a file when editing or otherwise processing. Usually when you open an audio file, a copy of that file is made to protect the original file. This allows mistakes or poor judgment to be corrected without any loss to the original file. This is called **nondestructive editing**. When a file is directly worked on and the mistakes and errors are made, the only way to recover back to the point before the mistake is to "undo." If the undo buffer runs out, there is no way to save your file beyond that point. This could be disastrous if your original was not backed up in a safe place. This type of editing is called **destructive editing**.

Always make backups of the original audio files, even when you are sure about the type of editing you are using.

Many professional level editors have the option of either working on a file destructively or nondestructively, but cheaper, nonprofessional packages (you will know them when you see them, there are usually many colors on the box cover), for the most part, destructively edit the audio files. Find the undo buffer and set it at 1000 if possible.

Effects

Digital effects are the sound designer's saviors. Before digital effects were around, all of the effects on a track were achieved through analog means. The raw sound was sent through a series of analog effects boxes and then back to tape. This process was time consuming considering the limitations of real-time recording. Adjustments to the analog effects were limited in real-time.

Today the digital effects can create the same effects on a file that the original analog devices did. Depending on who you talk to, one always sounds better than the other. Ask around for other people's opinions.

A good rule of thumb regarding the application of effects is this: Less is better than more. A sound file does not need to be bombarded with effects to sound better. When you think you have a sweet-sounding file, reduce the effects even more and that will probably be where you want it.

Below are some common effects that are located in audio editing applications.

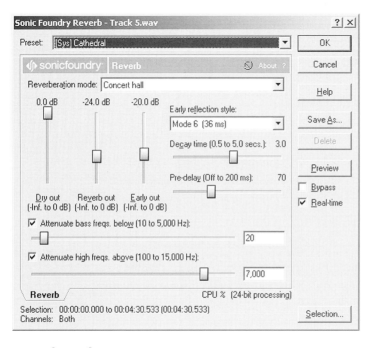

Figure **4-25**

The reverb window in Sound Forge.

Reverb

Reverb in the digital world acts the same as its analog counterpart. See the analog definition of reverb in Chapter 2 for a refresher. The use of reverb on a file can create an atmosphere that would otherwise not be there, or it can save a close-mic-ing situation where a little reverb is needed.

Many times presets can be used to quickly achieve a specific sound setting, such as a concert hall, garage, or bathroom.

Echo

A simple echo effect can create a sense of great size and depth. Use it only when it is useful for the sound design's intention. Overuse of this effect becomes redundant and boring.

Pitch Shift/Pitch Bend

Pitch shift is used when the sound needs to be at a higher or lower frequency. Pitch shifting does not change the duration of the sound sample. This may interpret into a signal that is cut off or has a piece of silence at the end depending on whether the sound was decreased or increased in frequency, respectively. Most professional sound editing applications offer the ability to cancel this option and allow the expansion and compression of a file duration.

The pitch shift is usually gauged in semitones, based on the equal temperament of traditional Western music. Sometimes **cents** are also given as an option to change the pitch of the frequency. Cents are small microtonal adjustments made in order to tune a sound up or down to a particular frequency.

Noise Gate

The noise gate effect has been in use for a very long time. Basically the noise gate removes all audio content below a given threshold. It is used to wipe out unwanted noises, tape hiss, and low-level hum, which is usually present in less than fantastic studios.

Compressor

A compressor can bring your audio material up to specification with professional recordings. You can add compression to one of three areas: the recording chain, the tracking or tweaking chain, or the mix-down chain. A compressor is used to even out an audio file. It shrinks the dynamic range of a piece of music. The quietist and loudest parts will become closer to each other dynamically. What does that mean? Many audio files, especially those of classical music, contain both quiet and loud sections of music or sound. The compressor pulls up the low-volume material and compresses the loud volume material so that all of the audio is closer to the same dynamic level. A lot of what is on the radio, as far as music is concerned, is compressed. Compression is used often in professional recordings. Both software and hardware compressors are available. Software compressors are used for post-recordings and hardware compressors are used before the sound is recorded, affecting the actual sound that is recorded. The hardware compressor allows recording levels to be controlled without destroying a good take in the studio. Without one, you may ruin a take.

Chorus

The chorus effect simply adds the illusion that there are many voices or sounds when there is only one. Chorus creates many voices from a single voice.

Flange/Wah-wah

The flange and wah-wah effects create a kind of sweeping or full sound. Many times, electric guitars are heard with some kind of flanger or wah-wah. This effect can find its way into your sound design work but it does not have too many uses with practical work. There are some interesting effects, however, that can be created, particularly for sound sculptures.

Processes

Processes are other forms of effects. They also give the sound designer the capability to alter and enhance sound objects. Some essential processes used to produce a high-quality audio experience are presented below.

Equalization (Graphic and Parametric, Paragraphic)

Equalization is basically creating a filter for the audio. The desired strengths and weaknesses of the frequency spectrum are controlled with the EQ. There are many presets that describe various types of general EQ settings, but most of the time these will be tweaked and altered.

There are three types of equalizers used in most audio editing applications: graphic, para-graphic, and parametric.

The graphic EQ is the general equalizer. It allows the user to define, through an envelope graph, the settings that are appropriate for the audio file. Presets are usually provided to start the EQ process. Or if measurements or specific effects are desired, these presets can quickly configure the EQ settings.

The paragraphic EQ is used to specify a select group of frequencies, depending on the para-graphic EQ used, for attenuation, or for boosting. The same principles can be achieved with graphic EQ but workflow is increased if this type of specificity is needed.

This type of EQ is usually visualized as a graph with the gain on the y-axis and the frequency spectrum on the x-axis, making it easier to get an overall picture that the EQ will have on the final sound.

A very good use of the paragraphic equalizer is its ability to quickly notch out certain fre-quencies. A 60-Hz notch is commonly used to cut out the 60-Hz hum that is introduced from an ungrounded wire.

The parametric equalizer is the most specific of the three mentioned. It allows very discrete changes to be made to a sound file. Usually there is a set of filters that accommodates this: low-frequency shelf filter, high-frequency shelf filter, band-pass filter, and a notch filter. These al-low the attenuation of frequencies below and above a specific frequency, and the attenuation and boosting of frequencies outside and inside a specified frequency, respectively.

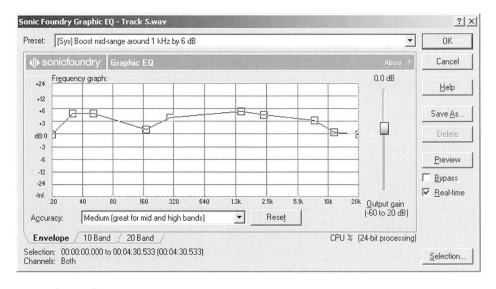

Figure 4-26

The user interface for a typical graphic equalizer.

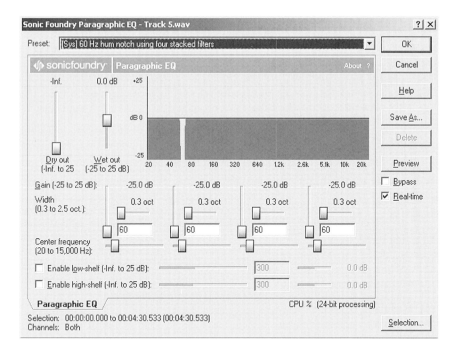

Figure 4-27

A paragraphic EQ with four discrete options for frequency control.

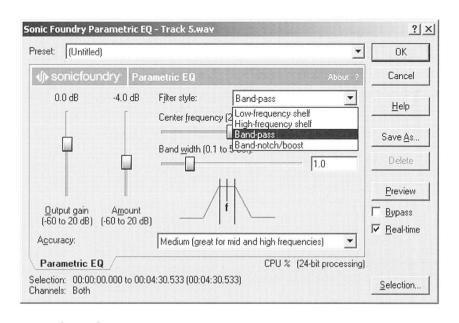

Figure 4-28

A parametric EQ with filters in dropdown menu.

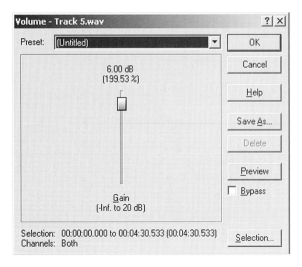

Figure **4-29**

Volume control adjuster.

Volume Control

The volume control allows the volume of the file to be reduced entirely or in part by selecting a region and applying the effect.

Reverse/Invert

Reversing a file does just that. The audio file is reversed. This effect has many uses. Mixing fragments of reversed audio on top of other files has a particular effect. Experiment, experiment, experiment!

Inverting a sound does nothing to the actual playback of the signal except reverse the polarity of the sound wave.

Normalizing

Normalizing a file is like adjusting the volume of it. It takes the highest peak and pulls it up to the level set by the user. This level is gauged in dB.

Normalizing a file is not the same as compressing a file. Whereas a compressed file decreases the overall dynamic range, yet filling it, normalizing simply increases the file proportionately up, stopping at the highest peak defined.

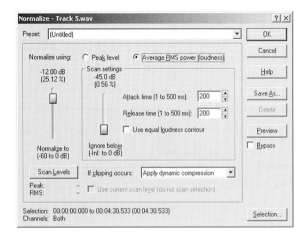

Figure **4-30**

Normalizing dB scale.

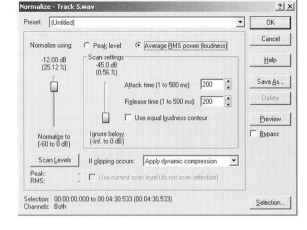

Figure **4-31**

Time stretching a sound.

Time Stretch

Time stretch is the process whereby the length of a sound file can be increased. Different types of sound applications have different parameters, but usually there are three ways of increasing a sound file's length: by time, by tempo, and by percentage.

Inserting Silence

Inserting silence is actually a valuable technique. This process of inserting silence into a file has the effect of extending it naturally. This device can be useful when creating a narration track. When voice needs to synchronize with a video track, the silence that is inserted can strategically be placed. Another good use of inserting silence is to add reverb to a file that was edited down to a length that is too short. By adding the silence at the end of the file, you can then accommodate the reverb space needed for a convincing sound.

Multitrack Editors

The multitrack editor is really a collection point of the assets that were created in the stereo editor. Sound can be edited individually in some multitrack editors and some cannot. On the whole, it is a good idea to have most of the work on individual sounds done on the stereo editor. This is not the only option, especially with multipurpose editors, but it is a good habit.

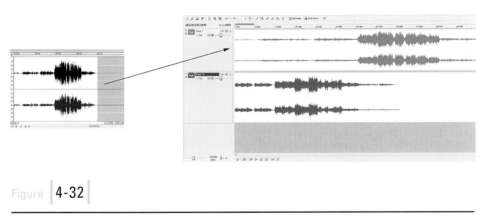

Figure | 4-32 |

A single file inserted into a multitrack editor.

The main advantage of the multitrack editor is the possibility of mixing multiple tracks and master them to a renderable file. The techniques applied in a multitrack editor can be applied globally as well as individually. This helps to acoustically place a multitrack session into a consistent context.

Rendering Multitrack Sessions

As in graphics, the term rendering is used to composite all of the audio assets in a multitrack session together. Most of the time you will be rendering out to a PCM audio format, but others

are available. One important point should be mentioned. If a multitrack session has been rendered and you hear something you want to fix, whether that is in the mix or otherwise, you will need to go back to your original multitrack session and repair it there and then render again. As you gain more and more practice, this will occur less and less often.

Many multitrack editors export to different types of output files. MP3 is a popular format to export to because of its slimmed down size (particularly good for web broadcasting) and good sound quality. Usually the file size of an MP3 file is about one-tenth the size of the same file rendered to CD-quality audio. Play around with different export types. There are many to choose from, but be careful of matching these with playback software. Not every audio player can decipher every kind of file format.

Music Notation Software

Composers today rarely write out entire scores of music. They more often use an application that helps to make the scores neat as well as save time copying parts for the orchestra to play. There are two major players on the market: Sibelius and Finale.

Figure **4-33**

Sibelius score with time code above each measure.

Sibelius

One of the best music notation software packages for composers is Sibelius, produced by the Sibelius Group. It handles many of the demands of today's composers and film composers. One feature built into Sibelius codes the measures for film scoring purposes, which coincidentally works fantastically for game composers as well.

Just about any of the current compositional techniques, barring graphic notation, are possible to be represented. One of the more interesting things, related directly to sound designers, is the MIDI capability for playback. There are various sound patches available to create full score replicas. Some of the more popular ones are the Garritan Orchestral Libraries and Vienna Symphonic Library. These can enhance your playback through MIDI incredibly. A score can be created to produce a large variety of sounds when played back. Overall, this is a great tool to have if the next step in sound design is desired, which is an understanding of the principles of music and music theory.

Finale

Finale has been around for a much longer time and it is also commonly used in the field. In my experience, Sibelius is the dominant package used today but that does not mean that Finale has nothing to offer. On the contrary, Finale can do just about everything and even a few more particular things than Sibelius can. The difference seems to be in the interface and work flow methods. Truly, it is up to each individual user. Try them both and if this is something needed in your arsenal of gear and software then by all means use them.

Although this type of software is for arrangers and composers, sound designers can learn a great deal about audio objects as organic entities and music construction, which is one of the advantages that could be gained above other sound designers. Ultimately, a fair amount of music theory knowledge and some practice compositions will go a long way for sound designers.

The Rig

The placement of monitors is very important. Once you have all of the gear you need to get started, it is time to set it up. Make all of the connections you need to, test for sound quality and balance, and then concern yourself with the setup.

Monitors

The near-field monitors, which is all that is needed for now, should be level with your head position. Because most of monitoring of the audio playback will be done while sitting, the monitors should be about the height of your head position while sitting in that nice chair you have to work in. Ideally the setup should form an equilateral triangle with you as one of the points. This results in a speaker being placed ±30° from the centerline created by the sitting position and the computer monitor.

These calculations are based on one of the standards created by the International Telecommunications Union (ITU) in their recommendation 775. Although the standard is for 5.1-channel sound systems, the triangular two-channel stereo setup works with these figures as well.

Figure | 4-34

Triangular two-monitor setup.

Figure **4-35**

5.1 The monitors of a 5.1 surround system.

If the speakers are separated by a distance much larger than ±30° from the centerline, an audio "hole" starts to appear from the sitting position. The stereo image will be degraded and will sound like it is coming from two locations, which defeats the purpose of a stereo image. Test the setup so that the stereo sound appears to be coming from your computer monitor directly in front of you.

All of the rest of the gear should be within arm's reach, unless you want to get up every time to adjust a fader or other control.

5.1 Surround

A 5.1 surround sound monitoring rig is a different animal. There are six individual speaker components: five loudspeakers with similar spectral balance, frequency range, and power capabilities for the front, center, and surround channels and one sub-woofer for the low-frequency content. The number 5 represents the main loudspeakers and the .1 represents the sub-woofer, thus 5.1.

The location of all of the speakers has been recommended by the ITU. The same configuration for the front left and right loudspeaker as the stereo setup is used, the center is at 0° from the listener position and the two left and right surround speakers are approximately 110° from the centerline of the listener.

Setting up a surround system according to specification may be a little tricky. Consult the Internet or see the references in this text for more details on 5.1 surround setups.

SUMMARY

This chapter discusses the hardware and software devices you will need as a sound designer to begin work. There are many variations of what has been presented and many other sources of information regarding these data. You should get as much information as possible to achieve the configuration you want.

in review

1. What is the typical stereo monitor configuration for an audio computer workstation?

2. What is the difference between destructive and nondestructive editing?

3. What is the difference between studio monitors and commercial speakers?

4. What does the chorus effect do to a sound?

5. What are the advantages and disadvantages of working in a multitrack environment compared to a stereo environment?

exercises

1. Record four random sounds and process them together to sound completely unrelated to the original sounds. No evidence of any of the four sounds should be apparent in the final render.

2. Volume-adjust, normalize, and compress a sound and determine what the differences are both visually and, more importantly, aurally.

3. Record sound directly into the sound card. Achieve results that are acceptable and contain no aural artifacts.

notes

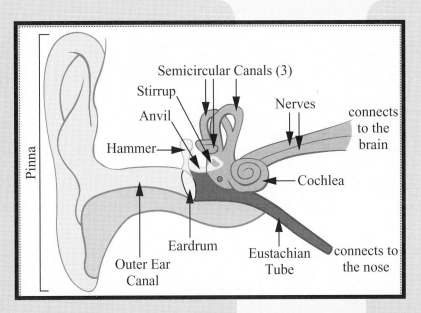

Semicircular Canals (3)

Stirrup

Anvil

Hammer

Nerves

connects to the brain

Pinna

Cochlea

Eardrum

Eustachian Tube

connects to the nose

Outer Ear Canal

SECTION

| theoretical knowledge |

A Crescendo from mp to mf and a Decrescendo back to mp

music theory for sound designers

objectives

Fundamental music theory for sound designers

introduction

The objectives of this chapter are to supply the fundamental musical material needed to successfully and competently create sound for a visual accompaniment. The theories apply to both linear and nonlinear audio situations and will help the learner integrate sound with music cues as well as support them.

WHY MUSIC THEORY?

Music theory is essential to understanding the effects of sound and music on linear and non-linear visual content. A familiarity with music theory is not absolutely necessary to becoming a good sound designer but it will certainly make the sound design collaborate more effectively with a music track and form an entity of its own. Understanding how music theory influences sound design decision will also add value to your overall output. Obtaining some of the basic constructs of musical theory and applying them to sound design yields a depth of design integrity with enormous potential for invention and creativity.

There are many different ways of creating sound effects, or sound assets, for visual media whether linear or nonlinear. The easiest way is to grab a sound effect, lay it against a visual track, and pray that it is effective. This is not very productive or creative, but it is quick. This brings up a very important point. Nothing in sound or music can be accomplished with lightning speed without sacrifices. There are extreme deadlines and pressures, but the great sound designer is the one who devotes many, many hours to the craft. The more you put into it, no matter whether you think the audience will hear it or not, the more solid and convincing the sound design will be. And if you think the audience does not know good sound design from bad, you are wrong. The audience may not acknowledge the fact that the sound was good or poor, but their overall experience of the visual media, which the sound supports, will be degraded, and that will be acknowledged. Put as much time into it as you can and then give a little more. The bottom line is the addiction and passion for sound and music. Music is an integral part of the aural experience and although music for visual media or film scoring is not covered by this book, the terms and thought processes involved with composing music for the visual media are invaluable to understand for the sound designer. Maybe a small foray into composing music is not such a scary idea, and it would add to your value as a sound designer.

Start Listening

If your ears are not sharp at this point that is okay. There are many ways to condition your ears. One of the great ways of giving your ears a good workout is to listen to classical music. Contrary to popular opinion, classical music was not composed with the intention that it be listened to as a sleep aid. There are many types and styles of music, so why narrow down all of that music to classical music? Well, classical music is not as narrow as might be expected. It covers a broad canvas of styles and genres. There are some absolutely incredible compositions that could have a profound influence on not only the sound design process but also on all of the creative processes. I am not necessarily talking about Mozart or Beethoven, although they provided many supreme examples of some of the greatest music ever written. I am talking more about the compositions of the mid 19th and 20th centuries, which contain an amount of imagery that is absent in the music of the classical era. Even though Beethoven did compose some image-based music in, for example, the storm in the fourth movement of the Sixth Symphony, generally speaking the idea of musical imagery did not take hold until the mid to

late 19th century, even if it was not intended to be image-based **impressionism**. Even though opera is image based, the music itself is not an attempt to create those images, it has the story, singers, actors, and set design for that purpose. The impressionistic composers of the late 19th and early 20th centuries hit the nail on the head with musical imagery. Debussy, Ravel, Fauré, Delibes, and many more accomplished this with absolute command. Compositions like "La Mer" by Debussy and "Daphnis and Chloe" by Ravel are exquisite examples of music that evokes images and emotions.

The details in classical music are what make it that much more appealing. Each listening will reveal more and more layers of content. This concept should be considered when thinking about the sound design of a project. After all, sound design is constructed on both the micro and macro levels. The details depend on how well constructed you want your sound design to be. Generally, there is an architecture underlying the concept of sound design.

Music Theory by Design

The fundamentals of music are not difficult to understand; on the contrary, they are quite easy to grasp if a few mysteries are cleared up at the start. Music is an art form that cannot be touched, smelled, visualized, or tasted. This abstraction makes it the most mysterious and magical of all the arts. Messages conveyed through sound and music must always be subjected and based on the listener's point of view. Sound objects, including music as an object, can have symbolic connotations. The **semiotics** of music, which is outside the scope of this book, is an area of aesthetics that covers the theory and philosophy of sound as sign and symbol. Understanding some of the philosophy behind the semiotics of music will directly affect sound design production.

In order to become a well-rounded sound designer, many areas of the art form need to be covered. The odds are that all of the information in this chapter will not be consumed in a day or even a year. Learning is an organic process that relies on practice, experimentation, motivation, and passion for the subject. Studying the fundamentals of music theory is the first step to gaining another level of depth as a sound designer. Pay attention!

Structure of Music Theory

In the beginning, there was rhythm—that's right, rhythm. The howls and grunts of our ancestry were accompanied by beating bones or sticks against surfaces such as a log or a skull. The human heart has been pounding out a steady, or not so steady, beat since the dawn of mankind. The heart in your chest has been keeping the tempo of your life and will continue to do so until the end. It is a valuable piece of percussion, musically speaking, that has a subtle influence on your sound creation.

The theoretical musical practice most widely used in the West is loosely called traditional music theory, that is, music theory based on the principles and practice of Western music.

Think of the renaissance, baroque, classical, romantic, and impressionistic styles all the way up to our modern day compositions and film scores. If you are unfamiliar with those styles, do not worry, just add learning them to your list of things to do.

Music theory begins with the tools needed to understand the written language of music, namely, rhythm and pitches, or notes.

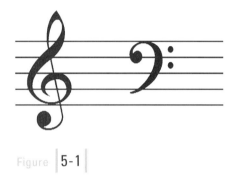

Figure 5-1

A treble and bass clef.

Fundamentals of Music

Clefs and Staves

Music, very basically, is divided into three general areas of sound: high, middle, and low. These areas are equivalent to the frequency spectrum discussed earlier. High register music contains high frequencies and low register music contains low frequencies with everything in between. Music is written using two fundamental identifiers to indicate mid to high range music and mid to low range music. These identifiers are called clefs.

The treble clef represents the upper part, from the middle, of the note spectrum and the bass clef represents the lower part.

There are other types of clefs but they do not need to be known for now.

The clefs sit on a series of lines called a stave. The stave is where the notes are held and read.

There are five lines in each of the bass and treble clef staves. This remains constant; the number of lines never changes.

Figure 5-2

A stave with a treble and bass clef.

Pitches in the Treble and Bass Clef

Each of the lines and the spaces between the lines contains the notes of musical language. The clef in front of the stave indicates how the notes are configured on the lines. The notes themselves can be thought of as isolated sound objects. Each note has an equivalent frequency based on the accepted tuning system of Western music called **equal temperament**.

The treble clef is also called the G clef because the circular middle part wraps around the G line of the stave. The note that sits on the second line up from the bottom is called G.

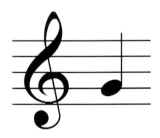

The G line

Figure 5-3

G clef with the note G on the stave.

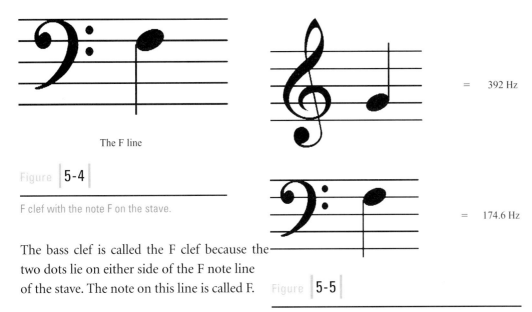

The F line

Figure **5-4**

F clef with the note F on the stave.

= 392 Hz

= 174.6 Hz

The bass clef is called the F clef because the two dots lie on either side of the F note line of the stave. The note on this line is called F.

Figure **5-5**

The notes G and F with their frequency equivalents.

Each of these notes has a specific frequency. The G note in the treble clef has a periodic frequency of approximately 392.0 Hz and the F in bass clef has a frequency of approximately 174.6 Hz. Notice the G has a higher frequency than the F; remember that the two clefs represent different registers in the musical spectrum: one in the mid to high range and one in the mid to low range.

The notes used in Western harmony span the letters A through G and then repeat. All of the letters that need to be known in music are A, B, C, D, E, F, and G. That is it! If we map those letters onto the staves, we get the following:

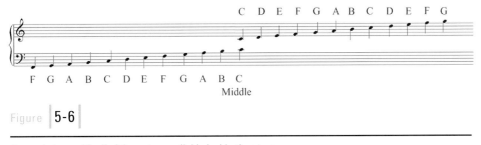

C D E F G A B C D E F G

F G A B C D E F G A B C
Middle

Figure **5-6**

A grand stave with all of the notes available inside the stave.

As can be seen, the F note under the bottom line, or better described as in the space below the bottom line, in the bass clef, repeats on the second line down from the top of the bass clef and repeats again in the first space and top line in the treble clef. These F's are the same note but they are divided by the interval of space called an **octave**. From one F to the next F is an octave. Now move up to the bottom line in the bass clef. The note is G and it repeats similarly up three more octaves.

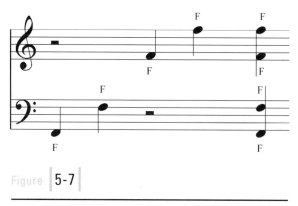

Figure 5-7

Three octaves above the low F in bass clef.

The distance between one note and the octave above it is exactly twice the frequency of the lower note.

There is one note that has not been mentioned yet: middle C. Middle C floats between the treble and bass clef. Theoretically, there is an invisible line between the two staves.

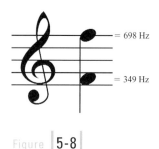

Figure 5-8

Doubling the frequency of the lowest note frequency yields the octave.

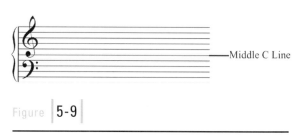

Figure 5-9

The treble and bass clef staves including the invisible middle C line.

As can be seen, with the line located there, it would be very hard to read the music. The eyes would have to focus much harder to decipher the notes. In fact, the lines continue above and below the two staves, but they are invisible as well. When a note, such as middle C, is needed above or below the stave line, a little **ledger line** is inserted. The middle C below is located one ledger line below the treble clef stave and one ledger line above the bass clef stave.

Both are Middle C

Figure 5-10

Middle C sitting on a ledger line.

This concept can be a little confusing. Just remember that there is only one ledger line below treble and above bass. What happens if there are notes above the clef?

If the notes extend above the treble clef, ledger lines are added until the note is reached. What would an E above the treble clef stave look like?

The same holds true for below the stave in bass.

What note lies on the third ledger line below the treble stave?

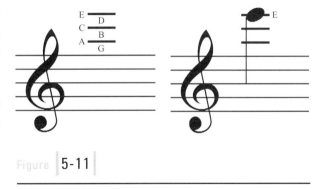

Figure **5-11**

Ledger lines above the treble clef with the note E inserted.

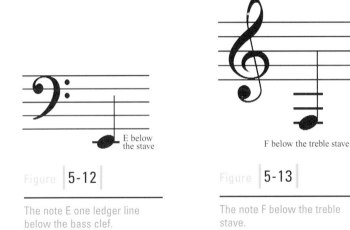

Figure **5-12**

The note E one ledger line below the bass clef.

Figure **5-13**

The note F below the treble stave.

How is this possible if there is only supposed to be one ledger line below the treble stave before running into the bass clef? Well sometimes in music there is a need to indicate pitches in the treble clef that could be equally notated in the bass clef. The F seen above is the same note and frequency as the note indicated in the bass clef below:

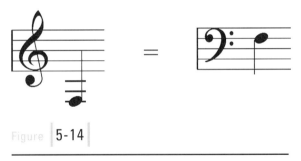

Figure **5-14**

The note F three ledger lines below the treble stave is equal to the same note two lines down from the top of the bass stave.

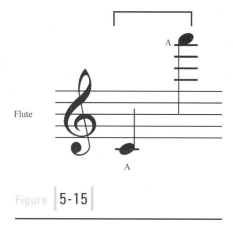

Figure 5-15

General instrumental range of a flute.

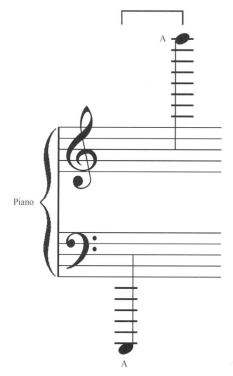

Figure 5-16

The note range of a piano.

Without getting into orchestration and instrumentation, it should be realized that not all instruments need to play all notes above and below the treble and bass staves. In fact, most have narrow ranges and have their notes within that range.

One instrument, however, covers a very large range of notes: the piano.

The piano is usually used for note visualization because the notes are literally under the fingers. An image of a piano or a drawing of a piano is useful for this visualization. Later in the chapter we will look at this in more detail.

Thus far, we have only looked at the white notes on a piano.

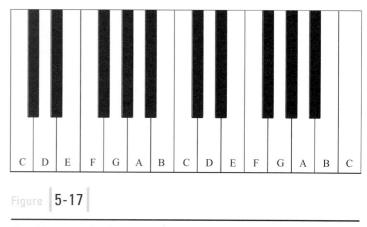

Figure 5-17

The white notes of a piano.

There are black notes as well. These notes are also part of the equal temperament tuning system but are affected by a symbol that indicates whether one of the white notes should be raised, lowered or made natural again. These symbols are called **accidentals**.

A **sharp** raises a note by a half step, a **flat** lowers a note by a half step, and a **natural** sign corrects a previous note affected by an accidental.

Table 5-1. Accidentals

Name	Symbol	Half Step Degree
Sharp	#	Raise 1 half step
Flat	♭	Lower 1 half step
Natural	♮	Naturalize the note to its original form

As can be seen on a piano, if you start on a C, there is a pattern of two black notes followed by a space and then three black notes. This repeats over and over to the top and bottom of a piano.

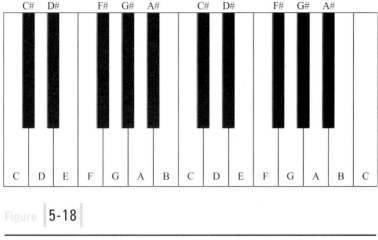

Figure 5-18

Black note patterns and note names on a piano.

Each note is considered a half step away from the next. In other words, all notes are a half step apart. When a white note is raised a half step by an accidental, the note indicated with the accidental should be played at that location.

The note A in the treble clef looks like the image below:

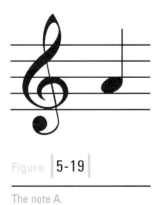

Figure 5-19

The note A.

If we want to play the note above A, which is a half step above A, we need to apply an accidental. The sharp raises the note, so a sharp needs to precede the note on the stave. All accidentals precede the note they are affecting.

This leads to our first scale. A scale is a sequence of notes that follows a certain pattern of intervals. An **interval** is the distance between two notes, such as an octave. The scale is called a chromatic scale. It encompasses every note of the 12 notes within an octave. Once these notes have been played, the pattern repeats.

Figure 5-20

The A was raised with a sharp symbol. Now it is A-sharp.

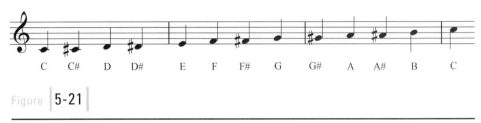

Figure **5-21**

The chromatic scale from middle C.

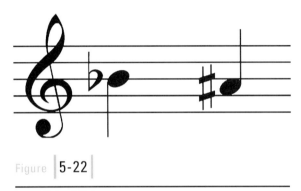

Figure **5-22**

B-flat is enharmonically spelled as A-sharp.

This scale has notes that are spelled differently but sound the same. These types of notes are called **enharmonic**. Once again, enharmonic notes sound the same but are spelled differently.

A B-flat sounds the same as an A-sharp.

The reason for the alteration of spelling has to do with the **harmony** that the notes are wrapped in. Harmony is the sonic foundation that the melody sits on.

An octave contains 12 notes, as shown above. These notes are equally spaced. One note is proportionately distanced between the previous and the next note. This was not always the case. The tuning system we use today is called the equal tempered tuning system. Each note is equal in distance from another and no single note has any prominence over another, theoretically.

These tuning principles form the foundation of music theory in Western cultures.

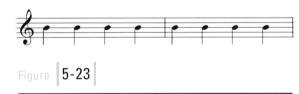

Figure **5-23**

Two measures of rhythm both containing four beats.

Beats, Meter, Measures, and Pitch Durations

The **rhythm** of sound and music is a moderately complex subject and volumes have been written on the subject. Sound designers need to have a very basic understanding of rhythm in order to time and work with a music track or as a stand-alone event.

When you tap your foot to a piece of music, you are considered to be "keeping a beat." What does that mean? A beat is a pulse of sound occurring at regularly spaced intervals of time. Most of the popular music of our time is strictly beat related. Most people have an innate ability to dance and keep time in one way or another. In reality, many people are musicians and do not realize it.

In music, a **beat** is the metric by which tempo and meter are kept. A beat in music is a pulse. The pulse may be strong or weak depending on where it lies in the **measure**. A measure can be thought of as a container of beats.

The beats above are counted from one to four. The measure line stops the counting. The second measure also has four beats and is also counted from one to four. These measures each contain four beats.

You may have noticed that there are **stems** coming down from the note heads. These stems define how long the note is to be played. Some notes are long and some are short, and some are in between. The speed at which these durations are to be performed is determined by another musical parameter called **tempo**.

Meter is the identifier that determines how many notes there are in a measure and what kind of note gets a single beat.

There are different types of meter, in fact, just about any combination of beats and durations can be made, whether that is performable by humans or not is another question, but you can be sure that the computer can handle many different meters and tempos.

Before decoding meter, rhythm must be discussed.

Rhythm

Rhythm is based on a fractional division of one. One is equal to a whole note. A whole note is made of four beats.

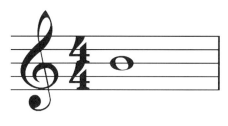

Figure 5-26

A whole note.

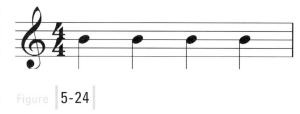

Figure 5-24

A meter of 4-4 representing four beats in a measure and each beat is a quarter note long.

Two Beats, Each One is a Quarter Note

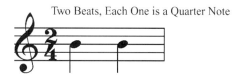

Four Beats, Each One is a Quarter Note

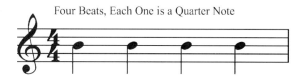

Three Beats, Each One is a Quarter Note

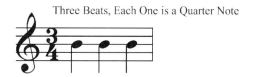

Six Beats, Each One is an Eighth Note

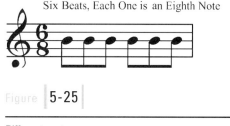

Figure 5-25

Different meters.

The whole note looks something like a small letter "o." A whole note can be divided into two half notes.

A half note contains two beats, or two quarter notes. A quarter note is one fourth of a whole note and one half of a half note. If the quarter note is divided, two eighth notes are produced.

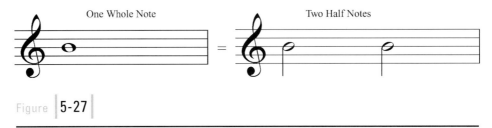

Figure **5-27**

Two half notes is equal to one whole note.

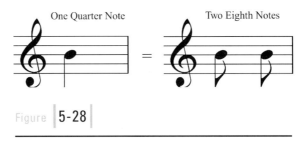

Figure **5-28**

One quarter note is equivalent to two eighth notes.

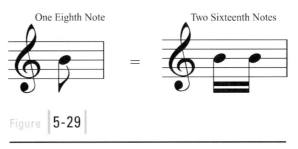

Figure **5-29**

One eighth note is equivalent to two sixteenth notes.

An eighth note can be divided into two sixteenth notes.

The division can go on forever. The sixteenth note is divided into two thirty-second notes, and a thirty-second note is divided into two sixty-fourth notes, and so on and so on.

Notice that there is no stem on the whole note and that there is a single stem on the half and quarter notes. The eighth note has a stem with a single flag and the sixteenth note has two flags on the stem. What would the thirty-second note look like?

Figure **5-30**

A thirty-second note.

The tree of rhythm from the whole note down to the sixteenth note is charted below.

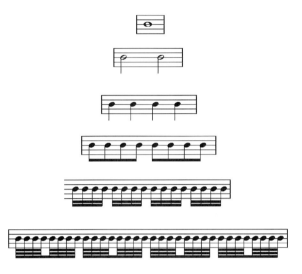

Rhythmic Breakdown of a Whole Note

Figure **5-31**

The breakdown of rhythm from the whole note down to the sixteenth note.

Back to Meter

Meter contains two numbers. The top number represents the number of beats in a measure and the bottom number represents what kind of duration each of the beats is equal to: whole, half, quarter, eighth, or sixteenth.

A measure of 3-4 is equal to three beats in a measure and each beat is equal to a quarter note in duration. Do not forget that the number 1 is equal to a whole note, 2 is equal to a half note, 4 is equal to a quarter note, 8 is equal to an eighth note, and 16 is equal to a sixteenth note.

A measure of 6-8 is equal to six beats in a measure and each beat is equal to an eighth note in duration.

Meter, duration, measures, and beats are essential to understanding the movement of music. The rhythm described above is the fundamental building block of Western harmony. The concept of rhythm has many

A Meter of 3-4 with Three Beats

Figure **5-32**

A measure of 3-4.

A Meter of 6-8 with Six Beats

Figure **5-33**

A measure of 6-8 meter.

layers of complexity, not the least being the rhythm of a single frequency. Think about that and its relation to vibrations described in Chapter 1. All of the concepts of music will slowly join together all of the aspects of acoustics and digital audio theory previously learned. Just keep thinking about these concepts.

Dynamics and Tempo

The **dynamics** of music represent the loudness or softness of music. Dynamics can be applied to sounds as well. Many times the same terminology is used for both music and sound regarding the magnitude of sound.

Today both the Italian and English representations of magnitude are used most often.

The dynamic marks are placed under the note to which it is applied. The dynamic volume is held until the next dynamic mark is placed. In other words, all of the notes following the dynamic mark are to be performed at the same dynamic intensity until the next dynamic mark is introduced.

The tempo is also represented in Italian and English. The tempo is how fast or slow a piece of music should be played.

Table 5-2. Italian and English dynamic conversion chart.

Dynamic Marking	Italian Word	English Translation
ppp	Pianississimo	Very, very soft
pp	Pianissimo	Very soft
p	Piano	Soft
mp	Mezzo piano	Medium soft
mf	Mezzo forte	Medium loud
f	Forte	Loud
ff	Fortissimo	Very loud
fff	Fortississimo	Very, very loud

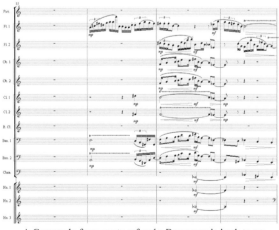

A Crescendo from mp to mf and a Decrescendo back to mp

Figure | 5-34 |

A dynamic change of forte to piano.

Table 5-3. Italian and English tempo conversion chart

Tempo Marking	English Translation
Largo	Slowly and broadly
Larghetto	A little less slow than largo
Adagio	Slowly
Andante	At a walking pace
Moderato	At a moderate pace
Allegretto	Not quite allegro
Allegro	Quickly
Presto	Fast
Prestissimo	Very fast

The tempo is indicated, usually at the beginning of a piece of music or at the point where the tempo changes.

Music contains many, many other markings in an attempt to accurately portray what was in the composer's mind. After all, musicians are reading the music and interpreting what is written. The more precise the music, the more accurate the performance: theoretically speaking. This knowledge will also be useful for the music notation software discussed in Chapter 4.

Figure | 5-35 |

A tempo marking in a score of music.

Music and Numbers

It has long been acknowledged that music has an intimate, if not dependent, connection with mathematics. From a macroscopic view, scale and proportion, all the way back to the Renaissance and beyond, were highly influenced by the beauty of mathematical forms. On a microscopic perspective, all periodic waves produce frequencies that can be easily measured.

Frequency proportions are intertwined with traditional harmony. The results of these proportions form the intervallic relationships that make up much of the musical and sound content in visual media. The idea of proportion and frequency was developed by a great Greek figure in history: Pythagoras. Pythagoras devised a fantastic way of understanding the harmonic series: He started with a string suspended at both ends. Through the proportional division of the string, harmonics were discovered.

Intervals, Frequency, and Harmonics

The notes mentioned above are single frequencies associated with a particular pitch. The combination of two pitches, either consecutively (melodically) or simultaneously (harmonically), form **intervals**. An interval is the distance between two notes measured in half steps.

Melodic and Harmonic Pitch Intervals

Each interval has a specific name and, as seen below, an emotional connotation attached to it. The names have been fixed for more than 500 years.

The chromatic scale was examined above. The distance between each note in a chromatic scale is called a **minor second**. The minor second is described as having a distance of one half step between notes.

Before proceeding, another type of interval should be explained.

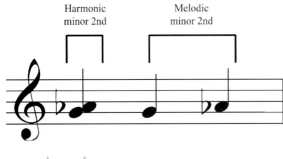

Figure | **5-36** |

The interval of a minor second.

In the beginning, there was only one interval, if it can be called that. The unison is the interval of two notes on the same frequency. Imagine two singers singing the same pitch.

This is the first perfect interval: the perfect unison. There are four perfect intervals in traditional harmony: the perfect unison, the perfect fourth, the perfect fifth, and the perfect octave. The reason they are called perfect is related to the theories of Pythagoras. See the section entitled Harmonic Theory for a complete explanation.

Figure | **5-37** |

A perfect unison sung by two voices.

The distance between the notes that make up a perfect fourth is five half steps. This can be visualized by looking at a keyboard. If we take the note C and count up five half steps, we arrive at the note F. C to C-sharp is one half step, C-sharp to D is the second half step, D to D-sharp is the third half step, D-sharp to E is the fourth half step, and E to F is the fifth half step.

By counting half steps, all intervals can be calculated. A perfect fifth is made up of seven half steps, and the perfect octave contains twelve half steps.

There are other types of intervals: major, minor, augmented, and diminished. The linear combination of these intervals leads to aggregates called **scales**. The vertical combination creates **chords**.

A chart of intervals and their half step equivalents is given below. There is only one interval, six half steps, which is either called an augmented fourth or a diminished fifth. This interval is also called a tritone.

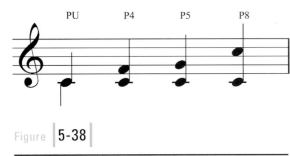

Figure | **5-38** |

All of the perfect intervals.

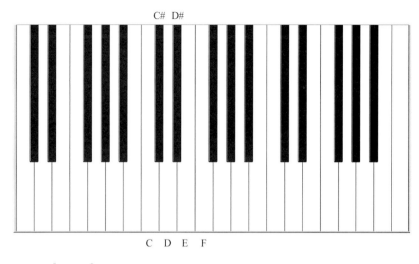

Table 5-4. All the perfect interval equivalents

Interval Name	Half Steps Required to Create the Interval
Perfect unison	0
Perfect fourth	5
Perfect fifth	7
Perfect octave	12

Table 5-5. Interval names and equivalents

Interval Name	Half Steps Required to Create the Interval
Perfect unison	0
Minor second	1
Major second	2
Minor third	3
Major third	4
Perfect fourth	5
Tritone/diminished fifth/augmented fourth	6
Perfect fifth	7
Minor sixth	8
Major sixth	9
Minor seventh	10
Major seventh	11
Perfect octave	12

Given a note, it is now possible to calculate the intervals above and below it. But the most important thing to understand is the actual sound of the intervals. Each interval plays a particular role in the visual landscape, either alone or accompanied by harmony.

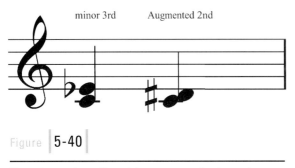

minor 3rd Augmented 2nd

Figure **5-40**

The enharmonic spelling of the same sounding interval.

A major third above the note F is the note A. There are four half steps in a major third and if half steps are counted up from F, you arrive at A. A major third down from F is the note D-flat for the same reasons stated above. The distance from the note C to the note E is a major third. If we decrease this interval by a single half step, we form the interval of a minor third. The notes C to E-flat form a minor third. This is where things get a little confusing. Since we examined enharmonic notes above, we could also call this same minor third an augmented second.

The reason these could be called two different intervals, that is, a third and a second, requires a broader knowledge of harmonic implication, which is addressed later in the chapter.

Interval Differences

What is the difference, theoretically, between the various types of intervals? We have discussed five types of intervals: perfect, major, minor, augmented, and diminished, but what is the difference?

The major interval is used as a base from which to start. To make any major interval a minor interval, reduce it by a half step; the reverse is also true.

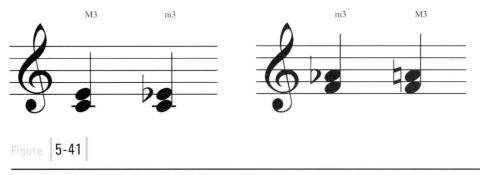

M3 m3 m3 M3

Figure **5-41**

Major to minor intervals and minor to major intervals.

To make a major interval an augmented interval, increase it by a half step. To create a diminished interval, decrease the amount of half steps in a minor third. Usually augmented and diminished major and minor intervals are rarely used by name. More common are augmented and diminished perfect intervals, particularly the perfect fourth and fifth.

The principle to understand from this is that augmented intervals increase the distance between two notes and diminished intervals reduce the distance of an interval.

Consonance and Dissonance

Sound intervals fall into two categories: consonance and dissonance. Consonant intervals are those that resonate with a more or less concordant sound. There are specific intervals, at least according to traditional practice, which are considered consonant.

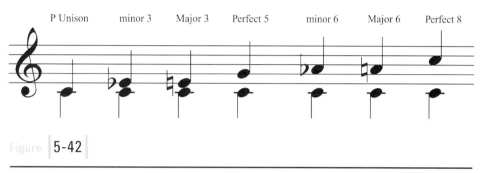

Figure **5-42**

All of the consonant intervals.

The dissonant intervals are those that sound discordant, such as the shrill of a close interval in the high violin range or the blast of a horn cluster. This can be related to the music usually associated with horror scenes or tense situations on film.

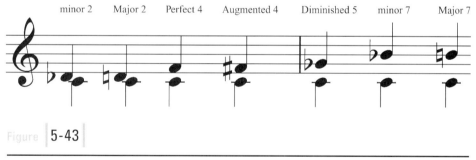

Figure **5-43**

All of the dissonant intervals.

Frequency Equivalents

Every note, from the lowest to the highest audible pitch, has an equivalent frequency that can be used for analysis. These frequencies can relate to each other through intervallic implications. Below is a chart of all of the notes on a piano with their equivalent frequencies.

Frequency Multipliers

Sound effects used in projects don't always exactly coincide with Western harmonic rules, nor should they, but in some circumstances when a relationship is desired between the music track and the sound effects track, a proportion must be used to relate two sound effects as an

intervallic relationship. An interval can be created using nontraditional frequencies to yield the same kind of effect.

A door lock sound and a footstep could be made to relate to each other through an intervallic relationship like a perfect fifth. The emotional meaning of a perfect fifth or other intervallic emotional implication described by Friederich Marpurg can be found in the section Intervallic Relations in Music and Sound Design in Chapter 6.

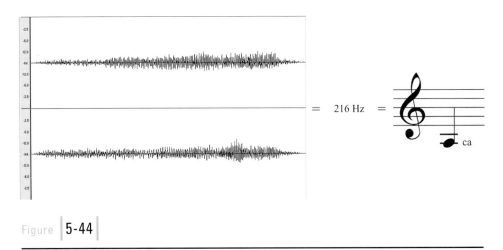

Figure **5-44**

A sound effect with an average frequency of 216 Hz.

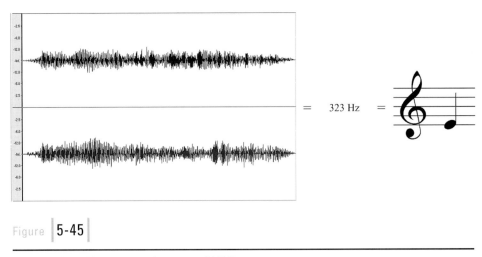

Figure **5-45**

A sound effect with an average frequency of 323 Hz.

How is this achieved? How can a footstep contain a single periodic frequency? It cannot, but it can be averaged to give a fundamental core frequency of an entire file or part of a file. This can be accomplished with an editing software application like Sound Forge.

But if a sound effect does not exactly coincide with a periodic frequency generated with equal temperament, then how can an interval be created? The core frequency, which is generated by

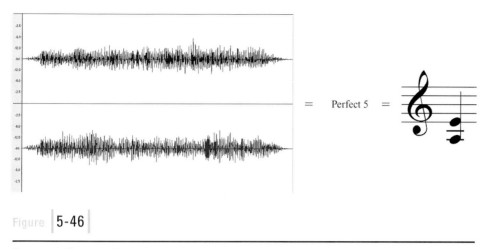

Figure 5-46

The sound effects combine to form the interval of an perfect fifth.

a **spectrum analyzer**, can be considered a starting point. The core frequency can be multiplied by a certain number which will yield the desired interval frequency above it or below it.

Table 5-6 on the next page provides the multipliers by which the core frequency is applied.

Although the frequencies are not exactly corresponding to a pitch frequency, the effect is still achieved. The ear, unless the listener has perfect pitch, is not precisely concerned with the exact individual frequency of

Figure 5-47

The average frequency of a sound can be determined with the spectrum analyzer.

a sound but rather with its relationship to other sounds. This relationship may form intervals, chords, and clusters of frequencies or none of these. Again, the intervals and chords discussed here pertain to the intervals and chords used in Western harmony.

Harmonic Theory (Pythagoras)

Where do the interval relationships originally come from? The harmonic spectrum is introduced in Chapter 1. The basis of the harmonics can be found in the doubling of a fundamental frequency. These resultant harmonics do not accurately describe the harmonics used to generate intervals and harmony in Western music, however. In music theory, the most important intervals started as being the octave, the fifth, and the fourth.

Pythagoras and the Perfect Interval

Pythagoras, born circa 580 BC, initiated the idea that if a vibrating string is divided in half it produces the octave above the open vibrating string. The ratio of the fundamental string to that of the divided string is 1:2.

Table 5-6. Intervallic multipliers

Interval Name	Frequency Multiplier
Unison	1.0000
Minor second	1.0595
Major second	1.1225
Minor third	1.1892
Major third	1.2599
Perfect fourth	1.3348
Tritone	1.4142
Perfect fifth	1.4983
Minor sixth	1.5874
Major sixth	1.6818
Minor seventh	1.7818
Major seventh	1.8897
Perfect octave	2.0000

Figure | 5-48 |

A 1:2 ratio creating an octave.

| NOTE |

It is written that Pythagoras lived an unnaturally long life. It was claimed that he gained strength, acuity, and vitality the older he got. He was assassinated in his 90s apparently because of his radical ideas. The exact cause of death is unknown, but at the time there was a fire and his university was destroyed. He wrote nothing down and all of what is known of the theories and ideas of Pythagoras come from those who wrote tracts of what they remembered.

By dividing the string in perfect proportions of 2:3 ratios, Pythagoras produced the perfect fifth above the original fundamental open string.

One more division with a ratio of 3:4 produced the perfect fourth.

The perfect intervals are derived from the fact that they are produced from pure or "perfect" frequency ratios. Pythagoras was only concerned with these intervals because he and his followers were convinced that numbers were the supreme principles of the universe and that musical harmonies reflected the mathematical laws of this universe. The octave, fifth, and fourth were the underlying structures of the expression of the universe.

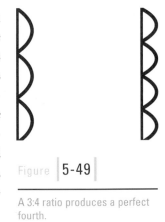

Figure | 5-49 |

A 3:4 ratio produces a perfect fourth.

Pythagoras thought of the musical landscape in three layers. The first type of music was the **musica instrumentalis**, or music produced by people playing instruments or using their voice to produce tones. The second type was called **musica humana**, which was considered the music that humans were made of. He believed that the organs, nervous system, and all of the components that make up a person had a universal mathematical relation. The third type of music was the **musica mundana**, or the **music of the spheres**.

Pythagoras developed a scale of pitches containing seven different notes enclosed within the octave for a total of eight notes including the octave—the diatonic scale.

The Pythagorean tuning system was built on fifths. If a fundamental note had a scaffolding built on top of it consisting of perfect fifths, the cycle would eventually end up where it started, with a slight alteration in frequency relationships. Basically all of the notes of the chromatic scale are produced if you keep moving upward but only the diatonic notes were of concern to Pythagoras when constructing a scale or aggregate of pitches. The first seven pitches created by increasing the interval above by a fifth can be mapped onto our modern day well-tempered system. If we start with the note F and move upward, we see that all of the white notes on the piano are covered within the first seven pitches reached. If these were reorganized into a conjunct scale, we could create the C major scale and the F Lydian scale quite easily.

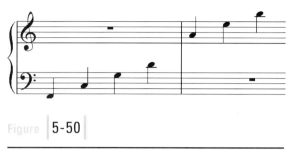

Figure **5-50**

All of the diatonic notes are produced.

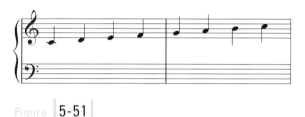

Figure **5-51**

If all of the notes are arranged to exist within an octave, it is a C major scale.

Pythagoras named this initial grouping of notes a mode. This particular mode was called the Ionian mode, known today as the major scale. There were modes built on each of the diatonic notes named after the region in Greece where they were thought to have been played. The Ionian mode and the Aeolian mode are known today as the major and minor scales. The Lydian scale mentioned above is the mode built on the fourth scale degree of the C major scale. Basically Pythagoras classified the modes into masculine and feminine categories. The interval of the third note of the mode, whether it was a major third or a minor third, characterized the mode as masculine and feminine, respectively.

The Pythagorean tuning system is not what is used today, however. After a period of using various tuning systems, the equal tempered system was created. This system, with its roots in the Pythagorean tuning system, is constructed with each note being of equal distance from the next proportionately, namely a half step. This is the accepted tuning system and the one we deal with as sound designers and composers.

How does all of this relate to sound design? It all boils down to the interval. The organization of intervals into scales and chords, based on a fixed distance pattern between each note, has yielded most of Western music harmony for the past 300 years or so. These constructs, basically major and minor scales and harmony, are the foundation of today's sound and music for visual media. This includes all of the visual media that has sound and music as a component.

Major and Minor Scales

The major and minor scales are built from the original modes of Pythagoras. In today's world of equal temperament, these scales, theoretically, sound the same no matter what the starting

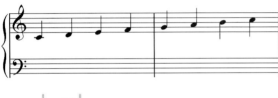

Figure **5-52**

A C major scale.

W W H W W W H

Figure **5-53**

The pattern used to generate major scales.

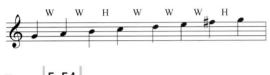

Figure **5-54**

The G major scale created from the WWH WWWH pattern.

note is. The pattern of a major scale is simple. Applying this pattern to any starting pitch creates a major scale with that pitch as the foundational note of the scale. For example, a C major scale consists of eight notes with the octave on C as the bookends.

As mentioned above, there is a set formula that makes up a major scale. Both the major and minor scales are made up of whole steps or half steps. A whole step is two half steps, and a half step has been explained above. If a whole step is designated with a "W" and a half step is designated with an "H," we can create a pattern for a major scale.

There are many ways of describing the relationships that intervals have with a major scale but for a sound designer, with no prior knowledge of music theory, this is the clearest way of describing this based on many years in the classroom.

Thus if the first note of a scale is G, and the major scale pattern is applied, the G major scale is created.

Notice there is an F-sharp created. This is the result of there being a whole step between the sixth and seventh scale degrees of the scale. The distance from E to F-sharp is a whole step. Do not forget, there is a only a half step between B and C

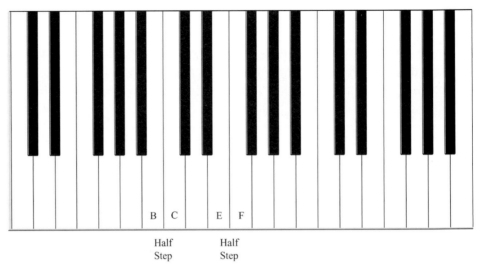

Figure **5-55**

A half step between B and C and E and F.

and E and F on the piano. There are no black notes separating these notes, so a single half step is the distance between them.

The minor scale is a little different. There are four forms of the minor scale as we know it today. If your interest gets peaked by all of this theory, you will find an abundant amount of information regarding these types of scales, but for our uses we only need to know the natural form, based on the Aeolian mode of Pythagoras. The natural form is not used in traditional music but acts more as a guideline for the other three forms. It has been used, but more as a harmonic device than a melodic device, at least in traditional music.

The pattern for the natural minor scale is made up of whole steps and half steps, as in the major scale, but they are shifted down a minor third from the major. What does that mean? If we have a C major scale constructed and play all of the notes of the C major scale starting from the A, a minor third below the C, we have an A natural minor scale.

The exact pattern is given below.

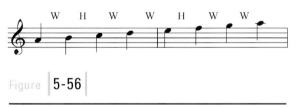

Figure | 5-56 |

An A minor scale built with the natural minor scale pattern.

Any given note can be the starting point for a minor scale, just as any given note could be the starting note for the major scale.

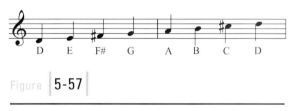

Figure | 5-57 |

The scale degrees of a D major scale.

Each of the notes of a scale is given a number as per Pythagoras. These numbers designate the scale degrees of the scale.

Scale Degrees

Each note of a scale has a specific number applied to it. The first note is called one; the second note of the scale is called two, and so on up to the octave, which is number eight. This is important when building relationships above these notes, such as harmonic and melodic formations.

Thus the third note of a D major scale is F-sharp, and the sixth note of the scale is B.

Play these scales on your software keyboard to become familiar with them. All of the major and natural minor scales are located on the CD for your convenience.

Scale Intervals

The scale contains certain interval relationships that make the scale unique. The distance from the one note to the fifth note in both the major and minor scales is the interval of a perfect fifth. The distance of the lowest note to the top of the scale is a perfect octave. If this is broken down into the types of intervals created from the root note of the scale up to the octave, we discover that in major scales there are only major and perfect intervals created.

In natural minor scales there are minor, major, and perfect intervals created from the root upward.

A multitude of intervallic combinations can be discovered by examining closely the construction and configuration of scales. This is one of the tricks of the trade of composing music.

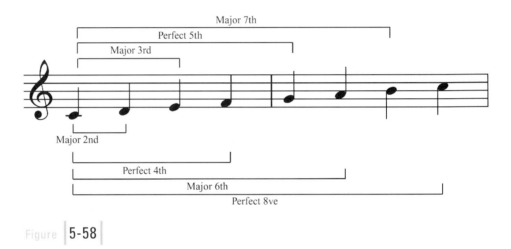

Figure | 5-58 |

The major and perfect intervals of a major scale.

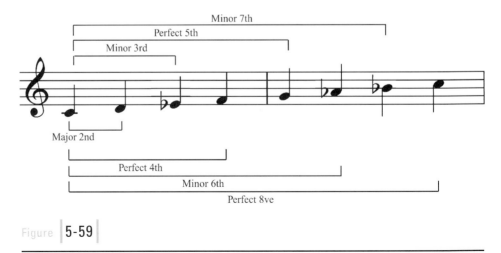

Figure | 5-59 |

The major, minor, and perfect intervals of a natural minor scale.

Intervallic combinations may act as motifs, melodies, phrases, cells, and many other compositional devices.

Further information regarding scales can be obtained through any good introductory music theory book. Seek out these sources and learn as much as you can on this.

Chords

The final area that needs to be understood, albeit not to a large extent in this book, is the formation and implications of harmony. Sound design can be thought of as the organization of sound events just as music can, so the principles that apply to individual notes also apply to individual sounds.

Figure | 5-60

A C major chord.

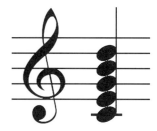

Figure | 5-61

A tertial chord containing five notes.

Tertial, Quartal, and Quintal Harmony

Most of the music you hear on the radio has its harmonic foundation built on the tertial theory of harmony. Just about all of the harmony you hear, outside of contemporary music and some parts of film music, are built in thirds. This means that, for example, a major **triad**, or a three-note chord, built on C consists of the first, third and fifth note of the C major scale, or C, E, and G.

Because the chord is built in consecutive thirds, it is considered to be tertial. The triad, which is the root of Western harmony, consists of three notes, although at the end of the 19th century, tertial chords consisting of more than three notes were common.

There are other types of harmonic structures that are not built in thirds. Quartal harmony is built in fourths.

Quintal harmony is built in fifths.

These all create interesting possibilities in both musical expression and creative possibilities. But the root to most of the music and the relationships between sound design and music reside within tertial harmonic principles.

The use of chords in sound can be directly applied to sound sculptures. Many times the principles of traditional harmony and **counterpoint** can be applied to an electroacoustic composition or other type of nonvisual sound work. The sky is the limit, just use your imagination and create some incredible sounds.

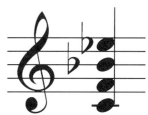

Figure | 5-62

A chord built in fourths.

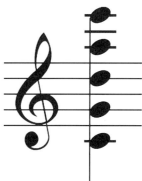

Figure | 5-63

A chord built in fifths.

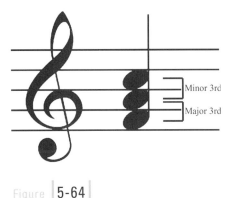

Figure **5-64**

A major third plus a minor third is a major triad.

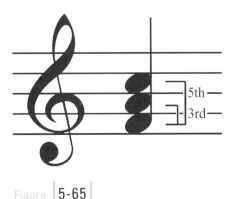

Figure **5-65**

A different way of building a major triad.

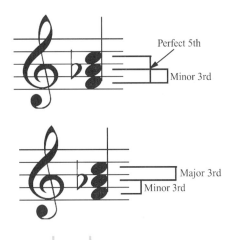

Figure **5-66**

A minor triad can be built either by adding intervals together or by building from the ground up.

Building Chords from Intervals

A major triad is built of two intervals but can be viewed in two different ways. One way to build a major triad is to add two intervals together. A major third plus a minor third on top of the major third is a major triad.

Another way to think about this is to build intervals from the root of the chord, or the lowest note in a tertial configuration. A major third above the root along with a perfect fifth above the root is also a major triad. You can decide which works best in a given situation.

A minor triad is built by either adding a minor third and a major third or by constructing a minor third and a perfect fifth above the root note.

In Western music, the major and minor triads are not the only basic chords experienced. Two more need to be mentioned: the augmented triad and the diminished triad.

As can be seen, the augmented triad consists of two major thirds and the diminished triad consists of two minor thirds together. Also notice the outer intervals are not perfect fifths. They are an augmented fifth and a diminished fifth, respective to the augmented and diminished triad.

Building chords is not a complex process but it does need attention when relating chords to one another. There is a definite connection between a chord type and the location of the chord in the **chord scale**. A chord scale is a series of triads built on the notes of the

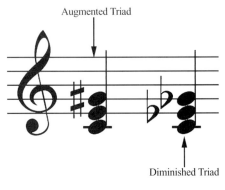

Figure **5-67**

The augmented and diminished triads.

major or minor scale, or any scale for that matter. A chord scale built on the C major scale is given below.

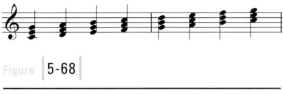

Figure | 5-68 |

A C major chord scale.

Chord scales are outside the scope of this book but are the keys to discovering traditional Western harmonic practices. There are many sources of information on this subject. The more music theory that is understood, the more effective the sound design will be.

SUMMARY

This chapter introduces music theory for sound designers. The aspects of notation, rhythm, meter, dynamics, and tempo are explored. Intervals and their relationship to each other are compared to frequency equivalents, which can be derived from a spectrum analyzer in any good audio editing software package. There are many more aspects to music theory to examine and it is your job as a sound designer to learn as much about the topic as possible, because it will give you the upper hand when it comes to crunch time.

in review

1. Where does middle C lie on the stave in bass clef?

2. How many half-steps are there in a perfect 5th?

3. How can intervallic relationships influence sound design?

4. How are harmonics related to intervals and harmony?

5. A major 3rd plus a minor 3rd creates what kind of chord?

exercises

1. Write out all of the major scales in the well-tempered system. The scales should include C, G, D, A, E, B, F#, C#, A♭, E♭, B♭, and F.

2. Create a perfect 5th between two sound effects using a spectrum analyzer.

3. Create all of the intervals from the note F upward.

notes

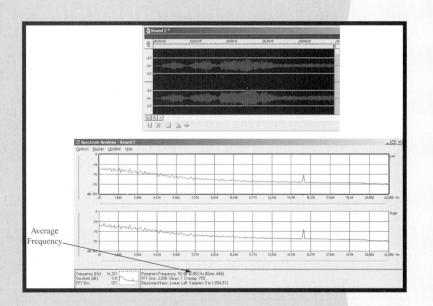

Average
Frequency

principles of sound design

The principles of sound design theory

Relationship between sound design and music theory

Psychological aspects of sound and picture

The objectives of this chapter are to provide a solid foundation for the design and construction of sound for interactive and linear media. There are many aspects to creating powerful sound design for both linear and nonlinear media, and the techniques for constructing sounds for this media are similar to each other. This chapter reveals many of the most important aspects of these techniques.

WHAT IS SOUND DESIGN ANYWAY?

What is sound design? How important is sound design to a visual and nonvisual experience? Where does it all begin? Sound effects originated in the theater. The effects of these sounds were to reinforce, to a large extent, the sounds of natural phenomena such as thunder, rain, and footsteps off stage. After a period of time, theatrical sound effects became more and more sophisticated, which produced better and more convincing sounds. Large mechanical devices were used for this purpose and required a large amount of space during the live performances.

In the 1920s, radio advanced the use of sound effects. At first, most radio was broadcast live using the same types of machinery used in theater to produce sound effects. By the mid 1920s great steps were taken in the direction of recording sound. Better electronic microphones and recording technology allowed sound effects to be recorded onto a medium and reused. The library of sound was thus created. The sound effects included natural sounds of the outdoors, cars, machinery, animals, planes, and people. This added a streamlined workflow to the process of radio production. It also eliminated the need to have multiple sound effects artists on hand for a broadcast.

In the late 1920s, sound was introduced into the moving picture. There was debate whether this was a good thing at the time. Some critics felt that the dimension of sound was not part of the film experience and that it should be left silent. This, of course, did not last very long as the public could hear and feel the impact sound had on the experience of watching a film. This opened up a whole new world for sound to explore, but it came with technical and aesthetic points that needed to be understood. Because film is a linear art form, sound had to be synchronized at specific points in the film in order to convince an audience. Originally the sound effects track was recorded live as the film was being projected onto a large screen in a recording studio. The synchronization was, more or less, done by eye. Because multitrack recording was not available, all of the effects had to happen during the screening of the film and recorded. Imagine if this was the case today.

In film, the sound effects track is compiled of many tracks layered together and mixed to form a dynamic, organic soundtrack. The sound effects track is really made up of many different types of sound objects created in many different ways. There are hard sound effects, which make up most of what is associated with the on-screen action and usually require synchronization, and background sound effects, which need no real synchronization and create the atmosphere and context of a scene. The background track should not have any conspicuous sounds that interfere with any foreground sounds. Ambience tracks are considered background sound effects, although ambience now has a special place among sound designers and is treated with more care than in the past. The next layer of sound in a sound effects track is **Foley** sound effects. These resemble the original way of recording sound effects to picture. Foley artists or Foley actors create the sounds for a picture as it is rolling. They act out footsteps, squeaks, squashes, clicks, clacks, and a multitude of other sounds that are directly synchronized to the picture. The name itself comes from a man named Jack Foley (1891-1967) who invented

Foley sound effects as we know it today. One interesting point about Jack Foley was that he used to record all of the sound effects in one take on one track. If a scene was being worked on, he would run through all of the sound effects, all of them, in one take. This is unique in that multitrack editors do the same today. He was a firm believer that the person performing Foley sound effects had to act and get into the role. He felt, which is quite true, that it made a big difference in the sound.

Foley sounds are recorded in a Foley studio, which contains various types of surfaces and textures for the actors to interact with. Gravel pits, sand pits, and concrete pits are some of the floor pits that are usually in a Foley studio.

Sound effects that need to be created are called **designed sound effects**. This type of sound effect is needed when there is no natural recording or sound in nature that can compare to the desired sound, like the sound of spaceship engines or other futuristic sounds.

At the end of the 20th century came another innovation for sound to explore. Video games originally had very basic digital sounds, like those of Ping Pong, for example. Around the mid-1990s, however, sound became an integral part of the game state and the need for greater and greater sound and gear was necessary. The sound effect process is relatively the same for games as for film, except there is essential programming that is needed with it. The sounds need to be prepared in order to be incorporated into the game engine. The sound programmer is responsible for this, but as will be seen, things are changing.

The sound designer's job today is more high-pressure than it was in the past. One of the main reasons for this is the increased interest in audio sound quality and the transformation of the home entertainment system to include a minimum of 5.1 surround sound. People are hearing better and better audio. In film it is expected that the absolute highest quality sound be delivered. In game production, the sound effects track and music track are gaining in importance, and the quality, although not as high as in film, is getting better and better. As of this writing, the game industry has higher gross revenue sales than the movie-making machine in Hollywood. That has opened a few eyes and a few ears. People are spending a lot of time in front of their consoles and computers playing games. Naturally, sound should support this fully immersive environment. This trend of high-quality audio has trickled down to web-based media. The expectations are becoming just as high for the web sound designer as for the game sound designer. It is not there yet, due to bandwidth considerations, but it is on the horizon. Keep your ears open, here it comes.

What Is Sound Design Today?

In the big, wide world of sound design, it may be difficult to accurately pinpoint the definition of sound design. It seems that everything related to sound is called sound design. This is not true at all. A sound designer's job is multifaceted; this is true, but it is not all encompassing. The primary job of a sound designer, in the visual world, is to create an overall sound character for the

project. Sound designers are brought in during the pre-production phase of a project and are informed of the threads of plot, story, or project expectations (at least they should be brought in this early). From this information, a design of the sound landscape is produced. The entire soundtrack is organically designed to support the thematic material presented in the visual side of the equation. The design of the overall soundtrack, with all of its components, is vital to your job as a sound designer. Usually you will perform your own mixes and contribute greatly to the sound effects themselves. One thing is for sure, sound designers are not just sound effects creators. The job is much more higher order than the micro aspects of creating sound effects, which has its own set of complicated needs. There is an aesthetic behind each project, film, or interactive scenario and the sound is an integral part of that aesthetic.

The best way to develop your skills as a sound designer, no matter whether it is in the linear visual field or the nonlinear visual field, is to study what is and has been done in film. Using film as an example, we can discern convincing and unconvincing sound situations more readily than any other type of medium for a few reasons. Film has been around longer than television, video games, or any other type of moving visual media. Sound for picture started with film and an enormous amount of attention has been given to it. In short, the best sound design created is that which is related in film. The principles and theories behind sound design for film and sound design for interactive environments is basically the same. Even though nonlinearity has an added layer of abstraction, namely the spontaneous connection and triggering of various sound events, it still deals with the principles of sound for moving picture.

What Is Heard and What to Listen For?

There are three essential parts that make up a complete soundtrack: dialogue, music, and sound effects. All sound for moving image falls into these three categories. They are all individually mixed together and finally mixed into a single file. If there are specific problems with levels or effects, the individual sessions must be revisited and balanced. In some larger scale operations, a broader mix of all of the tracks may occur, leading down to a single file.

Breaking the Tracks Down

The first thing you have to do when starting a study of sound and picture, and this may seem obvious, is to listen to and hear the separation of dialogue, music, and sound effects tracks in a film. After a period of time, it will be noticed that there are three distinct audio tracks. In feature films, the separation can be seamless if properly mixed. Television, on the whole, has many holes to exploit in the audio track. This is not to say that the sound crews are not professionals; on the contrary, they are performing miracles most of the time when considering the budget and time constraints as well as possibly limited hardware resources. Listen to any sitcom that has a laugh track and focus on the dialogue. The difference in vocal texture and the laugh track will be sorely apparent. Compare this to the live audience situation with hosts like David Letterman or Jay Leno. The audience sounds dynamically mix with the host; naturally, they are in the same space as the host, even with all of the microphones.

In film, the three sound categories are, many times, occurring at the same time. The craft of mixing these together as well as planning for possible trouble areas, like masking and cancellation, takes many years to master, but do not be afraid, you will get there sooner than you think. When you hear a film with a good soundtrack, it is hard, sometimes, to appreciate how good the sound is for the very reason that you do not realize it is there in the first place. A great example of this is the soundtrack for the "Lord of the Rings" trilogy. The power, emotion, and precision of the entire soundtrack is amazing. Sound designer David Farmer achieved greatness with this trilogy. With that said, listen to any one of the movies and focus solely on the sound. Farmer is not the only one responsible for the sound in these films; you will be surprised at the size of the sound crew.

Notice all of the different positions needed for a sound crew on a large film. With games and web work, the crew amounts, many times, to the enormous size of one: you. Logically, the

Table 6-1. The sound crew from "Lord of the Rings"

Sound Department for Lord of the Rings

Bruno Barrett	Garnier-assistant sound editor
Ray Beentjes	Dialogue editor
Beau Borders	Sound effects editor
Christopher Boyes	Sound re-recording mixer
Nick Breslin	Dialogue editor (as Nicholas Breslin)
Brent Burge	Sound effects editor
Jason Canovas	Dialogue editor
Hayden Collow	Sound effects editor
Meredith Dooley	Production assistant: sound
Corrin Ellingford	Boom operator
David Farmer	Sound designer
Nick Foley	Sound recordist
Mark Franken	Dialogue editor
Luke Goodwin	Assistant dialogue editor
Mel Graham	Assistant sound effects editor
Michael Hedges	Sound re-recording mixer
Simon Hewitt	Foley artist
Phil Heywood	Foley artist
Lora Hirschberg	Additional sound re-recording mixer
Mike Hopkins	Supervising sound editor
Paul Huntingford	Foley artist
Mike Jones	Temp mixer
John Kurlander	Scoring mixer
Martin Kwok	First assistant sound editor
John McKay	Temp mixer
Polly McKinnon	Dialogue editor

Table 6-1. The sound crew from "Lord of the Rings" (cont.)

Sound Department for Lord of the Rings

Adrian Medhurst	Foley artist
Peter Mills	Foley editor
Timothy Nielsen	Sound effects editor (as Tim Nielsen)
Martin Oswin	Foley artist
Hammond Peek	Production sound mixer
Angus Robertson	Foley engineer
Jurgen Scharpf	DVD audio remastering
Michael Semanick	Sound re-recording mixer
Nigel Stone	ADR supervisor
Matt Stutter	Assistant sound editor
Gary Summers	Additional sound re-recording mixer
Ted Swanscott	Sound mixer
Addison Teague	Sound effects editor
Craig Tomlinson	Sound effects editor
Ethan Van der Ryn	Supervising sound co-designer
Ethan Van der Ryn	Supervising sound editor
Chris Ward	ADR recordist
Chris Ward	Assistant dialogue editor
John Warhurst	Assistant sound editor
Justin Webster	Assistant sound effects editor
Dave Whitehead	Sound effects editor
Chris Winter	IT support
Katy Wood	Foley editor
Toby Wood	Assistant scoring engineer
Gareth Bull	ADR recordist (uncredited)
Ian Tapp	ADR recordist (uncredited)

larger the scale of a project, the more sound crew members are needed, but it does not always work out this way. At the beginning stage, this is good news. Where else are you going to learn the ropes?

It also helps to listen to older films as well. Before the massive explosion of sound in film, say around the late 1980s, the soundtrack was generally treated with much less respect as far as the budget is concerned than it is today. A movie like "Saturday Night Fever" or "The Magnificent Seven" have soundtracks that can teach many things about dialogue replacement, sound effect content, and specificity, as well as mastering the final soundtrack.

Once the three bands of audio have been discerned, move onto a more detailed approach to listening. For now, just take in all of the sound on the soundtrack. This will clearly distract you from the story or virtual environment, so choose a film or game that you have experienced.

Things to note are combinations of sounds, groupings of the three sound spectra, and isolated sounds without accompanying sound support like an individual door squeak without music or dialogue. This takes some practice and it may annoy those around you for the basic fact that you will not be paying attention to the story but solely to the sound. Eventually, these skills will translate into your own work.

Sound and Image

There is a definite and intimate connection between the visual world and the aural world. Our everyday lives are filled with both of these constantly. Many times the sound of objects around you is taken for granted and not noticed. A walk down a city street will contain hundreds if not thousands of sounds. These are part of the sound landscape but when you hear a car screech, even if it is not near you, your ears tend to perk up and take notice. The sound stands out and is visualized, without the visual context with which to reference it. The brain instantly tries to draw a visual reference object with which to attach the sound, that is after it has signaled you to be careful and not get hit by the vehicle if it is near you. The surrounding sounds are not necessarily important at that point. When the car screech occurs, there is an added sound placed by your imagination: that of the crash. Even when there is no crash, the ears are expecting to hear one and place a sound in the place of silence. This interesting phenomenon can be used as a form of sound manipulation in the visual media. A great example of defeated expectations is in "Star Wars Episode II: The Phantom Menace" in which Obi-Wan is being chased by the bounty hunter through an asteroid field. The bounty hunter launches a missile at Obi-Wan's spacecraft and misses, hitting an asteroid. The missile is actually a sound device that uses sound waves as its source of destruction. The interesting thing occurs, and this is with a stroke of genius, before the explosion. The entire scene becomes silent for an instant and then the pang of the explosion. Two things have happened here. The silence preceding the explosion builds an incredible amount of anticipation. In this case, the ear knows there will be an explosion but is not ready for the actual sound texture of it. When the sound texture is given, it is really something unexpected and original. This explosion occurs twice in the scene. The second time had to occur to give the ear the real sugar of the sound. Now that the ear knows it is coming, it can focus on the entire sonic event and savor it. Brilliant stuff!

A sound designer needs to know how to play with the ear and create audio illusions for the visuals. In film, there is rarely heard the actual sound of an event on screen concerning sound effects. A punch to the body rarely sounds like it does in the films. The illusion of power and contact are created to fill the needs of the thematic material in the story. This happens with many sounds on screen. The sound and image are intertwined in the overall illusion of the scene.

Sound Imagery and the Sound Sculpture

A great way to understand some of the subtleties of how sound can affect and support the visual is to actually work without using an image at all. Sound sculptures or sound landscapes can create imagery with the impact of sounds. Working with sound in this manner sharpens

PROFILES

Pierre Schaeffer

Pierre Schaeffer (1910–1995), was born in Nancy, France, and like many of the leaders and pioneers of electronic music, he had no formal musical education. He received his diploma from L'Ecole Polytechnique in Paris. He had an apprenticeship at the Radiodiffusion- Television Francaises (RTF), which led to a full time job as an engineer and broadcaster. During World War II, he was a member of the French resistance against the German occupation.

After his promotion at RTF, which occurred quickly, he was only 32, he convinced the RTF corporation, which coincidentally was under the control of the German occupying forces, to start a new branch of study, namely, the science of musical acoustics with himself as the director. At the RTF, he had various resources available to him including phonograph turntables, disc recording devices, a direct disc cutting lathe, mixers, and a large library of sound effects records owned by the studio, a good way to start experimenting with sound. After some naming issues, the new studio was finally named Club d'Essai.

After many months of research and experimentation, Schaeffer was drawn to the possibility of isolating naturally produced sounds, creating objects out of them. This would lead eventually to the term **"musique concrete"** which meant that the sounds were based on natural sounds recorded and played back in a musical context.

Pierre Schaeffer was a seminal figure in shaping the electronic sound and music fields of study and research. In 1995, he died in Paris of Alzheimer's disease. He was remembered as the "Musician of Sounds."

your skills as a listener and develops your surgical technique with sound. Acousmatic sound, a term coined by Pierre Schaeffer, is sound that has no visually identifiable source.

Acousmatic sound can be created from source recordings of natural events or recordings of events that do not have a specific context, leaving it up to the listener to focus on the sounds themselves and not necessarily connote them with an object or message.

Sound sculptures are collections of sounds organized in a way as to convey a story, emotion, setting, feeling, or any other form of inner expression. If this sounds like music, it is. Music is constructed by organizing pitches in such a way as to create a musical aesthetic even if the aesthetic is defined in the music itself. A lot has happened in the 20th century concerning pitch and its organization, or lack thereof, and basically at the end of the day, the concept of organized pitch as music is still left standing. Composition and organizing sounds organically is an enormous field of study, as can be imagined, and can reveal many things about how you organize sounds for your own projects.

In order to create a sound sculpture, sound assets are needed. The best scenario is to have all of the assets recorded originally. This tends to yield the best results as far as quality of sound is concerned, but for the beginner, library sounds will work fine. Sound sculptures are not created out of thin air. They need some kind of intention behind them. Collecting sounds without an end goal will sound like a misguided attempt with no forethought. Think of something simple, like waking up and going to your workstation to begin a new sound sculpture. This simple scene can lead to many interesting sound events. Literal interpretation is not very convincing, although it may create imagery on its own. Think of the thought processes as one gets out of bed, the increased heart rate when coffee hits the system, the excitement and anticipation of invention, and so on. Get creative. The same old footsteps and creaking bed are nice, but that is just the surface. Focus the listener on the actual sounds, not what the sounds mean in themselves.

This creative experiment is achieved by processing and manipulating the audio assets collected for the piece. Usually raw recordings or sound library objects never enter the piece without some form of manipulation acted on them and when they do, they have been professionally recorded.

The time frame can be anything you desire, but remember the impact of durational sound on a listener. The ear can get tired, just like the brain can. Start with a 3- to 5-minute piece. Work methodically and patiently. Remember the words "it is good enough" do not exist. What are you waiting for? Get to work.

The Impact of Sound on Image

Images are directly influenced by sound reinforcement. These two separate entities combine to create something more valuable than each on its own. Just turn the sound down during a tense moment in a film. It becomes saggy and deflated. There are interesting differences in the way we perceive objects visually and perceive them aurally. When something is seen that we do not want to look at, we simply close our eyes. This can protect us from sights that we are not interested in viewing. The ears do not act the same way; we cannot turn them off. They are always open to whatever enters them.

Our ears have the ability to perceive sound in ratios. The octave is a ratio that is recognized by the ear, whereas the eyes do not perceive ratios of light and they cannot define specific bands of light when they are mixed together. The ear can clearly define separate frequencies. The intervals and chords discussed in Chapter 5 are an example of this. If we heard all sounds mixed together the way sight combines light ray reflections, there would be no such thing as music.

Figure | **6-1** |

The ear perceives sound discretely and the eye does not.

The field of focus is also different. Your eye focuses on a point directly in front of them. Your peripheral vision is clouded. When an object enters the field of view, the eye instantly directs itself to the object. It is not perceived by looking at something else, other than the object. The ear is omnidirectional and can pick up sounds all around the head location as well as define, with a certain amount of accuracy, the location the sound came from within the omnisphere of perception: aural depth perception.

Images exist in space. They physically occupy a space and require a certain amount of time for the transmission of the message or content they provide. Sound exists in time alone. In order to perceive sound, space is required for the compressions and rarefactions to occur. You could say that sight and sound are polar opposites, and maybe that is why they work so well together.

Diegetic On-screen and Off-screen Sound

In film there are basically three types of sound parameters within the spectrum of all sound which may be acknowledged: **on-screen**, **off-screen**, and **nondiegetic** sound. **Diegetic** sound is that which is present on the screen and is part of the direct communication of the story. The same is true for interactive environments. There can be diegetic on-screen sounds like someone speaking, and you see their mouths moving, or the sound of an on-screen train. That same train may be heard off-screen and is never visualized in the scene but it is part of the on-screen story. This is called diegetic off-screen sound. Off-screen sounds can be further broken down into two categories: **passive** and **active**. Passive off-screen sounds are those that create a sense of environment and space. They also act as sound bridges across edit points, thereby smoothing and securing a transition. Active off-screen sounds create a situation of curiosity regarding the source of the sound itself. When a doorbell is heard, it is natural to want to see who or what is behind the door. This is considered active.

Nondiegetic Sound

Nondiegetic sound is sound that exists outside the on-screen story and events. It is basically all of the sounds not heard by the character or not produced by an event in the story. Music and voiceover are examples of nondiegetic sound. **Michel Chion** brings up an interesting point in his book *Audio-Vision*. Although the book is more than a decade old, he states that there are more than just three areas of screen sound when considering aspects such as sounds from phones, sounds from people when they have their backs to the camera, and so on. These considerations are still being discussed today. They create a wonderful area of the sound discipline to explore but basically it all still boils down to the three fundamental aspects of sound and image.

All of the three areas of sound we have discussed fall into a single category, that of **on-track**. All of the sounds on a film track are considered on-track. **Off-track** sounds are those that are assumed but not heard in a story, like the assumed sound of the car crashing sound mentioned above. Another example is when one person is talking to another, but only one side of the conversation is heard. Sounds that are buried by other sounds are also considered off-track,

whereby the sounds are assumed but not heard because of some other louder sound covering it up. This is known as masking.

Synchronization and False Synchronization

Although the synchronization process is mainly for linear media, it can have an impact on non-linear, virtual spaces as well.

Synchronization is the process of connecting a sound event with the action of a visual event. A door closing, a balloon popping, and a car horn are examples of synchronous sound with a visual cue. The effect of sound sync creates the virtual reality of the everyday experiences. But even with our natural surroundings, things are not always in synchronicity. The physical laws of nature dictate, as discussed in Chapter 1, that the speed of sound is much slower than the speed of light. Therefore, if enough distance exists between a sound source and the listener, there will be a discrepancy in the synchronization of the sound with the image. Sometimes this is called for in a scene and sometimes it is not. It really is up to the producer, director, and anybody else involved with the decision making for a project or film.

The real question about syncing sound to image is whether the effect is supposed to represent reality or to create the illusion of the reality presented. The choice is made by the sound designer and then pitched to the decision makers.

False synchronization is also used in linear visual media. This occurs when the sync point is obscured by another event or cut in the scene. This happens more often than may be thought. When a scene builds to a climax, the ear starts to expect a resolution. If this anticipated resolution is provided but not on the climax of the visual image, then a false synchronization has occurred. The resolution is given on a transitioning theme or cut in the film. Imagine that a plane is shot down during a World War II dogfight. The camera view is in the cockpit. As the plane loses altitude, we see the earth coming closer and closer. The expectation is that there will be an explosion of some kind. When the time of impact has arrived, the scene cuts to a train passing in front of a steel mill. The sound of the explosion and the train, on the cut to the train, creates a release and a transition at the same time but does not supply the graphic of the plane crash. This can have some interesting effects. As a sound designer, it is your job to inform the artistic director or film director of these ideas and try to hold on to them.

In nonlinear spaces, like games and virtual spaces, synchronization has a different meaning. Triggers set during game play define the sync points, and location identifiers set in motion various music and soundtrack intensities. When a first person perspective view moves forward, you may hear footsteps. This is a form of synchronization even though you do not see the footfalls. When you fire a gun in a game space, a trigger was set up so that when you virtually pulled the trigger, a sound as close to synchronization as possible was created. Most new machines can handle the audio but if the amount of data gets to be too large, there may be some choking, or **latency** in the sync. In other words, the sounds are not synchronized to the image, making a middle layer of abstraction, namely your computer, responsible for the transmission of sound

during an action or movement. Interactive environments require that the sound designer think both linearly and nonlinearly, but the same basic design mechanisms exist when actually building the sounds.

Figure **6-2**

A typical software reverb window.

Spatial Considerations

The illusion of space is one of the great tools sound designers possess. Large spaces do not sound like small spaces. Tiles and hard walls do not sound the same as rugged, dry wall textures.

Distance and proximity can be created by using reverb, echo, and certain filters that make it appear to be reflective. There are many software simulators that create the illusion of space, but basically they deal with the amount of reverb added to a sound. The more reverb, the bigger and more reverberant the space. There are exceptions of course, like big spaces that are not very reverberant, like a large office or an orchestral recording studio.

An explanation is in order concerning some of the terms used in the screenshot above. Notice there are three sliders: **dry out**, **reverb out**, and **early out**. The dry out indicates the amount, or level, of unprocessed signal that will be combined into the output signal. The reverb out gauges the amount of processed signal that gets mixed into the output, and the early out indicates the amount of **early reflections** that are processed into the output mix. Early reflections are the first reflections heard in a space. Usually this is the first reflection and gives the listener an accurate idea of the actual space they are in. Many times the first reflections are those that only bounced off of a surface once and then went to your ears. Echo can create an even larger space, usually outdoors, like the echo of a large canyon.

Reverb, echo, and EQ, along with ambience, can create the illusion of just about any space in existence, or at least those that have been measured.

The Texture of Sounds

A sound can give the impression of weight or texture. A thin glass sound gives the impression of a light glass object and a thick glass sound could represent a heavier glass object. But what it really comes down to is the frequency spectrum being used to create the illusion. Lower frequencies represent heavier or thicker objects, and high frequencies represent light thin objects. It is not all cut and dry, however. Many frequencies make up a sound object. They do not all fall neatly

into high-, mid, and low-frequency ranges. It is necessary to adjust the EQ in order to change the profile of the frequency spectrum to satisfy the needs of the visual and the overall mix.

Sounds are defined by their acoustic characteristics: water, wind, leaves ruffling, footsteps, and so on. All have certain characteristics. These textures and characteristics can be recorded or created through the use of some imaginative recording techniques and processing.

Sound textures are crucial to emulating an environment or visual object. It can also work in reverse. A sound that is contrary to a specific visual object can have a certain comical or ironic effect.

Focusing the Ear

Usually many sounds occur at a single time during a film or game scenario. Focusing the listener's ear can be a tricky proposition but is nonetheless desirable. A common way to focus a sound in a scene is to mentally reduce surrounding effects down to a few basic sounds that represent the action of the story. Think of it as a camera's point of view only for sound. The **point of audition** is the focal point for the listener to concentrate on. The creative point about this is that many different sounds can be the source of focus. This leaves the door open to invention and creativity. The camera angles, zooms, and pans can have a direct influence on the focus of the sound in linear film. In interactive spaces, particular sounds can draw the participants into areas of a virtual space where they would otherwise not have gone. A scratching at a door down a hallway invites a user to investigate. The door did not ask to be opened; the sound initiated the curiosity to open it. Linear and nonlinear visual event sounds can have different intentions, by either provoking action in a virtual space or reaction in a film, but the sounds themselves are built the same way technically. If focusing a sound is going to occur, the frequency band of the sound should be analyzed against the rest of the soundtrack or sound effects track alone. With that knowledge, you can accentuate frequencies that will stand out above the rest or are made more conspicuous within the file.

Walter Murch made the point that, within a single scene, only two sounds can be heard and understood at a time. As sound designers, this is an important point to remember. In interactive environments, there is no such thing as a scene, but the same principle remains. If you are moving through a virtual hallway, for example, the sounds of your footsteps are considered background sound. A monster growling in front of you and a whisper from behind you constitute the two primary sounds. If a third prominent sound occurred, the ear would have to set a priority to the two which have the most impact on the virtual situation. Think about this when you are listening.

Sound changes what is seen. This can be in a film or in an interactive space. The effect and power of sound on image can be astounding if in the right hands. The sound designer must consider all of the options available as well as consult with the artistic director for suggestions and approval. Underestimating the power sound has on the visual experience is what separates the amateur from the professional.

Study examples of sound and image in both film and virtual interactive spaces like games. Note what is going on. Pick up a game that has some interesting sound, like Doom 3, and use all of the cheat codes to move through the levels without focusing too much on the game play itself. "Listen" to what is going on in the game space. Then play the game and see how effective the sound is in the game space. Things to note are context, quality of sound, and sound placement, and whether they are convincing or not. Note whether specific sounds have more impact on the visual than others. Happy gaming!

The Ear

In order to manipulate a listener it helps to understand something about the mechanism that responds to sound waves: the ear.

The ear serves two functions: to maintain equilibrium of the body and to receive and convert acoustic pressure waves into a form that the brain can recognize.

The ear is a unique organ in that it is partially outside the body and partially inside. The outer part of the ear is called the **pinna** or earflap. The pinna contains ridges that focuses middle to high frequencies coming into the ear. This, coincidentally or not so coincidentally, is roughly the same range of the human voice with harmonics. The pinna also acts as a location detector. The sound, which surrounds a person, can be discretely isolated by the ear. The location of a sound is achieved by detecting slight differences in resonant characteristics of the sound. Once the sound passes the pinna, it moves toward the **auditory canal**. The auditory canal acts as an amplifier. Sound signal strength is boosted to a level strong enough to make the eardrum, or tympanum, vibrate. The canal is approximately 1 cm in diameter and about 2.5 cm long. At the end of the auditory canal is the eardrum, or tympanic membrane. All of these components make up the **outer ear**.

The middle ear is an airtight chamber between the outer and inner ear. The **eustachian tube** leads away from the ear to the throat. Air must be able to move through the eustachian tube in order to equalize air pressure on either side of the eardrum. If the air in the eustachian tube is unequal, the eardrum becomes distended. This usually occurs on flights. The act of swallowing temporarily equalizes the pressure, better known as "popping" your ears. Three bones act as a lever system to convert sound pressure waves into mechanical energy. These bones are called the **malleus** (hammer), **incus** (anvil), and **stapes** (stirrup). These are collectively called the ossicles.

The malleus is connected to the tympanic membrane, which receives the vibration. This energy sets the ossicles in motion, ending at the stapes. The stapes is connected to the oval window, which is the interface to the inner ear. The signal strength is again increased in order to set the oval window in motion. The inner ear contains fluid that requires a certain minimum amount of vibration power to produce waves.

One interesting thing about the middle ear is that it has a built-in defense mechanism against very loud sounds. Muscles in the middle ear contract when the volume gets too intense. This

contraction squeezes the bones together, thereby disallowing them to vibrate as much, and reducing the intensity of the mechanical energy reaching the oval window. When the muscles get tired, they relax and hearing damage may occur at that point. The process is more complex than stated here, but it should give you an idea of how the mechanism works. The ear is amazing.

The inner ear is surrounded by the hardest bone in the body: the temporal bone. Within this bone there are many tiny passages. In the middle of this bone is the **cochlea**. The cochlea is shaped like a snail's shell with an unrolled length of about 3.5 cm. In fact, all rolled up it is about the size of your pinky fingernail. Within the cochlea is the basilar membrane. This membrane vibrates according to the frequencies received by the outer ear and sends them on to the auditory nerve. Loosely connected to the inner part of the basilar membrane is the organ of the Corti which contains approximately 20,000 tiny hair follicles. Different follicles are affected when different frequencies are received, and these make the basilar membrane move, thereby allocating specific follicles or groups of follicles to separate frequencies. This follicular motion sends signals to individual fibers on the auditory nerve. The fibers of the auditory nerve do not go directly to the auditory cortex. They are mixed together and processed at various stops along the way. The signal identifier in the brain and how the brain processes sound as recognizable objects is outside the scope of this book, but is, nonetheless, an interesting topic.

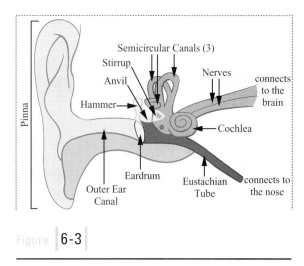

Figure 6-3

The human ear.

Protecting your ears is important if you want to keep sharp hearing. Prolonged exposure to loud sounds causes permanent hearing loss, like, for example, working outdoors at airports with improper headgear. Industrial factory workers are also at risk of hearing damage caused by noise pollution. Even small amounts of exposure to very loud sounds can cause damage, so treat your ears carefully.

The Physical Effects of Sound Events

Sound can have a profound effect on human physiology. Lower frequencies up to about 65 Hz directly affect, through resonance, the lower regions of the body, namely the legs, pelvis, thighs, and lower back. This can have an influence over certain physical and emotional centers of the body such as having an influence on the sexual and digestive components. Keep this in mind when working on your sound maps. The mid range frequencies affect the mid section of the body, particularly the mid and upper chest. The higher frequencies affect the higher parts of the body, ending with the neck and head. All of this is can play into your sound design when spotting and actually creating it.

Sound can also affect body temperature, pulse rate, breathing, and sweat glands. Amazing how something that is not smelled, seen, or touched can create such physiological enhancements. Soft tranquil music decreases heart rate, body temperature, and circulation, whereas loud, beat-centered music increases it. These particulars can be used to great advantage by a sound designer, depending on the scene.

All of these little aspects of sound contribute to an overall organic, convincing sound effects track. It may take a while to be able to fully use some of these devices, but that comes with time.

Sensitivity

The most sensitive part of the hearing range is around 2000 Hz to 5000 Hz. This critical band is where the ear responds the most effectively. The human voice lies directly in this range. Outside of this band, although the ear can pick up the frequencies, they are not as pronounced. With this in mind, mixing sounds against the human voice can be tricky if the sounds occur within the critical band. Certain characteristics need to be accentuated within the sound in order for them to be heard but not disrupt the dialogue tracks, unless that is desired. Careful consideration of the clarity of the tracks is essential.

Sound Perception and Sensation

One of the most interesting things about sound is its influence on visual perception. There are many types of listening modes we participate in when experiencing a multimedia project or film. The physical effects of sound also play an important part in visual media. Although a large field of study, it is important to grasp the fundamental concepts behind sound pereception and sensation.

Modes of Listening

According to Michel Chion, the author of four must-have books on film sound: *La voix au cinéma, Le son au cinéma, L toile trouvée: La parole au cinéma*, and *Láudio-vision*, or *Audiovision*, which is the only one translated in English to date, there are three distinct modes of listening: **causal listening**, **semantic listening**, and **reduced listening**. Causal listening is the most common. This type of listening requires that the listener hear a sound and from that sound figure out what the cause or source of the sound is. An example of a sound that signifies a source would be the sound of a finger tapping on a thick book. The sound can signify that it is a thick book and determine whether the pages are thick themselves or not, possibly indicating the age of the book to a certain extent. With visual support, this would be made clear. Without visual support, the listener would have to draw on a catalog of sounds created from a lifetime of aural experiences. The accuracy of causal listening is extremely precise within a certain limit. This limit is explained by the human's ability to recognize the source of sounds but not exactly define it, such as a dog barking. This sound would be recognized as a dog barking but the type of dog would not be precise. On the other hand, a person's voice is highly distinguishable, and the cause would be accurately estimated. This leads to the conclusion that there are two types of causal listening: unique and general.

The effectiveness of causal listening for a sound designer should not be underestimated. It can be used as a deceptive device as well, misleading and cajoling the listener.

Semantic listening, according to Michel Chion, refers to a code or a language to interpret a message. The most commonly used code is the spoken language. This type of listening is extremely complex and has been the fascination of linguists for some time. The principal behind semantic listening is the determination of phonemes and the variation in which they are pronounced while sending the same understood message.

Reduced listening refers to the listening to sound without any connotation or cause behind it. Sounds as isolated objects. This is the foundation of what is called electroacoustic music or acousmatic music. Pierre Schaeffer was one of the leaders in this field, as mentioned above. Sounds used without context, meaning, cause, or connotation leads the reduced listener into an area of focus otherwise not found. This type of listening does not come naturally. It takes a fair amount of concentration over extended periods of time and, initially, can be exhausting but in the end will sharpen the ear to such an extent that sounds become strategic. To achieve this is one of the most cherished skills a sound designer can have.

Focus Points

The ear is an amazing device. It can select sounds out of multiple sounds and focus down on them. In nature this is quite natural and most people do it without thinking. However, to convey this sense of focus in an interactive environment or film is another story.

In an audio soundscape, there is a foreground and a background. Many times in an interactive environment the sound is purely background. When a sound does surface above the background it is usually because its frequency band is distinct from the background frequency band or the dynamic volume of the foreground sound overrides that of the background.

This requires a bit of experimentation, but the payoff is fantastic. The effectiveness of detailed sound design, usually subconsciously, enhances the overall immersive space.

The Speed of Sound Objects

Sound can only be sensed and understood if enough time is given to the ear to pick up on it. Why is this important? If a scenario or environment rapidly changes, there needs to be some consistency within the distinction of sounds. The rapidity of the movement in the virtual space or linear edits of a film can cause the interpretation and cognition of sound objects to be blurred.

The human can sense sounds at different speeds.

Table 6-2. Sound sensory chart

Sonic Event	Time Needed to Sense Sound (seconds)
Sound	.001
Pitch	.013
Loudness	.05
Timbre and Consonants in Speech	.1

Sound Design Pre-production

When a project is proposed, there are a few things that need to be immediately addressed. Length of the project, fees for the project, and most importantly, the topic of the project. Following is a rough outline to guide the sound designer through the initial stages of pre-production.

A Rough Outline

The sound design process for interactive environments as well as web-based projects starts with a working concept. This concept can be anything from a design document to the mood the director or producer has in mind. Once the initial plan is established, there should be a basic sound character in your mind. A thorough understanding and research of the project concept follows the initial impression you have and the project is then "spotted" for sound or places where actual sounds are planned at specific key points. At this point, a **sound map** is created indicating the polar opposites or consistencies of the general project. Sound effects creation and design fill out the process before asset placement is commenced. A sound map is simply a visual or verbal description of the key polarizing characteristics of a projects concept. Sometimes it is a graph-like chart that shows tension and release or other parameters set out by the project, and other times it is a two-column page with the positives and negative characteristic sounds and how they will organically relate to the project. Writing these down can save time when production starts.

It all starts with an idea.

Story, Design Document, Website Proposal

When a new project is proposed, for example, a web site, one of the first things that should happen, besides talking to the artistic director or creator, is to read through the proposal design document and get a feel for what the message is going to be for the site. The character of sound should reveal itself, in loose terms, by reading through this document. If it is a game design document or a script, the text will need to be reviewed with the team leader or director as well as being spotted for sound or conceptualized for sound.

This document defines the parameters of the entire project, or in a film, it is the screenplay. Once a clear understanding is achieved, it is time to spot the document for sound.

"Spot" for Sound Effects

"Spotting" for sound is simply gaining some ownership to the design document or screenplay. This is the process of literally writing down aural ideas as the reading occurs. Usually your first impression is on target, sketched out in your rough sound map, with the outcome expected from the project. Get a pencil and start recording as many ideas as can fit on the page, between the lines, in the margins, and on the back of the page if necessary. Later this will save many hours of planning, even if it is in a rough sketch condition.

Defining Sound Effects and Sources

Once the general sounds are defined in the document, it is time to start detailing what the sounds are and where they are to be found. Options such as sound libraries and live recording have to be planned. This requires that the sound designer be familiar with certain sound libraries and recording techniques. Recording advice is given in Chapter 2 but becoming familiar with sound libraries requires some time with your headphones or monitor system. There is no way to implant a certain sound in your ear if you never heard it. A lot of listening is required. So, when you think you have accomplished a lot of work regarding sound design on a particular day, get up and listen to a few sounds from your library.

Keep in mind that if you cannot afford a sound library yourself, many libraries have them or can get them for you. There are also countless online sites with free downloadable sounds, albeit not of high quality, and fee-based sounds for usage and collection.

A good idea would be to start collecting sounds for your own sound library as soon as you read this sentence. Record, collect, purchase every sound you can get your hands on, even if you never use them in projects, they can combine to create other sounds in future work.

The Sound Blueprint and the Approval Process

Once the sound effects chart has been decided, it is time to have the work approved. Lay out the sounds in a cohesive way, usually in two columns labeled at the top with a list of words describing the sounds in each column, just like the word sound map except that these are almost finalized sounds. The two columns differentiate the most striking differences and contrasts in the project. This is the first step in creating a clear design construction for the overall sound direction for the project. If there is no clear contrast, divide the categories using frequency ranges, types of sounds used, and any other characteristic that can be defined.

Technical Playback Considerations

The world of the Internet contains as many audio configurations on user's machines as there are machines, or so it seems. When creating the initial plan for the sound design, consider what the playback devices will be. If the project is a game, then what platform or platforms will the production be for: Xbox, PS2, Nintendo, PC, Mac, or something else? If it is for the Internet, then bandwidth and the average playback system will have to be sufficient for the criteria decided upon. Compression formats also need to be considered with regard to bandwidth. In film Dolby, THX, DTS, and all of the other theater standards need to be realized before any final mixing or detailed work can be commenced.

These considerations should not be taken lightly. The sound objects created from this decision will have a profound effect on the overall mix. Be careful to get this information correct. It could save countless hours in the studio or at your desk.

Once the platform, initial intent, and general sound design concepts have been acknowledged and approved, it is time to start production of the audio assets. It is always a good idea to consult on a regular basis with the composer of the film, game, or interactive environment. Many times this is not possible because of time constraints or other political pressures that are unseen, but try to contact the composer of the project anyway. If you are going to be the composer, it should all be under control. This consultation can avoid sound and music collisions and dangerous combinatorial results. Clashing sounds during a mixing session will be addressed and fixed, but it is nice to have some warning ahead of time so that you can adjust your sound output. Dialogue, music, and sound, in that order, are how things are usually mixed for film. In games, it is slightly different because there is usually not that much dialogue and when there is, it is not covered up with music and sound effects.

The real fun starts with the production phase.

Sound Design Production

The production phase is where rubber meets the road. This is where all of the assets are collected, created, processed, or otherwise prepared for entry into the project.

Sound Asset Collection

With a detailed sound map and a clear idea of the content, you can start the process of asset collection. As stated above, this can come from sound libraries or source recordings. Either way, there will probably be a fairly large amount of them. From this large pool of sounds, most will be cut away from the list and saved for another day.

A sound object usually falls into two types: single and mixed sounds. More times than not they are mixed, so with this in mind, accommodations should be made for the multiple sounds needed to create a sound object. The accommodations mentioned above are primarily concerned with time. The results of combining audio files, such as processing, clipping potential, and other anomalies are going to occur if not watched during the creation stage of a sound effect. The point is that sound creation can take an enormous amount of time. The process of selecting sounds and generally laying them into the track is just the beginning. Once the sounds are finalized and synced up in a linear project or tested in a nonlinear project, they need to be mixed at a proper level. Mixing can take as much time as creation if the mixer is not used to the task. In some cases, it is a good idea to get someone else to do the mix, if your mix will be less than fantastic or your ears are tired.

It is also smart to have another pair of ears listen to the rough mix of sound assets in the project. This type of constructive criticism is valuable especially if the reviewer is someone you respect.

If there is going to be a music track, then the final mix is incredibly important. The music and sounds need to mix without clipping, in the first case, without masking each other in any way, unless specified by the boss, in the second case, and the sound effects must appropriately sup-

port the music, harmonically and intervallically, again if that is approved by the decision makers. Again, if possible consult with the composer. Usually, they have a pretty clear picture of the harmonic and melodic content of their own music.

Inventing Original Sounds

Originally recorded sounds are the best solution for any project. They sound better, are more fitting for the scenario, and are more original in the end. There are times when the project leader will demand high-fidelity sound effects. This necessitates the use of original sounds in conjunction with those in the sound designer's library.

There are basically two types of sound effects used in motion pictures and interactive spaces: small subject and big subject sounds. The small subject sounds are like glasses clinking, paper being crumpled, door squeaks, footsteps, cloth movement, and human noises, such as sneezing and coughing. These are usually recorded in a studio or by Foley artists. Most likely, you will be doing most of the recordings. If you do not own a studio, which probably is the case, a small quiet place will have to suffice until you can afford a small whisper room or isolated studio chamber.

Big subject sounds are usually sounds that need to be recorded outside. These include explosion, gunfire, crowds, cars, planes, trains, and machinery. If the producer has decided to go with original sounds, such as those mentioned above, then a session needs to be organized that may include permissions and legal clearance. Make sure you cover your bases. Under professional big budget situations, a **sound designer, sound effects editor** or a **sound effects recordist** is called in for the job. On a typical game budget or web job budget, these sounds need to be gained through some invention. Most times these sounds will be retrieved from prerecorded libraries but it is wise to have the "chops" to go out in the field and do some recording yourself. How do you get the sound of an airplane or train? They could be designed from sounds that are not source sounds to begin with. A few techniques (listed in filmsound.org) can be used to alter the sound shape of recorded source sounds which do not necessarily represent the sound effect desired. This list used to apply to the analog recording process; today they are all possible with software and digital processing.

When the opportunity to record out of doors exists, it is wise to examine examples of what the pros do. To start, more than one recording device is usually on site for different sound perspectives. A bullet shot and impact would be a good example. One digital audio tape (DAT) machine, Nagra, or hard drive recorder could be placed near the actual gun shot and one recording device could be placed near the object to be impacted, like a plank of wood. The combination of these sounds would be effective, but if another recording device is placed under the bullet shot, recording the sound of the bullet passing, it would make the sound even more convincing. College students can check out gear from their multimedia or audio departments. Plan a session and book the gear. Grab your friends and go out and get some good sound effects. There are many great solutions to recording and creating your sound effects. Use all of the available tools at your disposal including your brain.

Creating original sounds requires experimentation, a lot of experimentation. Use your imagination and see if your ideas are practical. If it is raining, troubleshoot the situation and get the recording. Do not let inclement weather or other meaningless obstacles get in the way of the work at hand.

Sound Processing

Altering or enhancing sounds to fit a scenario is like working on a sculpture. The sounds need to be shaped to fill the need. This shaping can occur through the combination of sounds, mixing together to form new sounds, or sounds processed to a certain degree, again forming a new sound. Ben Burtt, the sound designer for "Star Wars," had some very creative ideas about getting the specific sounds that George Lucas wanted. This kind of ingenuity is par for the course as a sound designer but do not expect to be a Ben Burtt tomorrow. Next year, maybe!

Below is a table of the sounds from the original "Star Wars" motion picture trilogy: Part IV, V, and VI and how they were constructed. Keep in mind that this is a predigital world that he worked in, for the most part. This information and much more about "Star Wars" sound can be found online at filmsound.org.

Mix and Mastering the Effects Tracks

The final stage of production is mixing and mastering the sound objects. In film, the re-recording process integrates all of the elements together and mixes them into a composite sound-

Table 6-3. Sound effects design in "Star Wars"

R2D2	Half of the sounds are electronic and the other half are vocalizations, water pipes, and whistles
Imperial walkers	A machinist's punch press along with the sounds of bicycle chains dropping on cement
Light saber	An old TV set along with the hum of a 35-mm projector mixed together
Laser blasts	A hammer hitting the wires of a radio tower
Tiefighter	An elephant's bellow altered in various ways
Speeder bike	A P-5 Mustang airplane and a P-38 Lockheed Interceptor combined and mixed
Luke Skywalker's landspeeder	The sound of the Los Angeles Harbor Freeway through a vacuum cleaner pipe
Chewbacca	The sounds of walruses and other animals combined together
Ewokese language	The combination and layering of Tibetan, Mongolian, and Nepali languages

track. In interactive environments, each object should be mixed in its own right. The sound programmer then takes the assets and incorporates them into the game engine or virtual space.

Currently there are options for composers and sound designers to work more closely with the programming side of the equation. Many times the control of assets is taken out of the hands of the sound designer and put into the hands of the programmer. This is the way it is for now.

Music, Sound Effects, and Dialogue

The integral parts of a soundtrack are the dialogue track, the music track, and the sound effects track. These three entities need to be properly mixed and placed in order for effective transparency and clarity to exist. The soundtrack should support the visual content and story line at all times. If a sound or clip of music comes through from the background, it should be meant to be conspicuous in the story line. If the music adapts to the movement of character in a virtual space, drawing attention to itself, it should be meant to. In other words, drawing attention away from the story or visual content through the use of aural distraction can disrupt the user's flow, either in the linear sense or the nonlinear sense. In the case that the distraction is needed or suggested, then it should be done.

A solid mix, smooth transitions, and credible music and sounds make up a rich and interesting soundtrack. The supervising sound editor is usually responsible for all of the assets, the final mix, and the overall outcome of the sound on a project. The sound designer may be called on to perform these chores in lower budget or smaller situations, which means that some knowledge of these three integral audio assets—dialogue, music, and sound effects—are necessary.

The Importance of Music in Linear Visual Content

Music has a magical effect on the emotions. It can provoke happiness, fear, anxiety, peace, tranquility, hostility, sadness, and just about any feeling in the emotional pallet. How this is accomplished is up for debate, but one thing is certain, music can completely influence a visual experience.

We have all experienced the power of music in film. Movies with outstanding music tracks have the impact of making the music a character in the story. A recent example of this would be the score of the "Lord of the Rings" by Howard Shore. The themes permeate the story on a level that transcends the literal storytelling, thus creating an identity all of its own: the Mordor theme, Frodo's theme, and so on.

Evoked emotions are everywhere in this trilogy. No visual can capture the emotional content of the scene after Gandalf's supposed demise in the "Fellowship of the Ring" like music can. The delicacy, orchestration, and pure economy of a line are beautifully crafted in this particular scene. No doubt, the whole score is amazing and there are many highlights to mention. An older example of how music can form an identity in the film is in "Jaws." That two-note theme

that John Williams composed is so simple yet creates a level of fear that is more than the sum of its parts. As mentioned in Chapter 5, dissonant intervals create a sense of uneasiness. The "Jaws" theme is built on the interval of a minor second, one half step. This is a very dissonant interval and the melodic usage of it along with the heart beat imitation of its rhythms taps into the very fabric of human physiology. It is amazing what two notes can produce when supporting a visual. At the beginning of the movie, a girl is attacked off the coast of a beach by a shark. The music grows and grows until the attack, and first-time viewers are petrified in their seats. But if we take a closer look, the shark is never seen during the approach and attack. The music track created all of the character of the shark, and the low lighting and camera angles, especially under water, created the visual fear factor. No shark was seen! Amazing.

If a nonlinear project requires cut scene linear material, remember the effect music can have on the visual content. Get yourself a composer or consult with the project leader to determine the best composer for the job and start working with him or her. You are not expected to be able to compose the music, but you are expected to know how music can influence visual meaning.

Separation of Frequencies

There are three general bands of frequencies that are all subdivided into discrete bands. The low, middle, and high bands are separated loosely into the band widths listed in Table 6-4.

These frequency bands need to more or less be separated in the final mix of a soundtrack. If the music contains low frequencies and the dialogue contains low frequencies, then there is the potential of masking. The worst-case scenario would create ambiguity between the music track and the dialogue track. The sound effects track usually has a pretty wide frequency spectrum. This spectrum can enhance the other sounds or block them to some degree. If a situation arises where the music and dialogue tracks conflict with the sound effects track, then the sound effects track needs to be equalized, band limiting certain frequencies, enabling the other tracks to fill in the holes. The mix can also alleviate some of the problems encountered when soundtracks collide regarding frequency.

Pay close attention to the separation of frequencies in an overall soundtrack. While sound effects construction is underway, consider the frequency bandwidth of the particular sound. This may eventually have to be altered to accommodate the rest of the soundtrack.

Table 6-4. Bandwidths of the three general frequency bands of the audio spectrum

Bands	Frequency Range
Low bands	20 Hz (ca.) to 250 Hz (ca.)
Middle bands	250 Hz (ca.) to 4000 Hz (ca.)
High bands	4000 Hz (ca.) to 20,000 Hz (ca.)

Creating Consonance and Dissonance Within a Soundtrack

In Chapter 5, the ideas of consonance and dissonance was introduced. Certain musical intervals combine to form consonant and dissonant traditional intervals. This harmonic base is carried through today in film scores as well as other places in the composition world. Separating frequencies is

important for clarity and precision, but how do these three entities combine as a structure unto itself? Do the sonic events, regardless of the visual "underscore," create consonant or dissonant sounds? Is the combination of sounds pleasant, abrasive, or offensive? The devil is in the details. If there is a scene in which a girl is kissing a boy, the sound effects that surround this moment, as well as the music, must support this emotional expression. Sounds, which create friction within themselves or with the music track, must be avoided in this circumstance. At this point, realizing something as simple as "that combination sounds good to my ear" or "that combination sounds harsh to my ear" is fantastically important. Classifying these into consonant clusters and dissonant clusters helps create the sound character for the film. The same theory can be said for sound and music in combinations regarding virtual spaces. Harsh sounds raise your level of tension and pleasant or nonaggressive sounds relax the tension. Do you see the potential for misleading and fooling a user in a virtual space? There is much work to be done with these concepts regarding games and interactive virtual spaces. It is hoped that these and many more great ideas will come out of them.

Intervallic Relations in Music and Sound Design

Intervals in music play an important part in conveying emotion and setting. These intervals combined with other intervals create harmony. The treatment of music can be applied to sound design as well, albeit in a much looser fashion. According to Friederich Marpurg (1718-1795), in an attempt to categorize mood states, progressions, rhythms, and harmony into acoustic equivalents, there is a defined emotion attached with an acoustic expression. Some of the categories are not specific emotions but rather are more personality traits.

Some of this is a little outdated. That is to be expected. In a more modern context, specific intervals have been described by music and sound therapists as well as by theoreticians and musicologists as containing emotional characteristics. These play directly into how music and sound influence visuals. Musical intervals can be broken down into specific frequencies, but what is more important is the distance that makes up each interval. In the previous chapter, it was seen in the intervallic multiplier chart how base frequencies could be calculated to get certain intervals. If the same method is applied to sound, some interesting results occur.

The intervals presented below are the generally accepted characteristic emotions created by standard Western intervals. These are also found in David Sonnenschein's book *Sound Design The Expressive Power of Music, Voice, and Sound in Cinema*. In fact a plethora of information regarding the inner meaning of music and sound can be found in this book. I would suggest this book as part of your permanent collection as a sound designer.

Sound effects can be as simple as putting sounds together and dropping them into a linear or nonlinear project. But more attention can and must be given to sound effects, especially when a specific mood or atmosphere is being set. Creating an interval out of the sounds that make up a doorknob turning or the combination of a truck passing and the squeak of a stroller in the street can directly influence the message of intention of the scene or interactive space.

Table 6-5. An older view of how acoustic sound can influence emotional states

Acoustic Expression of Emotional States by Friederich Marpurg (1718–1795)

Emotion	Expression Associated with Emotion
Sorrow	Slow, languid melody; sighing; caressing of single words with exquisite tonal material; prevailing dissonant harmony
Happiness	Fast movement; animated and triumphant melody; more consonant harmony
Contentment	A more steady and tranquil melody than with happiness
Repentance	The elements of sorrow, except that a turbulent, lamenting melody is used
Hopefulness	A proud and exultant melody
Fear	Tumbling downward progressions, mainly in the lower register
Laughter	Drawn out, languid tones
Fickleness	Alternating expressions of fear and hope
Timidity	Similar to fear, but often intensified by an expression of impatience
Love	Consonant harmony; soft flattering melody in broad movements
Hate	Rough harmony and melody
Envy	Growling and annoying tones
Compassion	Soft, smooth, lamenting melody; slow movement; repeated figure in the bass
Jealousy	Introduced by a soft wavering tone; then an intense, scolding tone; finally moving and singing tone; alternating slow and quick movement
Wrath	Expression of hate combined with running notes; frequent sudden changes in the bass; sharp violent movements
Modesty	Wavering, hesitating melody
Daring	Defiant, rushing melody
Innocence	A pastoral style
Impatience	Rapidly changing, annoying modulations

Table 6-6. Harmonic intervals and emotional characteristics

Interval	Emotional Quality
Perfect octave	Completeness, openness, unity
Major seventh	Spooky, eerie, off-center, strange
Minor seventh	Expectant, suspenseful, full but unbalanced
Major sixth	Peaceful, balanced
Minor sixth	A bit sad, soothing
Perfect fifth	Power, centering, strength, victory
Tritone	Horror, terrifying, scary
Perfect fourth	Ethereal, lightness, transparent, clarity
Major third	Neutral, hopeful, resolved, nonabrasive
Minor third	Uplifting, relaxed, positive feelings
Major second	Unresolved, unsettled, unpredictability
Minor second	Unclear, tense, anxious, uneasiness
Perfect unison	Peace, strength, calmness, security

An example would be to calculate an interval for a set of sounds. Using the intervallic equivalence chart, figure out what the interval of a perfect fourth above 40 Hz would be. This frequency is not in the normal spectrum of accepted musical notes in the equal temperament system, so basically you are dealing with a sound outside of this musical world yet adhering to its proportional rules.

If we consult the chart, we see that by multiplying 40 Hz by the ratio equivalent, which is 1.33483, the result is 53.3932 Hz. Now this is awfully precise, too precise for our ears, so if we reduce this to something like 53.4 Hz we will have achieved roughly the same thing when dealing with sound, not music. The trick is to adjust a sound, which will be combined with the 40 Hz sound, to equate something close to 53.4 Hz. This is a very low interval and extremely muddy. If we raise the 53.4 Hz frequency up two octaves:

53.4 + 53.4 + 106.8 = 213.6 approximately

Figure 6-4

53.4 Hz multiplied by 3 yields the frequency two octaves above the fundamental frequency.

Two octaves above the 53.4 Hz frequency in combination with the 40 Hz frequency has the same effect as the original fourth because of octave equivalents. The separation of the octave still preserves the interval. This sound might be more attractive now with a little more high end accentuated. The sound would have to be checked against the rest of the soundtrack during the mix to see if any adjustments needed to be made regarding the separation of frequencies, but now you have a group of sounds that follow, more or less, the emotional state of the scene.

All sound can be equated to a core frequency by using a spectrum analyzer. A sound effect will contain a certain band of frequencies more concentrated than others. This band yields the core frequency for the sound.

Every sound can now be equated to an interval, and that new sound interval can be combined with music to create a truly organic sound experience. It requires a lot of extra sit-down time but it is well worth it in the end. Not every sound effect will require such an extensive workover, but it does open up some great possibilities.

If you thought you had a lot of work to do before reading this last passage, you now realize the untapped potential of using theoretical music approaches applied to sound. The results are better than you think for putting in all of that work. Again, not all sounds need this kind of attention, but generally the more work you put into sound design, the greater the rewards when it all comes together.

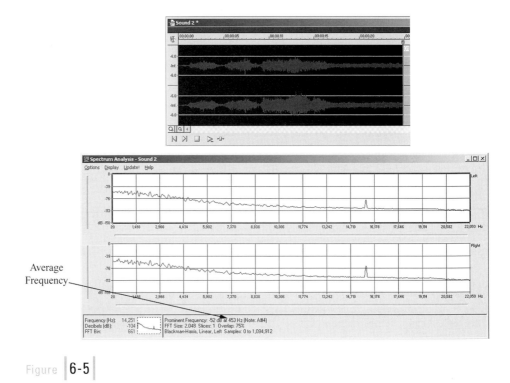

Average
Frequency

Figure 6-5

The core frequency of a sound effect through a spectrum analyzer.

SUMMARY

The creation and application of sound effects into a virtual environment or linear visual media, like film are similar processes. To study sound design for film is, in fact, studying the same concepts as those for interactive spaces. There are slight considerations concerning nonlinear connection points or overlaps, but the general rule of sound construction remains the same. Practicing the art of sound effects design is a task not to be taken lightly. The amount of time is considerable for the very reason that options are literally limitless and the techniques need to be experienced before committing to a project.

Working with the above concepts will enable a sound designer to build a solid body of work for the visual media. The knowledge and techniques presented are to be fostered over time. Giving time to understand and absorb the concepts is vital to achieving the goal of becoming a professional sound designer.

in review

1. What is the emotional significance attached to intervallic relationships and visual content?

2. What is the difference between on-track and off-track sounds?

3. Describe the usefulness of a sound map.

4. What are Foley sounds and where are they used?

5. Given a 230-Hz tone, what would be the frequency of a tone a minor third above it?

exercises

1. Create a small sound clip of 15 seconds. Combine three to five sounds together in some organized way as to create clarity and precision of intention. Process the sounds however you like. Render the file at CD-quality audio in your favorite file format.

2. Compose a sound sculpture lasting 3 to 5 minutes. Use all and every sound you can get your hands on, but do not use musical sounds like songs or instrument sounds. Work solely with sounds.

```
<html>

<head>

</head>

<body bgcolor="white">

<A Href="yourfavoritesound.mp3">Push to hear</A>

</body>

</html>
```

sound design for the web

objectives

Web-based sound design

Key areas of implementing sound and music into a web space

The effective and ineffective use of sound along with strategies to create web sounds

introduction

Using the sound design techniques and strategies mentioned in chapters 5 and 6, you can now apply sound competently in a web-based environment. This chapter explores the key areas of implementing sound and music into a web space as well as the significance of sound in a typical site. The effective and ineffective use of sound along with strategies to create web sounds are also covered.

AUDIO ON THE WEB

The world of combined media types, sometimes known as multimedia, that has permeated the world wide web is absolutely astounding. Content-driven pages have gained a new dimension of perspective due to the addition of video, animation, graphic design, and most importantly, sound.

One of the most interesting things about the Internet experience is how all of the given media types are starting to combine in an effective, convincing way. With the ever-increasing bandwidth available, the motivation and opportunities of integrating assets into a true multimedia are becoming possible. This is an exciting time. Just a few years ago, it was not really possible to listen to high-quality audio on the Internet without downloading the file and then playing it. Today, through the use of compression standards like MP3 and others it is possible to listen to relatively high audio quality through Internet streaming. The gaming industry also has increased its audio resolution output considerably, contributing, as a result, to the invention of better technologies usable for the web.

Sound applied to a website has the unique ability to heighten the participant's engagement level without eye candy. It is more like "ear candy" but with a much more direct intention. The implementation and placement of audio into a website is not really difficult, as long as you have some basic programming skills or resources, such as HTML, XML, JavaScript, or any of the higher level programming languages. Although this chapter presents some of the concepts behind implementing audio, programming audio into a website or Flash environment is not addressed. These topics can be better investigated by reading and learning the tool you are using as well as the code associated with it. If you use Macromedia Director, then you will have to study Lingo, if you use Macromedia Flash, you will need to know ActionScript, and so on. With a little knowledge you can go a long way with audio in a website, however. The issue is not getting the sounds to work and trigger correctly on a website, it is the selection and type of sounds to use in that website. The focus for you will be the choice and development of audio assets for a website.

There are many editing tools available that make audio implementation and, in fact, all asset integration relatively easy (e.g., Dreamweaver and Fusion), but you should also know the hard coding that goes with it. Being able to troubleshoot situations within the coding structure of a website using hard coding skills is an invaluable asset. Even if you do not have the hard coding skills, try them anyway. They will make you realize how important programming is.

Sound Advantages to Web Audio

There are many advantages to adding sound to a website. The clear advantages of sound are providing another dimensional aspect to the experience, creating otherwise unseen intentions to a website, and adding another sensory perception to the multimedia experience. A cursory glance at websites indicates that often the audio selection or quality is lacking in consistency or decent production standards. You can remedy this problem.

Where to Start?

The job of a sound designer on a website is a little different than that of sound designer for film. The first aspect of web audio is the fact that it is partially, if not fully, nonlinear. This implies that sound objects will be used, and in many cases, so will looped music. A **loop** is a fragment of audio that is prepared to infinitely repeat if programmed to do so. This keeps your sound files small rather than using entire pieces of music, which may be impractical due to size and bandwidth limitations. Usually the sound designer on a website is the same person building the site. Eventually, the sound component of websites will be taken a bit more seriously, and people with knowledge regarding sound and music will be brought in to enhance the overall experience. Some websites have dedicated sound people, but this increases the budget for the site. Many times the web designer is the proxy audio person on a project, which may explain the less than fantastic audio results on the Internet. Sometimes, however, there are outstanding examples of audio found on websites and no sound person worked on the site design. This goes to show that designers are learning more and more about overall website design, including the audio component, and are slowly managing it themselves. A very good site for sound design in combination with visual content can be found at www.debauer.de. The level and impact of the sound is impressive and fully supports the theme of the site.

The first thing needed to commence work on a website is the concept or details about what the website is about. From this point it should be determined whether there will be music, dialogue, sound effects, or some combination of these.

If there is going to be music on the website, then you must determine whether it is going to be original or prerecorded somewhere, which may require needing permissions. If the former is selected, then who is going to compose the music and prepare it as a loop or entire composition? Sometimes you get unoriginal music composed by someone who is not familiar with the process and techniques of composition. The result is music that could well turn people away from the site. It is ambitious to try to pursue music composition as a skill set along with all of the other things you need to know in order to become a proficient sound designer, and the time it takes to develop such skills is considerable. With multitrack editors like ACID, it is easy to line up a few looped tracks and call it music, and it may very well achieve the goals that you want, but what is most important is for the participant to be exposed to professionally recorded music written by professional composers or song writers, and initially that is going to be what is expected. Work and experiment with loops. See what you can come up with. If you think it is convincing, then have someone you respect listen for critical analysis. If you decide to take your musical skills a step further, find a teacher of composition and learn more.

The music has to be defined as to where it is intended in the site. Does the music start as soon as the participant loads the site or is it triggered or streamed in some way? Does every page have music? If so, is it the same music or a mixture of compositions? What will the volume levels be? Who is the intended audience and what is the style of music? These along with many other questions, which are site specific, need to be answered in order to start the music component of production, either by creating it yourself or hiring the help to do it for you.

If sound effects are needed, there must be specifically defined areas for them. In a website, these are usually attached to some user event like a button, rollover, or slider, or they act as a transitional device between two pages or to another area of a single page. Before production, the number of interactive objects, or at least the number of sound objects, needs to be defined

A professional may earn approximately $75 for each sound effect, with labor, gear, and time included. This may be a little expensive for website designers, so a library of sounds is typically used. This results in typical sounds for the site, if used straight from the box, possibly making the site itself less than interesting. In other words, there should be some degree of processing and sculpting to each and every sound that goes into a project. Make them yours!

Narration must be treated with care. Many different types of narration are used on the Internet including voiceovers, interviews, dialogue, newscasts, and the accompaniment of speech with text. The first and foremost requirement, however, is that it must be understood and be as clear as possible. Remember that the range of the voice is relatively small and a mono file will do just fine for dialogue. This also creates a band in the soundtrack that needs to be left open, or relatively unobstructed, and not occupied by other loud sounds or music focused on this band.

Compressing voice tracks, that is, file compression and not audio compression, can leave loud, audible sound artifacts. It is not that there are more artifacts, it is just that they may be more audible due to the nature of the sound material: Many silent breaks between words leaves room for problems to be heard. MP3 compression seems to work well for the voice as with other sound files. A typical web voice track is 22,100 Hz sampling rate, 8-bit, mono. This could be a Wav or Aiff file and sound relatively clean. This is also moderately small. There are files with a much lower resolution. Your ears will eventually be able to pick them out of a crowd.

Once the areas of sound have been discussed and agreed upon in a project, production should start regardless of whether the website is in production or not. Sound assets potentially take a long time to create and time should be allocated for them. If it is a rush job, put the coffee on.

Audio Assets for the Web

Audio assets are the core of the soundtrack. These assets consist of the three above-mentioned areas of sound: music, sound effects, and narration. Each one should be crafted in such a way that will satisfy the needs of the project. Button sounds, for example, can have many distinct sonic implications for a website.

Repetitive sounds, which can be annoying after the first play, can be problematic for the participant. An abrasive sound can keep people from enjoying or interacting with the website. This situation should be avoided. Logic dictates that aggressive or abrasive sounds have a particular place and fill a particular need. Most of the time, the web master wants people to stay at the website and browse. Harsh sounds can drive someone away in a hurry.

The editing, processing, and mixing of sounds all contribute to the final sound asset. Most of the time, the audio assets are short and distinct. With a limited amount of audio playback time to deal with, it is important that the sound captures the feel and intention of the page or site in general. A news site, for example, should not have techno sounding transitions or button sounds, unless the news is about techno subjects of course. Use some logic when preparing your strategy or plan for a proposal and be sure to get your ideas approved before production.

Website Intention and Scope

The overall scope and scale of a website is important information that needs to be analyzed and worked on. These data will determine how organic or inorganic the overall sound design will be. For smaller sites, the scope of the web content may cover 10 to 30 pages. This would be relatively easy to map out and build a sound plan for; however, the compressed nature of the site may require specific sounds that infer more than just a bell or whistle when you push a button. The sound may directly act as part of the site, as a "character," if you want to think of it that way.

In larger sites, with hundreds of pages, a larger sound map may need to be created. If all of the pages are to be cohesive, an organic sound track must be applied. Planning, again, should be achieved with consultation with the web master or project leader.

The user of the website is also a consideration that needs to be addressed. This could, as mentioned above, change the entire character of the site. There is a vast amount of website content available on the Internet. Health care should not sound the same as a children's learning site. A sports site should not sound the same as a commercial industry site. The target audience should already be determined, but if your position in the project dictates, you could make a few suggestions if you have any. Most of the time you will do what has been decided by the web master or manager of the site, but keep your head in the game and put your comments in where you feel they are needed. Do not be shy about this sort of thing. More times than not the person in charge will welcome the input.

Asset Creation

Combining and forging sounds goes hand in hand with editing and adding processes to them. One of the most critical aspects of audio editing is the loop.

Selecting Sounds and Loops

Many of the music tracks of web sites are made up of loops. The creation of loops, whether it is a music track or a sound effects ambient track, is a technique that must be understood and practiced to perfection. Many jobs, including those outside of web audio work, require loop creation to a certain degree. There are a few ways of creating loops, but there is one standard technique that is used often and yields great results.

Open up a sound file that you would like to create a loop out of in your favorite multitrack editor. If you want to start this process in a stereo editor, that is fine, but at a certain point you

will have to migrate over to a multitrack editor. Sounds like explosions and other percussive sounds are not usually used as loops except for drums, which set up a beat. The example used below is an ambient sound effect.

An ambient audio file.

The first thing to do is to locate an area about three fourths into the file. Here you must find the zero point on both of the stereo files. Many times this is possible, but if it is not, try to get as close as possible.

Marker at zero crossings

Figure |7-2|

Mark the file approximately three fourths of the way through the file.

Zero crossings

Figure |7-3|

A close-up of the zero points.

Once the zero points are found and marked, cut the last one fourth of the file and paste it to a new file.

Figure | 7-4 |

Remove the last fourth and place it into a new file.

At this point, place the new track you just created under the original track in the multitrack editor at the beginning of the track. If you were working in a stereo editor move your files over to a multitrack editor for this part.

Figure | 7-5 |

Place the cut portion of the file below the original file in a multitrack editor.

A fade-in needs to be added to the beginning of the original file, and a fade-out needs to be added to the cut part of the file. Basically you are creating a cross fade. This may take some time to get right. The fade usually does not fade entirely to zero nor does it fade in from zero. Play around with the fade tool that is part of your editor to get this sounding as seamless as possible.

Figure **7-6**

Fade the two files.

Now when you play the file as a loop you will hear a continuous stream of audio with no apparent point of separation between the end and beginning of the file. When this sound is looped together, the cross fade will be seamless every time. This is a very useful skill. Learn it well; its importance cannot be overstated.

Combining Sounds

The technique of combining sounds is very effective. Care must be taken when mixing the two so as not to clip or cause masking of one file or another.

Open two sound effects in your favorite multitrack editor.

Figure **7-7**

Two sound effects opened in a multitrack editor.

Now play the two together and see if they sound like anything. The goal here is to get an idea of the composite sound. You will still be able to hear the original sounds but after some processing you can change this and shape it into many different things.

It is always a good idea to work on sounds individually in a stereo editor and then export them out to the multitrack software.

Open your two sounds in your favorite stereo editor. Now pitch shift one of your files down about 12 semitones and reverse the other file. Make sure the preserve duration box is checked so that the processed file will still be the same length.

Bring these sounds back into your multitrack and listen to them. Make further adjustments until you get something you like.

A good habit to get into when just starting out with sound is to just create sounds using various combinations. Come up with some interesting sounds. You will catalogue, in your head, the processes you went through to get them and will be able to quickly create sounds in the future.

Tips for Web Sound Design

A few guidelines to get you started in sound production, particularly sound effects production, will help eliminate some of the potential time-wasting efforts usually encountered at the beginning of a project. Above is given just one idea to help increase speed when creating sound effects.

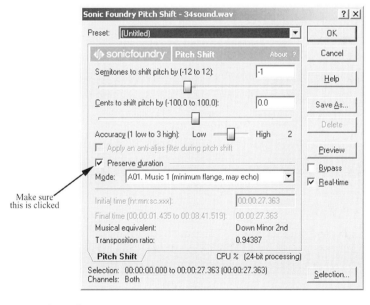

Make sure this is clicked

Figure | **7-8**

Be sure to check the preserve duration box.

Gary Rydstrom, the sound designer of such classic movies as "Jurassic Park," "Saving Private Ryan," and "Titanic," has come up with a few suggestions to help with your initiation into sound design. These were originally written with film sound design in mind but can transfer directly into web sound design techniques.

- Pay attention to the sounds around you in your everyday life. Imagine how you would re-create them with effects.
- Focus on sounds that have the highest emotional impact.
- Use silence in your soundtrack.
- The audio elements should have a harmonious rhythm or pattern when played in sequence.
- Keep your soundtrack varied
- Keep your soundtrack simple
- Try to orchestrate the sounds in your mix so that they use the entire frequency spectrum of bass, midrange, and high-pitched tones.

The sounds that you hear everyday can be emulated in some way. It is constructive to try to copy the sounds using various combinations and processing effects. Many times you will come up with sounds that are not the original source sounds but that will work well in your website anyway.

Sounds that have the highest emotional impact, in terms of sound in a website, occur when the overall organic strength of the soundtrack has been addressed. Buttons, sliders, transitions, menus, and all of the interactive elements in a website, if sound is applied to them, should all relate thematically in some way. Try to achieve this relationship using timbral similarities or pitch equivalents, exploiting the frequency spectrum. Experiment and come up with your own approach.

The use of silence, mentioned above, can have a significant impact on the film or project. In a website, the intention is the same. Let some of the visual accompaniment do some of the communicating. The points where sound is not used can focus the participant into one specific area of the website. The entire site is usually not a continuous soundtrack anyway. Listen to a few of your favorite sites and determine the balance for yourself. Address them and make notes for your own work.

The soundtrack should have a certain flow to it, rhythmically speaking. In film this is easier to achieve because of its linear nature. It is easier to plan certain types of rhythmic motifs constructed out of sound effects in a linear space. Websites are a little more unpredictable. A user might have a menu area to choose paths around the website from. The sounds that represent the menu should not all be the same, even though you hear this all of the time in reality. The combination of the different sounds produced when a mouse rolls over them should produce something relatively rhythmic, no matter what order they are rolled over in. You do not need

to have a good sense of rhythm to achieve this. Many people have a pretty good sense of rhythm but do not realize it. Again, use your ear and your sense of flow when analyzing and creating this kind of material.

As mentioned above, a rollover menu should have varied sounds, not the same sound every time. This would be a great place to apply some of the theoretical material learned in Chapter 5. Combinations of certain intervals and chords can go a long way in many contexts.

Simple soundtracks are always preferred by a participant. A complex, distracting soundtrack can and does remove the participants from the content of the website and brings them somewhere else, usually away from the site due to the complexities or poorly combined sounds.

Finally, exploiting the frequency spectrum bands is crucial to an interesting and dynamic sounding soundtrack. Use those lows, mids, and highs in creative combinations to achieve an interesting site.

Things to Avoid

There are a few things to avoid in a web design. The first is to never embed sounds on the first page of a web site. The Mime (Multipurpose Internet Mail Extensions) types may be different or any of a hundred other things may prevent your audio from being heard when someone first loads your site. In some cases, it can crash your browser. Another thing to avoid is the monotonous loop. Keep the loops attractive to the ear. The participant will grow tired quickly if an incessant loop is running in the background. A final no-no is using low-resolution audio and low-quality audio. Poor recordings will sound even weaker on the Internet.

Audio Implementation

Applying sound to a website can be confusing at first. There are various ways for participants to receive sound from the Internet. They can download the sound and play it or they can stream it, which means that they can start listening to the sound as it is "streamed" from the Internet into your computer. This chapter deals with the downloading portion of audio. As a sound designer, you should be familiar with placing audio assets into a website, but due to the massive amount of editors, markup languages, and other sound-implementing tools, the basic structures of the most basic web language are given below. A simple **HTML** (**Hypertext Markup Language**) example using Mozilla Firebird as the browser provides a rudimentary look at some code and how audio fits into it. As you start to move into the programming side of website development, more information can be gained regarding the specific tool you will be using from various websites and the user manual of the software you choose.

Placing Audio in a Website Using HTML

Below is some simple code that would work with most of the commonly used browsers. It is written in HTML and gives the user the option to click on a link, or picture, if you input one, and hear an audio clip.

```
<html>

<head>

</head>

<body bgcolor="white">

<A Href="yourfavoritesound.wav">Push to hear</A>

</body>

</html>
```

Figure 7-9

HTML code for hearing a sound when clicking on a link.

```
<html>

<head>

</head>

<body bgcolor="white">

<A Href="yourfavoritesound.mp3">Push to hear</A>

</body>

</html>
```

Figure 7-10

Inserting an MP3 file works just as well.

You could also have other types of audio files like MP3. The code would look the same as above except the MP3 file would be inserted.

Once you are more familiar with HTML or your favorite web editor, embedding audio becomes easier. As stated above, having the ability to hard code is very useful.

There is much more to learn about implementing audio assets into a website and you are highly encouraged to find the solutions to as many audio implementation questions as you can find. Most likely, the web master will be able to code in your work, but it is always useful to increase your skill sets; they may earn you more money in the future.

SUMMARY

This chapter introduces you to the world of web audio. Techniques and strategies are given to accomplish the job as a sound designer. Although there is much more to learn regarding the implementation and programming of audio assets, a brief example of the most common devices for implementing sound on a website are given.

in review

1. What is a loop?

2. Sound is a great addition to a website. Explain where sound is not a good option.

3. Write three possible ways to put sound into a website.

4. How does Flash deal with audio files as far as transmission is concerned?

5. What is the zero crossing of a file?

exercises

1. Create 10 loops using sounds created from source recordings or sound effects libraries; try to avoid using any pitched material for your loops.

2. Embed a sound file as a link in a basic web page.

streaming and midi

objectives

The principles of streaming media and the concepts of MIDI

Fundamentals of streaming media technologies and protocols

introduction

This chapter describes the principles of streaming media and the concepts of MIDI. The fundamentals of streaming media technologies and protocols as well as MIDI functionality are covered.

STREAMING AND MIDI

STREAMING

There are two audio concepts commonly used on the web and in the studio: streaming media and MIDI. A rudimentary understanding will help provide a framework from which to investigate further. Although not directly related to sound design, streaming media and MIDI play such an important role in today's audio world that it would be neglectful not to include some of the key points associated with them.

Streaming media can be defined as the use of media content, sent via the Internet, through a dedicated stream of data to a participant who locks into that particular flow of data. Audio streaming follows the same rules as all of the rest of streaming media types, so the phrase streaming media is used herein as a general term to describe audio streaming.

You may tune into a stream as it occurs live. This is known as webcasting. Streaming technology allows the same stream to be delivered to many participants at different Internet connection qualities. Some people may have a smaller amount of bandwidth, like a dial-up modem, and are only able to receive a lower quality stream, whereas someone with a cable or DSL connection, or better, will be able to receive a higher quality stream due to the more robust bandwidth. In most cases, when you access a web page from the Internet, a host server or other computer storing the file that was requested, is connected via the browser. The computer retrieves the file from the server and downloads it into the browser window or stores it on the hard drive. This requires a certain amount of time before you can access the data. Streaming technologies allow content to be accessed as soon as the request is made to the server. The data are "streamed" and do not need to be fully downloaded before reading the content. Streaming, however, is usually best effort and time based, and delivery is not guaranteed.

To take advantage of streaming media and webcasts, a decent graphics card, sound card, and speakers are required. Some kind of software media player is required as well. Common streaming players include Microsoft Windows Media technologies and RealNetwork's RealSystem G2.

Streaming Issues

There are a few major components responsible for the quality and speed at which you receive a streaming data file, either hardware or the software and the code used to send or compile the data. Below are some of the major contributors to how streams of data stream.

SMIL

SMIL (Synchronized Multimedia Integration Language) was created by the World Wide Web Consortium (W3C). SMIL is similar to other markup languages like HTML (Hypertext Markup Language), but it allows developers the ability to code multimedia into a website. This means that multimedia content can be divided into separate streams that can be played back as a single stream representing the individual parts of the multimedia content or combined

into a multimedia experience. The advantage is that it makes files smaller and faster to access. The true advantage to SMIL is that it allows different types of multimedia content to be combined in creative and efficient ways. This is made possible because SMIL is derived from XML (Extensible Markup Language), which allows commands that affect content to be defined rather than specifically defining the content objects through given tags.

Bandwidth

Bandwidth is the key to high-quality streaming media. Bandwidth represents the capacity of a network to carry data to devices like computers. The network transmission speed can be blistering, but if the capacity is not available, lower quality media will occur. You may have experienced poor streaming media files, particularly audio files in the Internet. Sometimes this occurs because many participants are trying to stream from the same source at the same time and the capacity of the network cannot handle the traffic. If everybody is trying to get their hand in the cookie jar, there will be some people with crushed hands complaining that they are not getting enough. The same thing occurs when many people access a streaming server at the same time.

Bandwidth is measured in kilobits per second (kbps) or megabits per second (mbps) called data rate. Higher bandwidth yields higher streaming media resolution. Naturally, there is only so much bandwidth available to you. The type of Internet connection you have is crucial to gauging the speed at which you will receive a stream of data. Streaming media, namely video, depends on the transmission speed of the network. Sometimes this results in the audio stream arriving before the video stream, because the video stream is larger than the audio stream of data, thus the audio stream gets sent faster than the video stream. This is called bad key framing. It doesn't sound possible but it does happen. Most codecs, however, mix the audio and video together.

There are many reasons, besides bandwidth, for a slow a connection. A poor connection, for an otherwise optimal connection, can kill streaming speeds. Another reason could be the hardware involved. The routers and firewalls can slow data streams down considerably. The server itself may be the cause of unwanted clogging. Either way an optimal connection is rare and should be accounted for when you create content for streaming media. Not everybody will have one, not even close.

Connections

Generally, you need a 10-mbps bandwidth for a full, high-resolution stream of data. The audio will sound good and the video will look good. An Ethernet connection can support up to 10 mbps of transmission. This type of bandwidth, unfortunately, does not exist in many homes today. This transmission speed is pretty fast, but it is still a little expensive. Many people have a slower transmission rate of 56.6 kbps. This is your typical dial-up modem. The network, which supports the dial-up modem, can supply a 56.6-kbps stream of data to the end user. There is, however, a growing population with higher speed connections. Either way, the optimal rates

achieved by all of these connections is overly optimistic. The rate received is much lower. Internet congestion and many other devices can degrade the amount of data received. The modem is slowly becoming a fossil, but will not go down without a fight. Once the cost of faster alternatives is reduced, the modem will become obsolete.

A faster connection is the digital subscriber line (DSL) or cable connections. There are two basic types of DSL: asymmetrical DSL (ADSL) and symmetrical DSL (SDSL). The ADSL connection allows you to receive a transmission of up to 1.5 mbps and transmit data at up to 128 kbps. This is what most people have if they have a DSL connection. The SDSL connection allows you to receive and transmit data at a rate of 384 kbps.

Another fast option is the cable connection. The cable connection comes into the home via a coaxial cable from your local cable company. Although the transmission rates are higher at the front end by the time the bandwidth is allocated for your service, the transmission rates are similar to the ADSL connection.

The decision is sometimes not yours to make when considering a DSL or cable connection. The service must exist in your area in order for you to get such a connection. Call your local telephone company to find out if the service is installed in your area. There are other alternatives if more speed is required. Below are various other types of connections that can be made and the speeds at which they can transmit data. Keep in mind, some of these can be very expensive.

Encoding

Whether you have a high-speed connection or a slower one, like a dial-up, you should be able to receive some form of streamable media. The streaming media files need to be created with the participant in mind. Different resolution content must be created for different connection speeds. A dial-up modem user with a connection speed of 56 kbps needs a file that will stream at that or a lower rate. This same file can exist in a much higher resolution for those who have a faster connection. While creating streaming media files, the size of the file must be a major consideration. The process of making full sized streaming files smaller is called encoding. This is the process of removing data information that characterizes high-quality files, leaving a more manageable file size for slower connections. The quality of the audio and video is obviously lower, but the participant can still derive the core data from the stream.

Bottlenecks

Streaming in high-resolution or low-resolution is fine but what happens if 10,000 people are accessing the same stream as you are at the same time? The network gets bogged down and the transmission rate at which you receive the file decreases proportionately to the number of users trying to access it. At a certain point there will be too much data trying to get through too little bandwidth. This is, however, a small problem with streaming media. The bigger issue is that with streaming media files, there is a continuous signal occupying the network, which just outright hogs up the space. Future technologies in streaming may solve these problems but researchers

Table 8-1. Various connections and the speeds associated with them

Connection Type	Speed	Connection Description
56k modem	56 Kbps at best Upload and download	The most commonly used connection Easy to set up Inexpensive
ISDN (Integrated Services Digital Network)	128 Kbps	Unlike connection types that depend on less reliable analog technologies, speeds are consistent ("guaranteed") because of the use of digital technologies Allows for an "always on" connection Almost obsolete Relatively expensive Not available in all areas
DSL (Digital Subscriber Line)	384 Kbps and higher	Allows for a connection that is always "on" Can use a shared phone line and does not interfere with voice or fax transmissions Existing phone lines can be unreliable Relatively slow upstream bandwidth speeds Not available in all areas
Cable Modem	384 Kbps and higher	An "always on" connection that does not interfere with TV reception Fast downstream and upstream speeds Shared connection can decrease speed
T1	1.5 Mbps	Used in many businesses Reliable Expensive
T3	45 Mbps	Extremely expensive Reliable Reserved for those institutions that require enormous capacity
Ethernet	10 Mbps	Used in local area networks (LANs) not the Internet
Fast Ethernet	100 Mbps	Used in LANs not the Internet

are working on even larger concerns with streaming and the Internet in general: namely, speeds faster than DSL and cable modems. Technologies such as Fiber to the Door (FTTD) and Ethernet over power lines are considerably faster than either DSL or cable. Not very popular yet, these technologies are at the doorstep of the next level of speed.

Streaming Theory in Brief

In order to create content for streaming media, you should understand some of the theory underlying the process. Live broadcasting and streaming media files are generally what make up the large majority of streaming audio. The process of getting that sound to stream is a little different for each.

Table 8-2. Live Broadcasting over the Internet

LIVE BROADCAST SIGNAL PATH

The signal enters an encoding computer through a sound card.

The encoder translates the data received from the sound card and sends it to the server.

The server sends the encoded audio data stream over the Internet to a participant's computer.

The participant's computer converts the data stream back into a digestible audio format and plays back the sound through the participants sound rig.

Table 8-3. Streaming Audio File over the Internet

AUDIO INTERNET TRANSMISSION

The audio content is converted into a streaming format.

The audio data is placed on a server where it waits to be called.

The participant's interact with a web site and invoke the stream.

The stream is converted back into audio, which is played back through the sound devices of the participant.

Streaming Encoding Algorithms

What makes streaming media possible is the type of compression algorithms used to create the files. In fact, the codecs (compression and decompression encoding algorithms) are really the crux of the story here. The ability to compress audio files and decompress them for playback is truly a great boon for the Internet. Without it there would be no streaming as we know it today.

There are two types of compression used for audio and video: lossy and lossless compression.

Lossy compression removes some of the data in a file to make is smaller. This is not really a compression type because a compression implies that you can receive all of the data when uncompressed. Lossy compression does not allow the retrieval of removed data. The encoding process attempts to remove audio data that is either masked or analyzed as mostly not important for the listener. MP3 is a lossy compression. Therein lies the issue. Can the missing data be "heard" as missing? A well-trained ear can hear low data rates or poorly encoded MP3 files in an instant. The important thing to remember about lossy compressed audio is that when the file is decompressed the data that were taken out are permanently missing! This leads us back to creating your source audio as the highest quality you can get and back it up. Once you have an original sound recorded at high quality, you can always degrade it and still have your source sound as backup.

The advantage to lossy compression is that is can make relatively large audio files (1 minute of Redbook audio is equal to 10 megabytes of data) very small, which is ideal for the Internet and streaming.

Lossless compression shrinks data into smaller groups of information without removing data from the original file. It temporarily discards the data but leaves a map for retrieving it when decompressed. Lossless compression has a much higher audio resolution but does not compress the file as well as the lossy compression. Audio losslessly compressed is decompressed perfectly. There is absolutely no loss of data on playback. These files tend to be large and therefore not very useful for the Internet. If the sampling rate and bit depth are low, then it is possible to stream lossless audio data, but it would sound considerably degraded compared to a good lossy compression like MP3.

There is one type of lossless compression devoted to audio. It is called Free Lossless Audio Codec (FLAC). FLAC is distinguished from general lossless algorithms such as ZIP and gzip in that it is specifically designed for the efficient packing of audio data. While ZIP may compress a CD-quality audio file 20% to 40%, FLAC achieves compression rates of 30% to 70%. FLAC has become the preferred lossless format for trading live music online.

Table 8-4. Examples of popular audio codecs

MP2	Layer 2 Audio codec
MP3	Layer 3 Audio codec
MPC	Musepack
Vorbis	Ogg Vorbis
AAC	Advanced Audio Coding
WMA	Windows Media Audio
ATRAC	Adaptive TRansform Acoustic Coding
DTS	DTS Coherent Acoustics
AC3	Ac-3 or Dolby Digital A/52

Streaming Media Formats

There are many types of formats for streaming audio available at the time of this writing. By far the most popular are streaming MP3, RealNetwork's RealAudio, Macromedia's Flash, Microsoft's Windows Media, and Apple's Quicktime.

Along with streaming, media types are common downloadable file types such as WAV, AU, MIDI, and MP3.

Which of these you want to choose depends on a few factors. The overriding reason to choose one type over another is the target audience. To use Microsoft Media Technologies for a user who may not use Windows as an OS is a concern. One positive point is that all of the available players are starting to interpret other file types. Thus Microsoft media player can read MP3 streams and others. This goes for all of the major players, especially RealAudio. The rate at which the current players change make writing about them pointless except that they are slowly merging as far as file type interpretation is concerned.

Streaming Content Creation

Once the audio assets are created, they can be literally encoded to fit any type of transmission speed. Many software packages can encode audio into many types of different sizes useful for just about any connection speed.

The Downside to Streaming

Yes, there is a downside. Traffic is a constant and growing problem. Unfortunately, you are not the only one on the Internet with a clear passage to your location. This can cause frustration and outright anger. When we all have sufficient bandwidth, all will be well, for a while anyway. Another issue outside the Internet's influence is your computer. Your computer may be slow due to many opened applications or a corrupted operating system, for example. Close as many of the applications you have open and work with a single browser if possible. Defragment your drives and run a registry cleaner if things are really slow. Either way, a faster computer, in general, will help.

A Final Note on Streaming

If streaming is going to be part of what you offer a client as a sound designer then learning about streaming servers and the software involved is essential. Sound design and encoding is considered part of production and is part of the trade, but this does not include information about the servers and programming involved. Just a little more to think about as a sound designer, along with everything else in this book. Nobody said it was easy.

An Introduction to MIDI

MIDI stands for **musical instrument digital interface**. A musical instrument is simply a device which, in the hands of a performer, produces sounds we call music. Digital represents the

Sound Forge Custom Settings

Figure 8-1

Encoding options in Sound Forge.

binary encoding of data structures, discussed fully in Chapter 3, and interface implies a communication device which allows communication between two or more devices. The coming of MIDI in the early 1980s paved the way for many different types of sound scenarios to be accomplished. MIDI allows the connection of many different types of instruments and devices to each other. Some of these include keyboards, synthesizers, samplers, computers, mixers, tape recorders, effects, and all sorts of instruments.

The MIDI standard was published in 1984. This came from a need to find a common communications standard between devices. Before this time, corporations were producing their own standards for each device, which was the cause of much anger in the music community. Since the standard was created, just about every sound card and electronic musical instrument can support the General MIDI standard.

But What Is MIDI?

MIDI is not sound. MIDI data is binary code describing certain musical characteristics. MIDI information is transferred by sending digital information, in the form of binary numbers, through a cable from one system to another. The data carried through the lines contains information on certain parameters for musical performance, parameters such as when a note has been pressed and released on a keyboard, what note has been pressed, how quickly, the volume of the note, and more. All of this information is sent from one device to another and decoded for its value on the user end. One misconception is that audio is sent through MIDI cables. It is not. Only binary data can be transmitted over MIDI cables.

MIDI Advantages

There are some great advantages to using MIDI. One fantastic advantage is that MIDI can transfer up to 16 channels of a performance through a single cable. In analog audio, only one channel of audio, mono or stereo, can travel through a single cable in one direction at a time. Another advantage is that just about every sound card is MIDI compliant, which means that if you use the **General MIDI** specifications, you can write a piece of music and have it played on every machine in the world with a sound card that is MIDI compatible. MIDI also has the ability to control musical and other equipment, such as lights. This worldwide compatibility is the key to the success of MIDI.

MIDI Disadvantages

There are some disadvantages to MIDI as well. One glaring issue is that the General MIDI sounds that come out of all of the computers around the world are less than fantastic. You will hear the term "MIDI sound." General MIDI has a very generic sound and, for most people, does not sound that pleasant. It is, of course, possible to change the bank of sounds and have them sound pretty convincing but the problem is that when another machine received the MIDI data, it interprets and produces the sound through the MIDI configuration set up on that machine, which is usually the General MIDI sound bank. Another issue is that once you

have 16 tracks per cable to play with, there is usually a need for more. More than 16 tracks are possible only with more cables and another MIDI interface device.

Figure |8-2|

MIDI connectors.

MIDI Details

As mentioned above, 16 channels of data can travel through a cable in only one direction. A MIDI device can play back the sound from one of the tracks or all 16 at once. If all of the tracks, or more than one, are played back, each one of the channels can have its own sound or patch. This allows a somewhat orchestrated sound to be accomplished. The trouble lies in what patch number is played through any given device. If patch 1 sounds like a grand piano through your system, patch 1 may not sound like a grand piano through someone else's system. The reason for this may have to do with the user's system being connected to a keyboard or other MIDI sound-producing device. The **sound bank** used by one may not be the same as for everybody else. The General MIDI standard, mentioned above, although universal to a certain degree, just is not good enough for a sound designer, especially for web-based work, because of the lack of a common playback device for sounds other than the General MIDI. Usually the sounds produced are from specific MIDI banks, either bought or created.

All MIDI data travels through a MIDI cable, which ends with a 5-pin DIN connection. This connection is both male and female depending on what is connected. All devices with visible MIDI jacks are female and the cables are fitted with male connectors to join the two together.

The length of the cable has an effect on MIDI as well. The optimal maximum length for cable is less than 20 feet, and most commercially manufactured cable comes in 3- to 6-foot lengths.

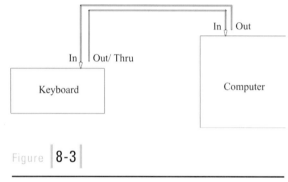

Figure |8-3|

A keyboard connected to a computer with MIDI connections.

MIDI Connections

MIDI is very simple to configure but may cause some gray hair once you try to get it all to work together. Basically there is a device, like a keyboard. There are usually three jacks on the back of the keyboard: MIDI In, MIDI Out, and MIDI Thru. If a cable comes from MIDI Out of the keyboard, it is attached to the MIDI In jack of the computer, for example. This forms a loop if we then go from the MIDI Out of the computer back to the MIDI In of the keyboard.

The MIDI Thru would be used to connect to another instrument's MIDI In jack, forming a **daisy-chain** configuration. Think of the MIDI Thru as a MIDI out jack except that it streams all of the data received from one instrument to the next in a combinatorial fashion, ending at the final destination with all of the data sent from the devices detected along the way.

MIDI Patches

General MIDI contains a standard "patch bank" associated with it. There are 128 patches that must appear in a specific order for it to comply with the general MIDI (GM) standard. These can be selected either through the MIDI device or through software like Sound Forge.

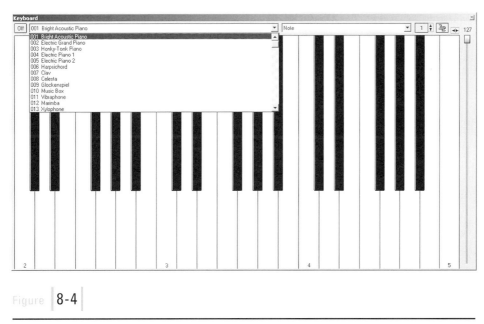

Figure | 8-4 |

Sound Forge MIDI dropdown menu.

The sound of the General MIDI standard are fixed into specific categories. A list of all of the 128 patches in the General MIDI standard is given below.

General MIDI Map

Generally, combining sine waves together in the form of originally recorded sounds creates MIDI sounds. What does this mean? Every sound has harmonic content that can be measured and replicated. MIDI sound is simply an attempt at reconstructing musical sounds based on the strengths and weaknesses of their frequency spectrum. If you combine all of the odd harmonics of say a 100-Hz wave up to about 700 Hz, you will get the sound of a woodwind instrument. This would be the starting point to creating your own MIDI sounds.

Table 8-5. All of the General MIDI sound patches

Channel #	Instrument Name	Channel #	Instrument Name
	PIANO		**CHROMATIC PERCUSSION**
1	Acoustic grand	9	Celeste
2	Bright acoustic	10	Glockenspiel
3	Electric grand	11	Music box
4	Honky-tonk	12	Vibraphone
5	Electric piano 1	13	Marimba
6	Electric piano 2	14	Xylophone
7	Harpsichord	15	Tubular bells
8	Clavinet	16	Dulcimer
	ORGAN		**GUITAR**
17	Drawbar organ	25	Nylon string guitar
18	Percussive organ	26	Steel string guitar
19	Rock organ	27	Electric jazz guitar
20	Church organ	28	Electric clean guitar
21	Reed organ	29	Electric muted guitar
22	Accordion	30	Overdriven guitar
23	Harmonica	31	Distortion guitar
24	Tango accordion	32	Guitar harmonics
	BASS		**SOLO STRINGS**
33	Acoustic Bass	41	Violin
34	Electric bass (finger)	42	Viola
35	Electric bass (pick)	43	Cello
36	Fretless bass	44	Contrabass
37	Slap bass 1	45	Tremolo strings
38	Slap bass 2	46	Pizzacato strings
39	Synth bass 1	47	Orchestral strings
40	Synth bass 2	48	Timpani
	ENSEMBLE		**BRASS**
49	String ensemble 1	57	Trumpet
50	String ensemble 2	58	Trombone
51	SynthStrings 1	59	Tuba
52	SynthStrings 2	60	Muted trumpet
53	Choir aahs	61	French horn
54	Voice oohs	62	Brass section
55	Synth voice	63	SynthBrass 1
56	Orchestral hit	64	SynthBrass 2

Table 8-5. All of the General MIDI sound patches (cont.)

Channel #	Instrument Name	Channel #	Instrument Name
	REED		PIPE
65	Soprano sax	73	Piccolo
66	Alto sax	74	Flute
67	Tenor sax	75	Recorder
68	Baritone sax	76	Pan flute
69	Oboe	77	Blown bottle
70	English horn	78	Shakuhachi
71	Bassoon	79	Whistle
72	Clarinet	80	Ocarina
	SYNTH LEAD		SYNTH PAD
81	Lead 1 (Square)	89	Pad 1 (New Age)
82	Lead 2 (Sawtooth)	90	Pad 2 (Warm)
83	Lead 3 (Calliope)	91	Pad 3 (Polysynth)
84	Lead 4 (Chiff)	92	Pad 4 (Choir)
85	Lead 5 (Charang)	93	Pad 5 (Bowed)
86	Lead 6 (Voice)	94	Pad 6 (Metallic)
87	Lead 7 (Fifths)	95	Pad 7 (Halo)
88	Lead 8 (Bass + lead)	96	Pad 8 (Sweep)
	SYNTH EFFECTS		ETHNIC
97	FX 1 (Rain)	105	Sitar
98	FX 2 (Soundtrack)	106	Banjo
99	FX 3 (Crystal)	107	Shamisen
100	FX 4 (Atmosphere)	108	Koto
101	FX 5 (Brightness)	109	Kalimba
102	FX 6 (Goblins)	110	Bagpipe
103	FX 7 (Echoes)	111	Fiddle
104	FX 8 (Sci-Fi)	112	Shanai
	PERCUSSIVE		SOUND EFFECTS
113	Tinkle bell	121	Guitar fret noise
114	Agogo	122	Breath noise
115	Steel drums	123	Seashore
116	Woodblock	124	Bird tweet
117	Taiko drum	125	Telephone ring
118	Melodic tom	126	Helicopter
119	Synth drum	127	Applause
120	Reverse cymbal	128	Gunshot

You can do a lot of experimenting with this by combining different harmonics together at different dynamic levels. You can learn a lot as a sound designer by attempting to create your own MIDI patches, whether they are usable or not.

Wavetable Sounds

The limitations of General MIDI sounds and the fact that the sounds are limited by being modeled on mathematical constructs led to the development of **wavetable synthesis**. A wavetable is a sampling of originally recorded instruments stored in each of the MIDI patches. Wavetable synthesis is used basically in synthesizers to produce natural sounding sounds. The samples in the wavetable are very small and when looped together create the impression of the original sound. This is a large improvement from the "MIDI sound" mentioned above. Different samples in the wavetable are used for different parts of the sound. The attack phase would exist as one sample and the release phase would be another sample. The advantage of using small bits of sound to create a whole sound is that it requires very little processing power to produce it. The overall sound is very good when considering it is generated as it is. Furthermore, single wavetable samples can be combined for an even more realistic sound. Wavetable synthesis is worthwhile investigating when MIDI management is understood. Downloadable sounds (DLS) is also something to look at when you want your MIDI files to sound better. DLS allows you to access and listen to thousands of new sounds outside of the General MIDI sound set. You can use your sound card for playback or a hardware sampler or in a software sampler running on your computer. One great thing about DLS sounds is that you can tweak them so that they are reproduced exactly the way you want them. Sounds great right? It is and it is all coming at you full force. Start reading and learning about all of this material.

SUMMARY

Streaming media and MIDI are associated facets of the digital audio experience. Sound designers who are working more in the web and streaming audio fields would be wise to further pursue the concepts and principles addressed in this chapter. Although not a major concern for the beginning sound designer, keep this material in the back of your mind for when you are prepared to move in that direction.

in review

1. What are some of the more popular encoding options used for audio files?

2. What does MIDI stand for and define what it actually is.

3. Is there a specific cable needed to attach MIDI equipment to each other?

4. What are some of the advantages and disadvantages to streaming media?

5. Explain why different transmission rates are used for different types of connections when preplanning a streaming file.

exercises

1. Play an MP3 file with a Wav file and see if there are differences in the sound. Describe them.

2. Create a file containing different transmission speed sizes for use with a 56K modem and a DSL connection.

sound in various environments

objectives

The applications and engines that could accommodate sound effects and music

Game engine modifiers as well as the software used to produce some of the results gained in interactive and nongaming environments

introduction

This chapter presents applications and engines that could accommodate sound effects and music. The application of these sound effects within these packages draws on the most common ways of incorporating sound into environments. The thrust of the chapter is based on game engine modifiers as well as the software used to produce some of the results gained in interactive and nongaming environments.

VIRTUAL SOUND ENVIRONMENTS

Sound in virtual environments ranges from educational, training, and medical environments to full-blown, high-resolution games. Incorporating sound into these environments used to mean accessing and manipulating the underlying code to achieve the desired ends. Today, thankfully, the sound designer can now focus on the job at hand: sound design. This is accomplished by eliminating a large part of the coding process. In virtual walkthrough museums, for example, all of the sound objects and music can be applied directly through a GUI (graphic user interface). In these cases, the sound designer has control and programming tie-ups are avoided. Programmers are still the key, however, to large scale, newly created video games. There is always a battle between the programmers and the artists on a game development team. The artists include all of the asset creators in a game from visual to audio, and programmers add the interactive game-play. In the end, the programmer wins because the core responsibility of games is to the participant: game-play must be optimal at the expense of all else. But, if you, the sound designer or composer, could maintain some of the control, then maybe more of the original sound ideas will end up in the final application and not at the mercy of the programmer. This, of course, is not always possible. When new game engines are constructed, the convenience of having a **game editor** is not always available to you when working on the project, or for the composer for that matter. This leads to a loss of a certain amount of control. Keep in mind, every development team is different and different rules apply for each team.

Today some game titles supply a game editor, which allows you to construct levels and even entire games themselves. Basically they are modifying a games engine to perform and present a new game idea. Sometimes, but rarely, the **source code** of the game engine is made open for the public. Some of the bigger game companies have released the source code to their games. Quake is one of the most famous games. Open source code allows a programmer to change the way that code is executed. Graphics, interactivity, and of course audio are all components of the engine and can be manipulated to a designer's end. The downside is that not many people can code within the source code itself, especially the artists on the project, not because they cannot but rather because they do not possess the skill set required for the job. One way for you to become familiar with the process and techniques of working with sound and interactivity is to work with game editors that have the sound engine as a part of the editor. Another way is to find early work in 3D on the Internet and place and manipulate sound objects within environments that support the old standard: **VRML**.

Good Ol' Trusty VRML

VRML (Virtual Reality Markup Language) was created in response to the need for 3D interactive environments. The first standard was released in 1995 and promised a great future. The original plan was a good one, and for a while it looked like it would catch on, but development stopped and the first effort became stagnant. VRML2 was released and allowed more interactivity and creative components to virtual environments. It is not used widely except where you

do find 3D on the Internet. Even though there have been attempts to replace these, nothing has really caught on. Either way, most of the VRML viewers can handle both VRML and VRML2.

VRML is particularly good, however, as an instructional tool for sound designers. There are many different parameters that can be applied to the audio component of VRML. Learning how to put audio assets in a VRML environment will help you understand how objects in a virtual environment call sound objects and more. This is especially important in game and other types of engines. Furthermore, this allows the creation of interactive 3D content with very little or no cost—music to the ears of student sound designers.

3D Studio Max is a state-of-the-art 3D creation, animation, and rendering program. One thing that has been left in Max, through its many revisions, is the VRML attributes. These were created to fill the void of where visual content creators were going to get their geometry for the virtual worlds. As VRML started to lose its luster, Max kept the VRML attributes in the program, either because it was hard to remove or simply to keep this option available. Maya, another high-end 3D program, also has the VRML availability, but its interface is a little trickier to handle. A brief look at some of the key attributes related to VRML in 3D Studio Max will help you realize the potential of this great tool. If you are not an owner of 3D Studio Max then pay extra attention to the capabilities it can afford. Eventually you will want to work with it if sound and interaction is going to be part of your skill set offering.

Figure **9-1**

The different sound parameters in VRML as supplied in 3D Studio Max.

3D Studio Max VRML Attributes

The typical 3D Studio Max interface looks more or less similar to many of the high-end packages on the market today.

Before any VRML viewing can occur, there must be a VRML viewer that will act as the window into the VRML worlds. One of the better VRML viewers is the Parallel Graphics Cortona viewer. It is more than a viewer, as you will discover when you see the web site, but it will handle just about any VRML site created. The viewer can be located at www.parallelgraphics.com/products/cortona. Once this is installed you are ready to view VRML worlds through your browser.

| NOTE |

Cortona supports a variety of browsers including Internet Explorer, Netscape Navigator, Mozilla, and Opera. If you are using another type of browser, check at Parallel Graphics for information regarding the entire list of supported browsers or just try to install the viewer plug-in and see what happens.

Figure 9-2

The main interface screen in 3D Studio Max.

Figure 9-3

All of the VRML attributes in 3D Studio Max.

Sound Node and Audio Node in 3D Studio Max

In Max there are two objects directly associated with sound implementation: The **sound node** and the **audio clip** node. The sound node is the actual location for the audio assets in the virtual space and the audio clip node is simply a reference to the sound on a particular server or, in this case, the hard drive. Both of these must exist in a space in order for sound to function properly in the virtual space.

By using these two assets and linking them to each other, entire sound worlds can be created in Max, exported as VRML files, and quickly viewed through the VRML viewer. This is a quick and relatively easy way to create interactivity with sound. Along with the sound attributes, you will notice that there are many other VRML attributes available, which increases the interactivity of the space.

FarCry Game Editor

FarCry is a popular first person shooter game. One of the great aspects of this game is that a sandbox editor is supplied with the purchase of the game. This allows you to create your own 3D worlds and fill them, in our case, with audio assets. You may have seen other game modifiers included with other games in which all of the assets need to

be compiled and viewed and then reimported and modified to perfect it. With the CryEngine Sandbox, the editor allows you to move freely between working environment and game environment, allowing instantaneous revision capabilities. Think about this for a moment. You are working in the sandbox putting in sound assets and want to check if they are all triggering or mixing together well. You simply click two keys, CTRL + g and you are in game mode listening to the environment.

Sandbox Editor

The editor allows the creation of just about any type of world, but it excels at outdoor scenes. The one sticky point at the time of this writing is the availability to import 3D objects easily from various packages like MAYA and Max. The creators are slowly creating plug-ins that will allow this to occur. Most of you reading this will not be too concerned with that and you shouldn't really. Just remember that when you are creating worlds in the sandbox and ask yourself the question "How can I put other types of objects into the space?" In answer, think about importing models.

Figure **9-4**

FarCry.

Figure **9-5**

CryEngine Sandbox.

For the needs of a sound designer, the assets, which come with the editor, are perfectly suitable for the needs of experimentation, and even more, full-blown professional virtual audio spaces can be produced, which your users will truly enjoy.

Creating an island or land mass is easy in the CryEngine Sandbox. Simply give a name and a resolution, and you have the space to create a world.

Sound in the Sandbox

The sound capabilities in the sandbox are extensive and can be a little complex at times. There are generally three areas of sound that can be defined in the space. Basically there are (1) sound spots, which are sounds that are specifically placed and either looped or played once, (2) environmental sounds with full reverb potential and full scale dynamic, adaptive sound, and (3) music triggered and reacting to a character in the space. All of this is possible through the sandbox.

Sound Spots

The sound spot is used very often in a space. With the sandbox editor, you have the option to create a single sound or a group of sounds that are randomly selected and played one after the other. This kind of random ambient sound can create a truly nonrepetitive sound space that would be convincing even to hard-core listeners.

Figure 9-6

Create an island with a few clicks.

Figure 9-7

The Island.

To access the sound material, simply locate the Sound box under the Objects tab and click it.

You will see the three main options for a sound available in the object selection window. Below that are the sound properties available.

Figure 9-8

Sound options in the sandbox editor.

Figure 9-9

Sound properties.

These properties allow you to define where and what the sound is going to be at that particular spot. Along with these are specific parameters indicating the inner and outer radius of the sound file in the space. This provides a zone of fade if the inner radius is smaller than the outer radius. When you approach the sound node in the game space, you will hear the sound fade in as you get closer to the center of the sound source.

Also notice that the volume is set to 255. This is the loudest a sound can be set in the engine, indicating that you could create a small amount of mix if desired by decreasing and increasing certain sounds appropriately.

The sound itself can be retrieved through the source option.

Figure | 9-10 |

A sound spot; notice the inner and outer radius.

Another property in the sandbox is the preset sound option. This option allows you to create a group of sounds, actually as many as you like, and apply them to a region in the space. Basically you create an area where the sound presets exist, and they are then played and heard as you enter the sound area. This is different than the sound spot in that a geographic region can be set, whereas a sphere is created with a sound spot.

The presets can also be organized to fill the needs of the space.

Figure **9-11**

Sound presets.

Figure **9-12**

Sound entities.

Entities

Another area of sound in the sandbox is using artificial intelligence (AI) entities as sound objects. Under the Entities box in the sound folder, you will find these AI objects.

These are placed into the space, given parameters, and allowed to perform as artificial entities in the space. Are you excited yet? Read on.

Music in the Sandbox

Music and sound cues can be created to fit a required level of anxiety or pressure in the game space. The CryEngine Sandbox allows this fascinating capability. Used most often with music, this device can work equally well with sound effects. Basically you assign an object into the space and set the parameters of the object like naming it Calm, Danger, Conflict, or At Rest, depending on the type of sounds applied because the source determines the effectiveness of the scene in the space. There are six different moods that can be set: Alert, Combat, NearSuspense, Sneaking, Suspense, and Victory. However you choose to use them is up to you. The sneaking option does not have to sound like sneaking music or sound. It is up to you what comes out of the speakers.

The sky is the limit with this sandbox editor. A true treasure chest of sound and music ideas can come from all of this available interactivity. The implementation of the audio assets can become complex when scripts and advanced parameters are entered into the equation, but overall it can all be figured out. If something still causes you problems, get on the FarCry forums and get your answers.

Figure 9-13

Music entity parameters.

Adaptive Audio

Adaptive audio, like the music AI presented above, is usually described as analogous to interactive audio, but it is really not the same thing. Interactive audio implies a user request or interaction for an audio event to occur. Adaptive audio has elements of interactive audio in that the sound events are triggered in some way, but on a more subtle level the audio reacts to the participant's reactions and intensity levels in a game space or interactive visual environment. This chapter reveals some of the aspects of adaptive audio and some of the techniques used in the field. Generally, the game model is used to explain this.

There are different tools currently available for the creation of adaptive audio environments. DirectMusic Producer is one of the most current. Although DirectX has disappeared in name, Microsoft is still going to incorporate it into its new configuration.

DirectMusic Producer

DirectMusic is an audio component of DirectX Audio, which contains all of the aural assets of DirectX. DirectX was created by Microsoft to enable programmers to create games. The PC was chosen as the delivery platform. The first such program was DirectSound. This was used by programmers to play back basic audio objects. DirectMusic was then developed to put some of the control in the hands of the sound designer and composer. It allowed music to become more

adaptive, interactive, and variable in a game environment under the partial control of the sound designer and composer.

There are many things that can be achieved with DirectMusic regarding interactivity and sound and music. The problem, for a long time, was that there was no easy way to interface with the audio layer of DirectX. Then came DirectMusic Producer. This free piece of software was supplied by Microsoft as part of the DirectX package. Currently you can get it at www.micrsoft.com under the DirectX menu. Producer allows a composer or sound designer to directly influence what once was completely controlled by the programmers. It is a fantastic piece of software but it can be complex in the beginning. It has a rather long learning curve. It is still under development and more features will become available.

DirectMusic Producer and Overview

Once you download DirectMusic Producer it may look intimidating but once the process is understood it will all fall into place. Primarily a tool for composers, DirectMusic Producer can also have a large impact on sound.

Todd M. Fay, Scott Selfon, and Todor J. Fay edited a great book entitled *DirectX 9 Audio Exposed: Interactive Audio Development.* This book fully explains all of the aspects of Producer and DirectMusic in general. It also includes an extensive explanation of how to program in a DirectX Audio environment. The case studies presented are important to understanding the complexities of DirectMusic Producer.

Dynamic Audio, A Core Understanding

The three most important aspects of sound and music in an interactive environment are generally accepted to be interactivity, adaptability, and variability. The three terms are confusing. Interactive audio is the audio that exists when a participant interacts and evokes a sound event to occur. When a button is pushed on a website, it makes a sound, or if the mouse passes over a visible object, it also makes a sound.

Adaptive audio is audio that reacts to participant changes in an environment. These parameters can be anything from pitch to volume, orchestration, tempo, and so on.

Variability relates to the slight differences in repetitive sounds, like in repeat hearings of live performances. Many times, sounds that repeat become a distraction and sound artificial.

These three important interactive aspects can be accomplished with DirectMusic Producer. The integration of the sound events into an environment is usually accomplished by the programmer. It is important to

Figure 9-14

DirectMusic Producer.

Figure | **9-15** |

DirectMusic Producer project options.

understand these three distinctions in order to better grasp the tools and concepts you will use in the future. The special thing about DirectMusic Producer is that it is made available to anybody who wants to work with interactive adaptive audio in a moderately friendly fashion, and it is free.

DirectMusic Producer can be a little complex if you are unfamiliar with MIDI channels and downloadable sounds (DLS). But once these concepts are understood, Producer can do amazing things for your sound and music.

There are many options given to you at the beginning of a project.

Through these options, you can achieve a wide array of interactive possibilities such as linear playback, wave playback, through DLS, variability within styles created in Producer, and adaptive music and sound, among others.

If you are working in a Windows environment, then DirectMusic Producer is something that you should consider. It costs you nothing but a little time. Just download, do the tutorial, and off you go.

Other Sound Engine Options

As mentioned above, there are many games now produced with a modifier editor that allows you to create your own levels and games. Some of the more interesting ones are Doom III, Half-Life 2, Battlefield 1942, and Neverwinter Nights, to name a few.

These all contain an editor with varying amounts of documentation and support, but they do not have a nice integrated environment in which to build these worlds and easily manage them. They all need a certain amount of compiling in order to experience all of the mixed assets of a game level, whereas FarCry can give you instant gratification before you actually compile the level out.

SUMMARY

A great way to get some experience with sound and virtual spaces is to work directly in them. This chapter presents a few examples of some of the more well-known tools and game modifiers available to users for interactive and adaptive sound creation. There are many, many examples, and this chapter introduces the learner to exploring and seeking more of them.

CONCLUSION

It is hoped that you have learned a great deal about sound and sound design principles. I encourage you to investigate everything you can that is related to this topic. I also encourage you to contact me with questions or suggestions regarding the content of this book. I can be reached at infom@xfoundry.com. I look forward to hearing from you. Good luck and happy sound designing.

in review

1. What does VRML stand for and what is it used for?

2. Describe what a virtual sound environment is.

3. What is interactive audio?

4. What is adaptive audio?

5. What is variable audio?

exercises

1. Create a sound world with 10 sounds in the CryEngine Sandbox editor or game engine editor of your choosing.

2. Build a sonic environment in a VRML space. Many worlds can be downloaded from the Internet.

notes

| bibliography |

3D Audio Programming, Daryl Sartain, Infinity Publishing Company, 2000.

5.1 Surround Sound Up and Running, Tomlinson Holman, Focal Press publisher, 2000.

Audio Made Easy (Or How To Be A Sound Engineer Without Really Trying), Ira White, Hal Leonard, 1997.

Audio Programming for Interactive Games, Martin D. Wilde, Focal Press 2004.

Audio Vision Sound on Screen, Michel Chion, Columbia University Press, 1994.

Contemporary Music Theory: Level One, Mark Harrison, Hal Leonard Publishing Corporation, 1999.

CryEngine Sandbox FarCry Edition User Manual, David B. Weems, McGraw-Hill/TAB Electronics, 1996.

Designing Web Audio, Josh Beggs and Dylan Thede, Publishers: O'Reilly and Associates, 2001.

Designing, Building, and Testing Your Own Speaker System with Projects, David B. Weems, McGraw-Hill/TAB Electronics, 1996.

Desktop Audio Technology: Digital audio and MIDI principles, Francis Rumsey, Focal press, 2003.

Digital Audio, Russ Haines, Coriolis, 2001 .

DirectX 9 Audio Exposed Interactive Audio Development, Todd M. Fay, Wordware Publishing, Inc, 2004.

Fundamentals of Physical Acoustics, David T. Blackstock, Wiley-Interscience, 2000.

Harmony, Walter Piston, Mark Devoto, Arthur Jannery, W. W. Norton & Company, 1987.

Introduction to Digital Audio Coding and Standards, Marina Bosi, Richard E. Goldberg, Leonardo Chiariglione, Kluwer Academic Publishers, 2002.

Introduction to Digital Audio, John Watkinson, Focal Press, 2002.

Loudspeaker Design Cookbook, Vance Dickason, Audio Amateur Publications, 2000.

Mastering Audio: The Art and the Science, Bob Katz, Focal Press, 2002.

Microphones: Design and Application, Lou Burroughs, Sagamore Publishing Company, 1974.

MIDI Power!, Robert Guérin, Muska & Lipman/Premier-Trade, 2002.

Modern Recording Techniques, David Miles Huber, Robert E. Runstein, Focal Press, 2001.

Musical Acoustics, Donald E. Hall, Brooks Cole, 2001.

Principles of Digital Audio, Ken C. Pohlmann, McGraw-Hill Professional, 2000.

Professional Microphone Techniques. David Mills-Huber, Philip Williams, ArtistPro, 1999.

Sound Design: The Expressive Power of Music. Voice and Sound Effects in Cinema, David Sonnenschein, Michael Wiese Productions, 2001.

Sound Reinforcement Handbook, Gary Davis, Ralph Jones, Hal Leonard, 1990.

Streaming Media Bible, Steve Mack, Wiley, 2002.

Streaming Media Demystified (Mcgraw-Hill Telecom), Michael Topic, McGraw-Hill Professional, 2002.

The Complete Guide to Game Audio, Aaron Marks, CMP books, 2001.

Theoretical Acoustics, Phillip M. Morse, K. Uno Inqard, Princeton University Press, 1987.

Rear Output

Input

MIDI/Game Port

Microphone

Output

Color may vary according to manufacturer

0 dBfs: Zero decibels, full scale. All of the bits in a sound sample are filled with ones. This is the maximum amount of signal possible in a digital recording without clipping. If a signal needs more than the maximum amount of bits available, clipping occurs.

Accidentals: Any of various signs that indicate the alteration of a note by one or two semitones or the cancellation of a previous sign.

Active off-screen sounds: Active off-screen sounds are those in a film which raise the questions of what and where did they or it come from in the scene. They are not seen but provoke the viewer to try to discover what and where the sound came from.

Aliasing: Aliasing is a type of error which has basically caused by two events: 1) when frequencies enter a system which are outside the parameters of the Nyquist limit. Unwanted audio artifacts result from aliasing. 2) When a sound is recorded at a low-bit rate creating the stair step effect.

Ampere: A unit of electric current in the meter-kilogram-second system.

Amplitude: Measured in decibels, amplitude represents the maximum change in air pressure, from a resting position, created by a vibrating body. The more particle displacement, the more impactful the sound.

Analog-digital (A/D) converter: The hardware in a digital recording and reproduction chain, responsible for the conversion of analog electrical signals into a stream of digital bits.

Anti-aliasing Filter: The same as a low-pass filter .

Audio Clips: There are many definitions of what an audio clip can mean, but, it is specifically referring to Flash audio clips here. These are sounds, which are stored in the library in Flash, and placed into a Flash project. The nice thing here is that they can be used over and over again as the need arises.

Auditory canal: The auditory canal is part of the outer ear leading from the pinna to the ear drum. It is out 2.5 cm to 3 cm long and about .8 cm to 1 cm wide.

Base 10: A number system based on units of 10.

Base 2: A number system based on units of 2.

Base 60: A number system based on units of 60.

Beat: Beat is any of the periodic transient signals in music that mark the rhythm.

Beats: The number of pulses which result from two similar but not exact frequencies. The normal boundary for the dissolution of beats is around 20 Hz. This means that if the difference between the two frequencies is 20 Hz or greater, beats are generally not heard and individual tones are then hear, or sum difference tones.

Bit-Depth: Refers to any coding system that uses numeric values to represent something. The depth, or number of bits, determines how many discrete items can be represented, in the case of audio these represent amplitude.

Boom: Boom is a short way of saying boom operator. The principle responsibility of the boom operator is microphone placement, sometimes using a "fishpole" with a microphone attached to the end and sometimes, when the situation permits, using a "boom" (most often a "Fisher Boom") which is a special piece of equipment that the operator stands on and that allows precise control of the microphone at a much greater distance away from the actors.

Boundary Behavior: The behavior of a wave (or pulse) upon reaching the end of a medium.

Boundary: The interface of the two media when one medium ends, another medium begins.

Bus: A bus is basically a path in which you can route one or more audio signals to a particular destination.

Causal listening: As opposed to semantic listening causal listening is that which is for the purpose of gaining information about the sound's source. (Source - Michel Chion *Audio-vision*, (Gorbman, C. ed., trans.).

Cents: The cent is a unit in a logarithmic scale of relative pitch or intervals.

Channel: The section of a console which receives a signal meant for recording.

Chord Scale: A scale with chords produced above each fundamental scale tone.

Chords: Three or more notes played at the same time.

Clipping: A digital audio file which requires more bits than is allocated for the recording or playback.

Cochlea: The entire inner ear structure containing two canals and the organ of the Corti.

Compressions: Regions in the air where molecules are more concentrated than they would be at stasis. This occurs when a sound wave is produced.

Console: Same as mixing desk.

Counterpoint: The technique of combining two or more melodic lines in such a way that they establish a harmonic relationship while retaining their linear individuality.

CPU: Central Processing Unit. The main source of speed and power in a computer.

Crossover: A device which channels frequencies to specific audio drivers of a loudspeaker.

Cue: On many consoles the monitor mix and the cue mix are identical in meaning. The sound which is sent to a headphone set or monitors. The cue on a console indicates that this is the cue mix stage for the output of a signal.

Current: A flow of electrons forced into motion by voltage is known as current.

Cycle: One complete rotation of a vibrating mass from for example, compression to rarefaction and back to compression again.

Daisy Chain: A hardware configuration in which devices are connected one to another in a series.

DAW: Digital Audio Workstation.

Destructive editing: The process in audio editing that does result in damage to the audio file.

Diegetic: Sound whose source is visible on the screen or whose source is implied to be present by the action of the film. This can include voices of characters, sounds made by objects in the story, music represented as coming from instruments in the scene. **Digetic sound** can be either **on screen** or **off screen** depending on whatever its source is within the frame or outside the frame. Bordwell-Thompsson, Film Art, Reize-Millar, The technique of film editing.

Digital-to-Analog D/A converter: The hardware in a digital recording and reproduction chain responsible for the conversion of digital bits back into analog signals.

Driver: A piece of software that enables a computer to communicate with a peripheral device.

Drivers: The cones of a loudspeaker which produce the sound from the incoming signal.

Dry out: Dry out is sometimes a software device used to set the level of the unprocessed signal that will be mixed into the output.

Dynamic microphone: Dynamic mikes use a diaphragm attached to a movable coil that generates voltage as it moves between the poles of a magnet.

Dynamic Range: A range of signals from the weakest to the strongest.

Dynamics: The indicator of volume in music.

Early out: Early out is sometimes a software device which controls how early reflections are mixed into the output.

Early reflections: The early reflections portion of an impulse response is defined as everything up to the point at which a statistical description of the late reverb takes hold, often taken to be the first 100ms. Copyright © 2005-02-28 by Julius O. Smith III.

Enharmonic: A not that is spelled differently but sounds the same.

Equal Temperament: The "equal tempered scale" was developed for keyboard instruments, such as the piano, so that they could be played equally well (or poorly) in any key. The equal tempered system uses a constant frequency multiple between the notes of the chromatic scale. In other words, all of the notes are all equidistant from each other. http: //www.phy.mtu. edu/~suits/scales.html.

Eustachian tube: The Eustachian tube plays no part in hearing but rather helps in balance and keeps the middle ear pressure balanced.

False synchronization: A false synchronization point is a technique used which sets up a scene, aurally speaking, and leads the audio spectator to a climactic point only to visually change scenes but not sound.

Far-field monitors: Reference sound producing devices, speakers, which are meant to be located at a distance of 7 to 15 feet from the person monitoring the sound. The distance varies according to the setup and configuration of the studio.

Flat: Lowering a note by a semitone.

Foldback: Foldback is another way, albeit antiquated to some degree, of describing aliasing.

Foley: A technical process by which sounds are created or altered for use in a film, video, or other electronically produced work. Foley involves Foley actors who, in real-time, synchronize sounds in a Foley studio to image. The American Heritage® Dictionary of the English Language, Fourth Edition Copyright © 2004, 2000 by Houghton Mifflin Company. Published by Houghton Mifflin Company. All rights reserved.

Frequency response: In an audio system, the accuracy of sound reproduction. A totally flat response means that there is no increase or decrease in volume level across the frequency range.

Frequency: Frequency is defined as the rate at which a vibrating mass, electrical signal or acoustic generator reiterates a complete cycle of compression and rarefaction.

Fundamental Frequency: The frequency of the simple wave produced by the simplest back-and-forth motion is called the fundamental frequency. This can also apply more complex waves such as this produced by instruments with more complex results.

Gain: Gain has several definitions but usually it refers to the transmission gain, which is the power increase of a signal most often expressed in dB.

General MIDI: There were basically two types of General MIDI: GM1 and GM2. GM2 was introduced after GM1 and allowed all GM2 devices to be completely compatible with GM1 devices. The General MIDI, General MIDI 1, specification was designed to provide a minimum level of performance compatibility among MIDI instruments. When demand for more parameters and functionality was made, GM2, which increases both the number of available sounds and the amount of control available for sound editing and musical performance, was established. Today just about every computer created has a MIDI device which has a full feature General MIDI set already on it, allowing for massive distribution possibilities.

Harmonics: The series of frequencies created at each multiple above the fundamental pitch. Theoretically harmonics ascend infinitely but decrease in amplitude as the ascend.

Harmony: Simultaneous combination of notes in a chord which reveals the structure, progression, and relation of chords.

Hertz: A unit of frequency equal to one cycle per second.

HTML: Hypertext Markup Language. The is the language used to create basic web pages for use on the Internet.

I/O: Input/Output.

Impressionism: Movement in painting and music that developed in late 19th-century France in reaction to the formalism and sentimentality that characterized academic art and much of the 18th- and early-19th-century music. The impressionist movement is often considered to mark the beginning of the modern period in art and, to a lesser degree, in music. The impressionist movement in music was led by the French composer Claude Debussy. http: //members.tripod.com/~Tatiyana/impressionism.htm.

In Phase: When two signals combine constructively and are identical to each other, leads to a doubling of the amplitude.

Incus: The middle bone in the middle ear which lies between the Malleus and the Stapes.

Interference: The phenomenon which occurs when two waves meet while traveling along the same medium. There are two types of interference, constructive and destructive.

Interval: The distance between two notes or groups of notes.

Latency: In general, the period of time that one component in a system waits for another component to communicate with it or deliver data. In networking, the amount of time it takes a piece of a message to travel from source to destination. Together, latency and bandwidth define the speed and capacity of a system.

Ledger Lines: A short line placed above or below a staff to accommodate notes higher or lower than the range of the staff.

Line level: Line level is the strength of an audio signal used to transmit analog sound information between audio components such as CD and DVD players, TVs, amplifiers, and mixing consoles.

Longitudinal waveform: Wave forms which produced particle movement parallel to the direction of travel.

Loop: A loop is a piece of data that repeats over and over again. Audio loops can be anything from drum kicks to full ambient sounds.

Loudness: Sound loudness is a subjective term used to describe the strength of the ear's perception of a sound. It is similar to sound intensity but it is not identical. A sound intensity must be increased by a factor of ten to be perceived as twice as loud.

Low-pass filter: A filter which allows frequencies to enter a system below a set limit. This prevents aliasing from occurring when the frequency is above the Nyquist limit, for example.

Magnetic field: A condition found in the region around a magnet or an electric current, characterized by the existence of a detectable magnetic force at every point in the region and by the existence of magnetic poles.

Magnitude: Can apply both to the scientist's desire to measure and quantify the physical size of a sound wave, and also to the listener's subjective evaluation of the loudness of the aural experience.

Malleus: The first bone in the chain of three located in the middle ear. It touches the inside of the tympanum and sets the conversion of sound pressure wave into mechanical energy.

Master Fader: The point at which all of the sub mix faders meet and sent to either a recording device or monitor system.

Measure: A musical division of notes into metric distances.

Meter: The indicator defining beats and measures in a musical composition.

Mic level: The level (or voltage) of signal generated by a microphone.

Michel Chion: Michel Chion is an experimental composer, a director of short films, and a critic for Cahiers du cinéma. He has also written a trilogy on sound for cinema which is highly influential: La Viox au cinéma, Le Son au cinéma, and La Toile trouée.

Microphone: An instrument that converts sound waves into an electric current, usually fed into an amplifier, a recorder, or a broadcast transmitter.

MIDI (Musical Instrument Digital Interface): A standard for representing musical information in a digital format. It also is the software that conforms to this standard, used for composing and editing electronic music.

Midrange: A loudspeaker driver that produces the frequency range from approximately 300-5000 Hertz is known as a mid-range.

Mixing Desk: An electronic device for combining, routing, and changing the level, tone, and/or dynamics of audio signals.

Monitor: A monitor is usually referred to as a reference loudspeaker. Monitoring involves the process of listening to the playback or live performance of a session through monitors for level and mixing definitions or simply to communicate with the recording studio from the control room.

Mono: A single channel of audio.

Multitrack: Having, using, or produced with multiple recording tracks.

Music of the Spheres: A perfectly harmonious music, inaudible on the earth, thought by Pythagoras and later classical and medieval philosophers to be produced by the movement of celestial bodies.

Musique Concrete: Electronic music composed of instrumental and natural sounds often altered or distorted in the recording process. The American Heritage® Dictionary of the English Language, Fourth Edition Copyright © 2004, 2000 by Houghton Mifflin Company. Published by Houghton Mifflin Company. All rights reserved.

Natural: Putting a note back to its natural state.

Near-field monitors: Reference sound producing devices, speakers, which are meant to be located within a several feet of the person monitoring the sound. The distance varies according to the setup and configuration of the studio.

Noise Floor: The noise floor is the measure of the signal created from the sum of all the noise sources and unwanted signals within a system.

Nondestructive editing: The process in audio editing that does not result in damage to the audio file.

Nondiegetic: Sound whose source is neither visible on the screen nor has been implied to be present in the action such as a narrator's commentary, sound effects which are added for dramatic effect, mood music. Non-diegetic sound is represented as coming from a source outside story space. Bordwell-Thompsson, Film Art, Reize-Millar, The technique of film editing.

Nonperiodic Complex Wave: Any set of sine waves whose frequencies do not belong to a harmonic series which when combined to make a complex wave that is not periodic, and will generally sound impure or unsteady in one way or another.

Octave: The interval of eight diatonic degrees between two tones of the same name, the higher of which has twice as many vibrations per second as the lower.

Off-screen: Off-screen sounds are those which are heard but are not seen on the screen.

Off-track: Off-track sounds are those which are assumed to exists but aren't actually heard in the sound track.

On-screen: On-screen sounds are those which are visible on the screen. See on-track sounds.

On-track: On-track sounds are those which exist in a scene and are seen.

Out of Phase: When two sound waves are exactly opposite to each other. The result is zero disturbance, or no sound.

Outer ear: The outer ear contains the pinna and the ear canal.

Overtones: The term overtone is used to refer to any resonant frequency above the fundamental frequency.

Passive off-screen sounds: Passive off-screen sounds are those which are not seen in a scene but do not necessarily draw attention to themselves either. These types of sounds create a comfort zone for the viewer by creating a recognizable soundscape with which to enact a scene.

Peak amplitude value: Peak Amplitude (Pk) is the maximum distance of the wave from the zero or equilibrium point.

Peak-to-peak: The distance between the negative peak amplitude and the positive peak amplitude.

Period: The period of a wave is the time it takes a particle within a medium to make one complete cycle.

Periodic Complex Wave: Any set of sine waves whose frequencies belong to a harmonic series which when combined make a periodic complex wave, whose repetition frequency is that of the series fundamental.

Periodic: Something which occurs in a looped fashion. This can be a simple periodic wave or the cycle of a group of waves occurring concurrently.

Phantom power: The device needed to power microphones which require a charge to produce a useable signal.

Pinna: Another word for the pinna is the earflap. This is the fleshy part of the ear which lies on either side of the head. It is also considered part of the outer ear.

Pitch: The musical term usually given to a particular frequency created by a musical instrument.

Point of audition: Sound identified by its physical characteristic as it might be heard by a character within the film. Rick Altman: Sound Theory/Sound Practice page 251.

Powered Mixers: Powered mixers contain their own power (amplifier) source like the Mackie 1604 VLZ. Powered mixers come in all sizes but tend to be smaller rather than larger.

Production Sound: The sound recorded while production is underway. This may be during a film or video shoot.

Psychoacoustics: A branch acoustics dealing with the methods related to how humans actually hear sounds, the sensations produced by sounds, and the problems of communication associated with sound.

Psychology of Sound: The study of how sound and music influence factors on psychological behavioral change.

Pulse amplitude modulation (PAM): A pulse is generated with an amplitude corresponding to that of the modulating waveform. PAM is very sensitive to noise.

Pulse Code Modulation (PCM): The most simple encoding scheme for digital audio. In Pulse Code Modulation, PAM samples are quantized. The amplitude of the PAM pulse is assigned a digital value. This number is transmitted to a device which decodes the digital value and outputs the appropriate analog pulse.

Quantization: The process of converting a sampled sound into a digital value. The number of distinct sound levels that can be represented is determined by the number of bytes used to store the quantization value. The more bytes available, the more sound levels can be represented and thus, a higher resolution sound.

RAM: Random Access Memory.

Rarefactions: Regions in the air where molecules are spread apart, or less concentrated than at stasis.

Redbook Standard: The Redbook Standard is 44,100 Hz, 16-bit stereo or mono.

Reduced listening: This is a type of listening where the sound heard for its own sake, as a sound object by removing its real or supposed source and the meaning it may convey.

Return: The stage on a mixer where a signal returns from a device or other processor.

Reverb out: Reverb out is sometimes a software used as a device to set the level of the processed signal that will be mixed into the output.

Rhythm: The pattern of musical movement through time.

Samples: A sample refers to a value or set of values at a point in time and/or space. The defining point of a sample is that it is a chosen value out of a continuous signal. The sample need not be discrete or digital.

Sampling: Sampling constitutes the rate at which a converted sound is captured. The ``snapshots" are taken at equal intervals. These intervals are larger when the sampling rate is lower and shorter when the sampling rate is higher. There exists a direct relationship between the sampling rate, sound quality, and storage allocation. The higher the sampling rate the higher the fidelity and the higher the storage requirements.

Scales: Groups of notes sequentially placed to create an aggregate.

Semantic listening: Listening for the purpose of gaining information about what is communicated in the sound. This basically is dealing with spoken words. (Source - Michel Chion *Audio- vision*, (Gorbman, C. ed., trans.).

Semiotics: The theory and study of signs and symbols, especially as elements of language or other systems of communication. Musical semiotics is the study of the signs and symbology of music as well as the semantics associated with music.

Send: The stage on a mixer where a signal can be sent from the console to a device or other processor.

Sharp: Raising a note by a semitone.

Signal Flow: Understanding signal flow logic is the key to maximizing the operation of a console. The flow of a signal through the console is one of the most fundamental, but essential, pieces of information to know. Understanding signal flow helps in realizing the most efficient way of how the controls on a console interact.

Signal-to-Noise Ratio (SNR): The total amount of useful information in a signal. The noise floor of a recording is subtracted from the peak level of the recorded signal leaving the signal-to-noise ratio. It is a good idea to get the hottest signal possible with any recording. Get as close to 0 dBfs as possible without clipping.

Simple harmonic motion: Otherwise known as SHM, this is the most efficient and economical movement of a mass can make. More specifically, the acceleration of a mass is always proportional, but opposite to the displacement from the equilibrium position. A sine wave is representative of SHM.

Sinusoidal: A shape marked by curves usually representing a sine wave form in audio.

Sound Bank: A collection of sound samples usually meant for MIDI output.

Sound Designer: The sound designer usually works alone and many times performs his/her own mix. The sound designer works with the project leader, or director, to construct an overall, consistent soundtrack that exploits the expressive possibilities of sound. The large-scale sound design is organically related to the story, narrative and thematic needs of a project or film. This kind of attention to organic unity is usually best created by a single person on the job.

Sound Effects Editor: Sound editors create the entire sound plan for a movie. They are more or less invisible and behind the scenes of a movie production. He/She is also responsible for overseeing all of the production done on the sound track as far as sound effects are concerned including rerecording, or mixing. His stamp of approval is essential to completing a film with sound.

Sound Effects Recordist: This is a person on a sound crew who is responsible for a group of sounds effects recordings. They usually work out in the field, bringing their work back to the studio for enhancements of some kind. Sometimes the sound effects recordist works on the production track of a film or project as well, depending on the situation.

Sound intensity levels (SIL): The sound energy transmitted per unit time through a unit area.

Sound map: The first draft of a sound map may contain a listing of sequences in the film where the general sound content and emotional direction is presented verbally. Traditionally a sound map is a cue sheet prepared by the sound editor.

Spectrum analyzer: A device which can analyze the frequency spectrum of a sound.

Standard Reference Level: This is the standard by which other sounds are compared. 0 dB SPL is the accepted reference level.

Stapes: The stirrup shaped bone which interfaces with the inner ear through contact with the oval window.

Stems: The line extending from a notehead.

Steps: Quantization degrees.

Stereo: Stereo represents two tracks that either interleaved or contain duplicated left and right channels.

Tape Returns: Many times an auxiliaries are used to control a tape return. The tape return is where the signal comes back into the console after being recorded onto tape.

TDM: Time Division Multiplexing, a type of multiplexing that combines data streams by assigning each stream a different time slot in a set. TDM combines Pulse Code Modulated (PCM) streams created for each conversation or data stream.

Tempo: The speed of a piece of music.

Theory of electromagnetic induction: Relates to the magnetic field generated around a conductor when current is passed through it.

Throughput: The speed with which a computer processes data. It is a combination of internal processing speed, peripheral speeds (I/O) and the efficiency of the operating system and other system software all working together.

Timbre: The characteristic sound an object or instrument makes due to the harmonic spectra associated with it.

Transducer: A substance or device, such as a microphone, or photoelectric cell, that converts input energy of one form into output energy of another.

Transient: A short-lived oscillation in a system caused by a sudden change of voltage or current or load.

Transverse waveform: Wave forms which produced particle movement perpendicular to the direction of travel.

Tweeter: The tweeter is the driver in a loudspeaker which produces the high frequencies of a sound. Usually around 4000 Hz on up to the upper range of hearing and beyond.

Unpowered Mixers: Unpowered mixers, usually larger ones, need to have a power source applied to them to power up.

Voltage: The electron moving force in electricity, also called electromotive force (emf), and the potential difference is responsible for the pushing and pulling of electrons or electric current through a circuit.

Walter Murch: The modern grand master of sound design. Walter Murch has been in the business for many years and is widely acknowledged as being one of the most influential people behind the emergence of sound in film as a "respected" art form.

Waveform: A sound waveform is a visualized shape of a signal as a plot of amplitude versus time. Sound is usually visualized as a transverse wave. This approach makes it easier to analyze and understand sound properties than by looking at longitudinal waves.

Wavetable Synthesis: Wavetable synthesis is a technique for generating sounds from digital sound data. Wave table synthesis stores digital samples of sound from various instruments, which can then be combined, edited, and enhanced to reproduce sound defined by a digital input signal. .

Woofer: The driver in a loudspeaker configuration which produces low frequencies. Can be from 20 Hz to about 250 Hz.

Zero Crossing: The point at which a wave file crosses the standard reference level.

| index |

index

Page numbers followed by **f** indicate figures; page numbers followed by a **t** indicate tables.